The Stories Were Not Told

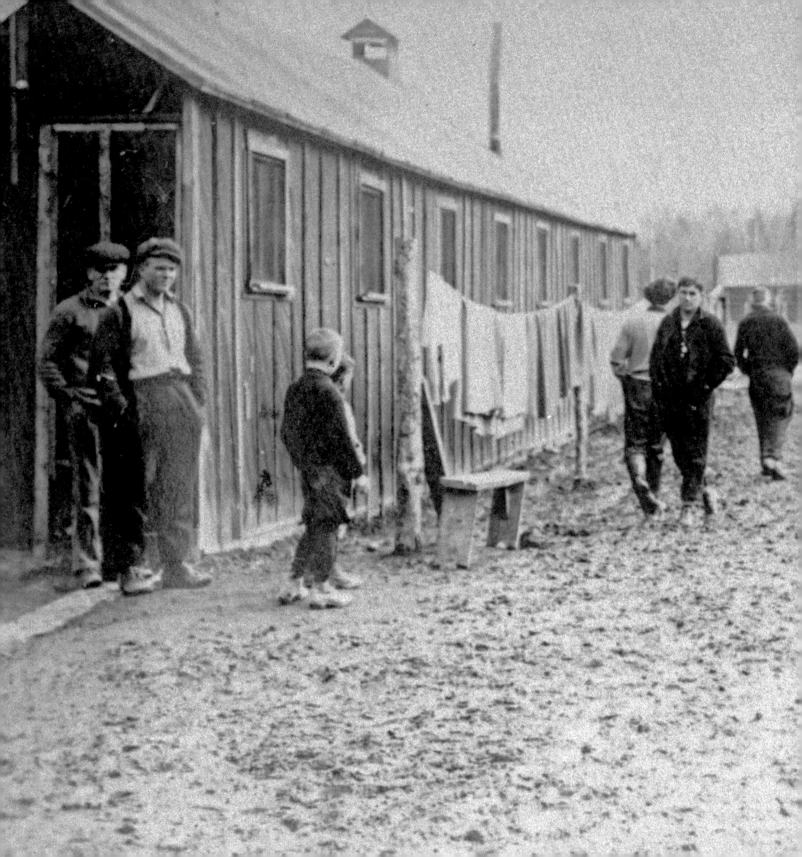

Canada's
First World War
Internment Camps

The Stories Were Not Told

SANDRA SEMCHUK

UNIVERSITY of ALBERTA PRESS

Published by

The University of Alberta Press
Ring House 2
Edmonton, Alberta, Canada T6G 2E1
www.uap.ualberta.ca

LIBRARY AND ARCHIVES CANADA
CATALOGUING IN PUBLICATION

Semchuk, Sandra, author
 The stories were not told : Canada's First World War
internment camps / Sandra Semchuk.

Includes bibliographical references and index.
Issued in print and electronic formats.
ISBN 978-1-77212-378-4 (softcover).—
ISBN 978-1-77212-439-2 (PDF)

 1. World War, 1914–1918—Concentration camps—
Canada. 2. World War, 1914–1918—Prisoners and prisons,
Canadian. I. Title.

D627.C2S46 2018 940.3'1771 C2018-906044-1
 C2018-906045-X

First edition, first printing, 2019.
First printed and bound in Canada by Friesens,
Altona, Manitoba.
Copyediting and proofreading by Joanne Muzak.
Indexing by Judy Dunlop.

University of Alberta Press gratefully acknowledges the
support received for its publishing program from the
Government of Canada, the Canada Council for the Arts,
and the Government of Alberta through the Alberta
Media Fund.

Half-title page photo: Stanley Barracks, Toronto, Ontario.
[Sandra Semchuk]

Dedicated to the internees, the descendants, to those who listened to their stories and passed them on, and to my grandchildren

We know of course there's really no such thing as the "voiceless." There are only the deliberately silenced, or the preferably unheard.

—Arundhati Roy, *2004 Sydney Peace Prize Lecture*

Almost any experience can be reshaped if those who have endured it are given the power to write their own narrative.

—Boris Cyrulnik, *Resilience*

Contents

Foreword The Serpents around Our Hearts

JEN BUDNEY

THE STORIES WERE NOT TOLD comes together like pieces of an elaborate musical score, with Sandra Semchuk configuring and reconfiguring transcripts, images, and personal reflections, seeking to find the appropriate pitch, rhythm, and dynamics, the right timbre and texture. She approaches this challenging undertaking with the same determined yet gently playful manner that characterizes her four decades of practice as a photographic artist. The result is a work of great poetry and lightness, for all the weight of the stories told and the depths of sorrow exposed. It is light in the sense that Calvino expressed, going as it does "with precision and determination, not with vagueness and the haphazard."[1] The book's syncopated structure, the loops and ties made to wars against Indigenous Peoples, the internment of Japanese Canadians, and David Lowenthal's writings on victimhood, conspire to make the book light in the sense that Semchuk's final arrangement is not "dense, opaque melancholy, but a veil of minute particles of humours and sensations, a fine dust of atoms, like everything else that goes to make up the ultimate substance of the multiplicity of things."[2] In this way, the book is a model for the process of reality. No matter what our discipline or subject, each time we try to explain how we got to here from there, we compose narratives based on the multiplicity of fragments of things we've observed, heard, felt, and imagined.

"We want recognition that this really happened during the First World War," states Andrew Antoniuk. Why is this so important? As Semchuk tells us, the story of the internments was not merely forgotten or overlooked by Canadian society but actively suppressed, and, in some part, the internees and their families have been complicit in this suppression. Shame, that acutely self-conscious state in which the self is split, imagining the self in the eyes of the other, can lead to self-repression in the form of "secret shame," the state of being ashamed to feel ashamed.[3] How *would* an adult communicate this complicated feeling to their children or grandchildren, for whom they only wish confidence and positive integration into Canadian society?

Valdine Ciwko writes of her grandparents, "He was gone for almost three years and Baba was all by herself. Baba was ashamed and didn't want to talk about it." Marshall Forchuk states, "I knew that my dad was ashamed of something. I didn't know what... Even though he knew he had done nothing wrong, there was shame attached." And Lawrence Sharun says of his father, "Oh yeah, after, as soon as they got out, they went back into mining and everything carried on. They just crawled in a hole and were sort of ashamed of the fact that they were interned. They didn't bother to make any waves or nothing." Shame brought silence, along with other behaviours, that gave many families feelings of incompleteness, haunted as they were by unexplained sadness, anger, or disregard. When Donna Korchinski discovered that her dido (grandfather) had been interned, she could barely comprehend: "This was surreal. Surreal would be the only word—the fact that I did not know about it. Then the outrage. Why wouldn't he talk about it?" There were those who were not silenced. Vasyl Doskoch wrote letters and fought against the injustices in the camps. But for many, the suppression of the history of the World War I internments has made it difficult for descendants to integrate their experiences of family dynamics, which have been shaped by traumas unbeknownst to them, with what they assume to be true: the gaps in the narratives are too big so the stories don't make sense. If the causes of pain cannot be attributed to external

sources, we blame ourselves, and so the shame is passed down through multiple generations. Even I, daughter of a third-generation Ukrainian immigrant, felt a vague and inexplicable sense of shame about my ethnic heritage when I was a teenager in the mid-1980s in Alberta.

Recognition means we can see our families differently, and understand that the shame in fact is not ours.

What Semchuk has created with this publication is not a history book in a traditional sense. She has not set out to describe the internments as a chronological sequence of events, or to "objectively" analyze their legacy by determining cause and effect. Precise details of the internments are not what she aimed to establish. Indeed, when she first started to collect the stories and testimonies of descendants, she was warned to take little of what they say as historical fact, because the forces of time, selective memory, and even individual attempts to shape experiences into narratives—to understand them, to learn from them—transform memories. But in the absence of "facts"—with the 1954 destruction of some of the records of the First World War internments, and the national disinterest in the internments that resulted in nearly all survivors dying before their testimonies could be recorded—we descendants of victims and survivors of the internments must strive by other means to find out how we got from there to here, and what it means. There is always a longing to reconcile ourselves with stories of past

events, even those stories that hinge upon distant memories or speculation.

Many of the testimonies in this book are based upon stories that were told to children or events and sensations experienced by children a long time ago. Only a few descendants were deliberately and repeatedly told the stories so that they would carry the memories and knowledge forward. Other descendants learned that someone in their family had been interned only after the publication of *Roll Call*, a 1999 document compiled by Lubomyr Luciuk, Natalka Yurieva, and Roman Zakaluzny for the Ukrainian Canadian Civil Liberties Association, which lists nearly 5,200 internees' names gathered mainly but not exclusively from Library and Archives Canada.[4] And still others have quite by accident stumbled across documents in archives or attics that have shed sudden light on a personal trait of their father or grandfather (his silence, maybe, his anger, or his drinking), or even, as in Valdine Ciwko's case, on the haunting reason for the place of pride for a boat in a mickey bottle. In nearly all descendant families, we have little more than fragments—snippets of trail, a few signposts—to guide us. What do we do with this incompleteness?

My beloved baba's older sister, my great-aunt, Christine Witiuk (neé Letawsky), is one of the people Semchuk interviewed for this book. Christine, like all her siblings, except one born in the old country, was born and raised in the bush ten miles from Hadashville, Manitoba. In her interview with Semchuk, she recalled the night the men arrived at the door of their one-room house to take her uncle and her father away (my baba, now departed, was the baby in the bathtub of this memory). Only the little girls' uncle went, and he was never heard from or seen again. Semchuk interviewed my great-aunt when Christine was ninety-eight years old,[5] which meant asking her to access memories from ninety-five years past. What Christine remembered most were the family's terror and tears, and that her tato refused to leave his wife and little children, even while his brother was compliant. It is a profoundly incomplete recollection, the observations of a tiny girl undoubtedly influenced by things she may have heard or overheard from her mother and father. Since I first became aware of this bit of family history, I've tried to find more information, but about this, like everything in the story of our early years in Canada, my family is characteristically vague and inexpressive. Official documents, where they exist, are also of little help.

"We want recognition that this really happened during the First World War," states Andrew Antoniuk. Again, why is this important? Actual physical or textual evidence is today very limited. Many of the internment camps have been reclaimed by forests or have been built upon. Many official documents have been destroyed, and what remains can be frustrating for descendants and other researchers. If the national

identity of the early Ukrainian immigrants was somewhat plastic to officials when they arrived—Austro-Hungarian, Ruthenian, Austrian, Slav, or Ukrainian—their names were even more so, as several individuals in this book have noted. One of my great-grandfathers was Petro Budnyj, sometimes recorded as Petco or Peter Budny. The uncle who vanished, Emilian Letawsky, brother of Michael or Mikhailo (my great-grandfather), was known to his family as Emil, but was usually called by the diminutive "Milko." Using the Latin alphabet, the surname has been spelled Letawsky, Latawsky, Litowski, and Lytowsky. In his introduction to *Roll Call*, Luciuk warns descendants that the spellings of surnames may have shifted in intervening years. There are two Litowskis listed: "Alex," no POW number, "interned, released, or paroled" on January 17, 1916, in Brandon, Manitoba, and/or Moose Jaw, Saskatchewan; and "Mike," POW #1795, "interned, released, or paroled" on April 2, 1916 in Kapuskasing, Ontario.

My great-aunt, who was born in the spring of 1913, remembered there was snow on the ground when the men came to their home, and determined that she was probably three years old. The dates fit. Could Emilian have been interned under the name Alex, three hundred kilometres away in Brandon? Alternately, was he interned under his brother Michael's name and sent 1,200 kilometres east to Kapuskasing? Or did he give them his nickname, "Milko," and

was it recorded as "Mike"? Kapuskasing was the camp to which the government sent men they considered "dangerous foreigners": labour radicals or particularly troublesome detainees. It was the last camp to be shut down; many died there, and others were deported to Europe. Was Emilian one of them? His parents never saw him back in the old country, but my brother once rode a motorcycle from Paris to the family village, Bosyry, in western Ukraine, and photographed a memorial stone in the graveyard. We believe Emilian's parents may have made it for him: it bears his name, Emilian Letawsky, but no dates of birth or death. It is frustrating that we will probably never see any "hard" facts about my great-great-uncle, not a single verifiable article to confirm his existence or his disappearance. Today, the proof of Milko's life and disappearance is borne out solely through this book.

Here I return to the structure of Semchuk's book. It is through its richly textured composition that *The Stories Were Not Told* acknowledges the essential incompletion of its contents. This is not a deficiency. Rather, it is a way for Semchuk to establish the contents as explicitly desirous of interpretation by readers, as longing to be made sense of within the contexts of the readers' own lives—quite simply, as relational. Her own voice and reflections, interwoven among the variety of images, conversations, and texts, ground her subject-position and responsibility as author/artist and image-maker. Yet this voice is interrupted,

loops forward and backward in time, and switches between the personal and academic. Semchuk, as composer of this book, accompanies the interview subjects, writers from the past, and we, the readers, in a sense-making process that continually unfolds, linearly, laterally, and otherwise. And as we concert our consciousnesses upon the layers and layers of fragments of stories and pictures, the World War I internment program and its legacy become established as phenomena independent of any one person's interpretation. Semchuk is thus positing knowledge much as Dorothy Smith described, as "a definite form of social act in which an object world is constituted by participants in a world in common."[6] In becoming phenomena "out there"—no longer held privately—they also become phenomena that we can overcome, that can connect us rather than divide us, ground us rather than expose us. This is why we want recognition.

The book's heavy texturing achieves something greater as well. Semchuk's compositional techniques of layering, bridging, and looping or refraining—her insistence on sense-making as relational—result in a book that is about something far larger than just the internments. Semchuk's project does not serve simply to make a case for reparations or apologies owed, or even to try to help descendants heal. Rather, the revelations contained within *The Stories Were Not Told* aim to shift the terms of personal and national identities of all Canadians, placing

the responsibility on readers to reach, as Semchuk paraphrases from Bernice King, "across pain and suffering—to reach across whatever issues separate and divide and reach across misunderstanding to feed each other." Once we recognize the patterns in the legacy of oppression through the story of the internments, we are obliged to see such patterns elsewhere. Most significantly, this book helps us to develop a more nuanced appreciation of colonial impacts on Indigenous Peoples in Canada, whose dispossession has been the foundation for all immigration.

In part of her interview with Semchuk, not recorded in this book, my Great-Aunt Christine quoted her late husband, who described in Ukrainian his own inability to give voice to his loss and sorrow as being like "a serpent around [his] heart" (Змію мати під серцем, or *zmiiu maty pid sertsem*).[7] This vivid metaphor of a snake strangling the emotional core of an individual can be applied to entire communities who have not had the ability to speak of what they've suffered, or who have not had that suffering recognized by others. In Ukrainian folklore, as in most folklore, snakes embody wickedness, anger, anxiety, and deceitfulness. But in Egypt the snake has healing abilities, in Australia a snake gave birth to all creation, and in West Africa snakes embody wisdom. Snakes are flexible and mobile, and the skins they shed are weightless—just like lightness.

Sandra Semchuk's *The Stories Were Not Told* is a powerful and moving effort toward

healing and liberation, not just for the families of those who were interned during the First World War but for all Canadians who have not yet faced the historical and political realities of our nation, and therefore suffer under the weight of ignorance and misconceptions. Reading this book is part of a process of a long journey toward responsible citizenship, in which we seek to escape the dense web of private and public constrictions enfolding us. It is a means of loosening the serpent's grip, of coming to understand our stories as vectors taking us to other stories, as distinct from structures.

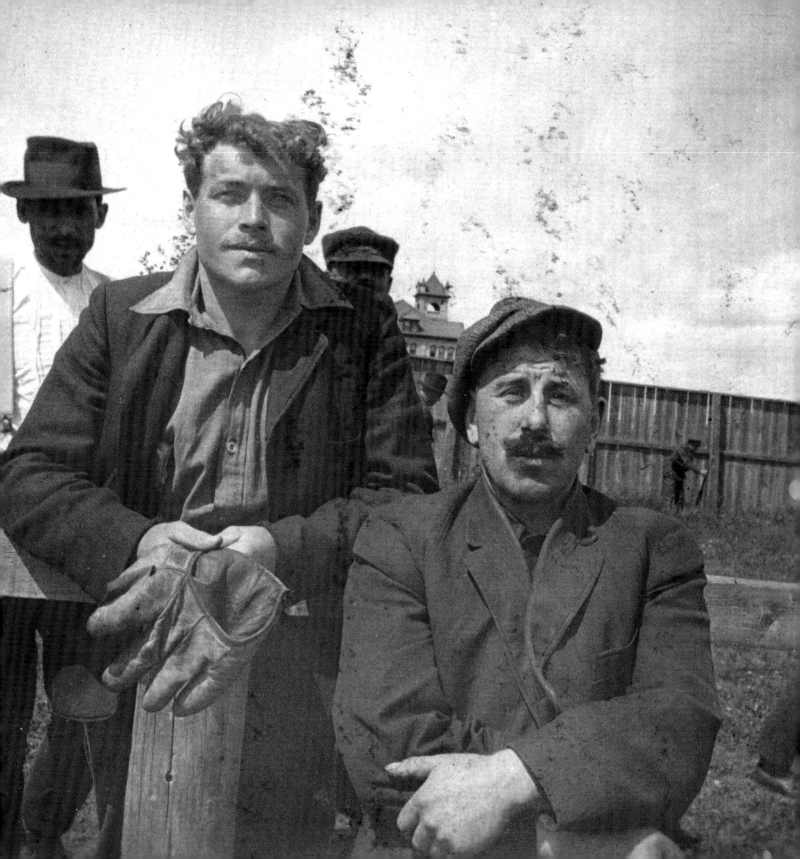

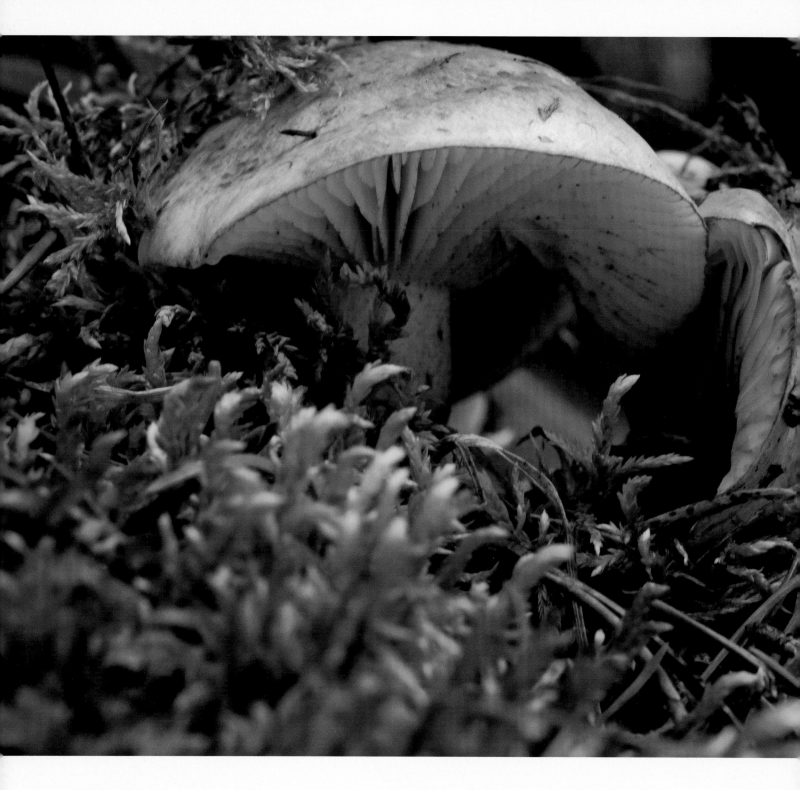

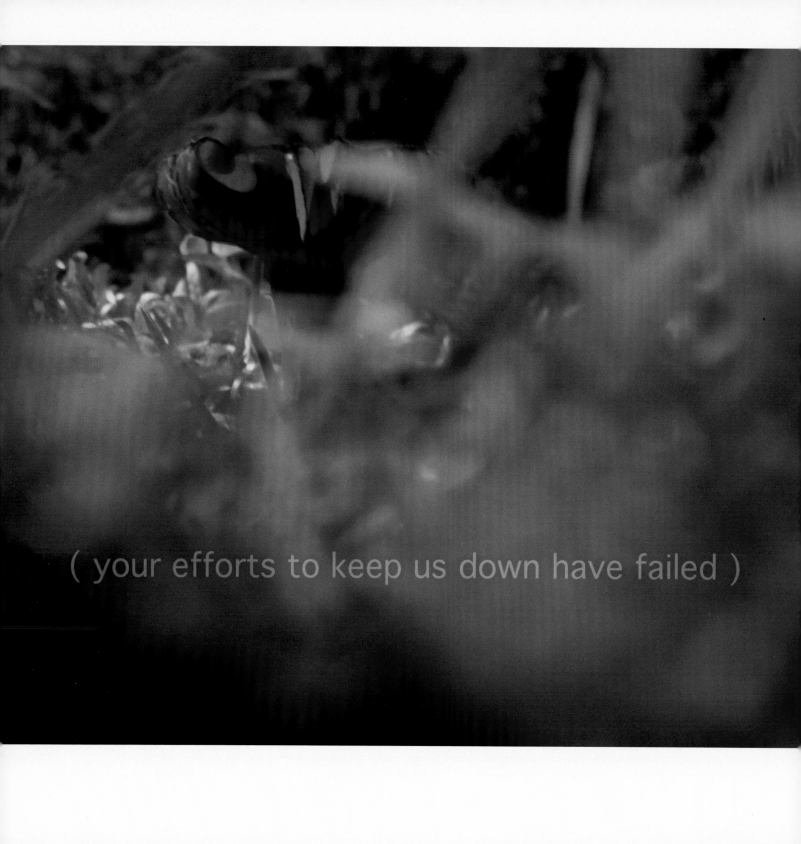

(your efforts to keep us down have failed)

Preface A Gesture That Locates Me in History

> During Canada's first national internment operations in World War I, thousands of immigrants from the Austro-Hungarian Empire, the majority of Ukrainian origin, some citizens of Canada, were imprisoned as "enemy aliens." Internment operations lasted from 1914 to 1920. This plaque is in memory of those held at Castle Mountain camp from 14 July 1915 to 15 July 1917.
>
> —*Plaque inscription, site of Castle Mountain Internment Camp, Alberta*[1]

MY FATHER'S FAMILY, my great-grandparents, came in 1912 from Galicia, a land then ruled by the Austro-Hungarian Empire. They came with their children in response to the Canadian government's invitation and promise of land.[2] They strategically had made a break from Galicia and the past. The door was closed. They used their strength and what little resources they had to go forward.

My father, Myroslaw (Martin) Semchuk, was born in Saskatchewan in 1914, at the start of the First World War. In 1920, when my father began school, there was still a divide in Canada between British subjects and those who were not.[3] This was the year the internment camps at Kapuskasing in Ontario and Vernon in British Columbia were finally closed and those called "enemy aliens" ceased their forced labour.[4] I remember when my father spoke of being called a *bohunk* or a *hunkie* and beaten up: "It was as though they had torn your heart out. You had done nothing wrong. Why?"[5]

My father assimilated, hid aspects of his identity while still speaking Ukrainian and engaging the culture at home. He had learned to box from his Uncle Walter—to protect himself from bullying. Those experiences, and the trouble his anger and learned authoritarianism got him into, taught him how to resist strategically and gave him a desire to help. When he grew to be a man, he participated in bringing Medicare to Saskatchewan.[6] My father kept

his childhood experiences secret until a near-death experience in later life when he let his boundaries and masks come down. The stories that my father then told provided much of the primary ground for my own learning and identity today.

Learning is personal and intergenerational before it is collective. At the 2013 Walk for Reconciliation in Vancouver, Bernice King, the daughter of Martin Luther King Jr., asserted that for us to be free, it is important to reach across pain and suffering, to reach across whatever issues separate and divide, and to reach across misunderstanding to feed each other.[7] My father's ability to speak about his early experiences helped me recognize, across cultures, the negative projections that my Cree husband, the late James Nicholas, faced almost daily as a result of colonization and racism. When James and I stopped at Castle Mountain near Banff, Alberta, a place where a plaque indicated an internment camp was located during the First World War, he was a witness as I learned that my people had been imprisoned in this place with no recourse to justice. The statue at the site by John Boxtel shows a worker in farmer's overalls holding his right hand out in a helpless gesture. On the base of the statue the same question my father had asked appears: "Why? Pourquoi? Чому?"[8]

As James and I walked the land where the internment camp was located, we found hundreds of rose-coloured mushrooms emerging unexpectedly, each one its own shape, colour, and size. Some huddled into others, a community of mushrooms. I came back the next morning when the light was good. I photographed to locate myself on the land where the internees were held captive and forced to labour. I photographed to connect with this blossoming of mushrooms, the memory of walking with my baba, seeing the beauty that each mushroom is—there on the land, and later on our plates. Their quick appearance and equally quick disappearance! The past lay with me, within centimetres of the mushrooms, photographing. I imagined how internees would have responded to seeing wild mushrooms. I imagined how seeing the mushrooms, picking and eating them, would have returned them to themselves for moments.

Then I wondered, were these edible mushrooms like those my baba had shown me? Some *Russula* are poisonous. Were the internees cautious—remembering how they walked in the old country, vigilantly choosing which mushroom to gather to eat based on experiences passed down from one generation to the next? This was a new country. Death could occur from mushroom poisoning. Did this awareness, too, return them to themselves?

Many communities in Canada where internees originated do not know these stories—Alevi Kurds, Armenians, Bulgarians, Croatians, Czechs, Germans, Hungarians, Italians, Jews, Ottoman Turks,

Poles, Romanians, Russians, Serbians, Slovaks, Slovenes, amongst others. Most were Ukrainians; almost all were civilians. Some people have been compelled to ask questions about relatives who may have been interned. Often it has been difficult to trace internees when names were badly spelled or changed.

We are learning the important work of listening and speaking truthfully across cultures. Today's fears for security in the world stir memories and experiences of racism, paranoia, and distrust of new immigrants. Insights emerge within what filmmaker Ali Kazimi calls an evolving conversation about race and immigration in Canada. This conversation is the work of reconciliation, within ourselves, and with each other. As Kazimi writes in his book *Undesirables: White Canada and the Komagata Maru*—another story from 1914 that is not known well—coming out of silence and fear "gives us sustenance in the ongoing protection of human rights, the rule of law and democratic freedoms."[9]

Acknowledgements

I WOULD TO LIKE TO ACKNOWLEDGE the internees posthumously and those descendants who have told their stories. It is a privilege to have been able to create a place where these stories are told. This is your book. Thank you to my daughter, Rowenna Losin, for receiving these stories with self-reflection and criticality.

Thank you to the members of the Descendants of Ukrainian Canadian Internee Victims Association, particularly, Anne Sadelain, Jerry Bayrak, Otto Boyko, Florence McKie, and the late Andrew Antoniuk. You were crucial to the development of this book. I would also like to thank Lubomyr Luciuk, who provided key information and historical advice as I travelled across the country to photograph and meet people. And to all the other bright minds and hearts at the Ukrainian Canadian Civil Liberties Association (UCCLA), the late J.B. Gregorovich, Olya Grod, Marsha Forchuk Skrypuch, Borys Sydoruk, Roman Zakaluzny, and others, a special thank you. Your inspiration is ongoing. Thank you to former Member of Parliament (Dauphin–Swan River–Marquette) Inky Mark, whose private member's Bill C-331, Internment of Persons of Ukrainian Origin Recognition Act, was successfully passed in the House of Commons. You encouraged so many with your actions.

I am grateful to those who listened first hand to internees' stories. Special thank you to producer/director Yurij Luhovy for his generous contributions and permission to quote from his documentary film *Freedom Had a Price: Canada's First Internment Operation 1914–1920* (MML Inc., in co-operation with the National Film Board of Canada, 1994); to Harry Piniuta for permission to reprint an excerpt from his translation of "Internment" by Philip Yasnowskyj as published in *Land of Pain, Land of Promise: First Person Accounts by Ukrainian Pioneers 1891–1914* (Saskatoon, SK: Western Producer Prairie Books, 1978, 1981); to Lubomyr Luciuk for allowing the reprinting of "WWI Internment Account of a Ukrainian at Fort Henry by Nikola Sakaliuk," published as Appendix 1, "An Internee Remembers," in Royal Military College of Canada, "Internal Security and an Ethnic Minority: The Ukrainians and Internment Operations in Canada,

1914–1920," *SIGNUM* 4, no. 2 (1978): 55–58, held in Special Collections, Massey Library, Royal Military College of Canada, Kingston, Ontario.

As I travelled the country photographing and listening to stories, I had the privilege of meetings many archivists who were committed to the nation's stories. I acknowledge the following archives for access to documents and for use of photographs: Library and Archives Canada, Ottawa, Ontario; Fort Henry National Historic Site of Canada, Kingston, Ontario; Peterborough Museum and Archives, Peterborough, Ontario; Ron Morel Memorial Museum, Kapuskasing, Ontario; Glenbow Archives, Calgary, Alberta; and the Revelstoke Museum and Archives, Revelstoke, British Columbia.

This project was funded by grants from the Endowment Council of the Canadian First World War Internment Recognition Fund (CFWWIRF), the Emily Carr University of Art + Design, the Alberta Ukrainian Heritage Fund, the Ukrainian Canadian Civil Liberties Association, the Ukrainian Pioneers Association of Alberta, and the Canadian Institute of Ukrainian Studies (from the Alexander and Helen Kulahyn Endowment Fund and the Anna and Nikander Bukowsky Endowment fund).

A special thank you to Andrea Malysh, program manager for the CFWWIRF Endowment Council, for her commitment to educating the public about the internment operations and for her thoughtful support.

I am grateful to historian Peter Melnycky for his thoughtful historical comments on the manuscript; Glen Lowry, Karin Konstantynowicz, and Beth Carruthers for editorial help; and Natalia Khanenko-Friesen and Gladys Linklater for translations. Your knowledges are greatly appreciated.

Thank you Jen Budney for your ongoing support and your insightful Foreword. Thank you to those who made contributions to this book: Annette Kuhn, Andrea Kunard, David Lowenthal, Jars Balan, Andrew Hladyshevsky, Diane Tootoosis, Eric Tootoosis, Bill Waiser, Bohdan Kordan, Ayumi Goto, Jay Frankel, Carole Harmon, Joan Borsa, Marcia Crosby, Manuel Piña, Sam Olynyk, Gerald Kohse, Joe Jazvac, Alan Polster, John Kinnear, Terryl Allen, and Charlane Bahry. Thank you Janice Morton, Madelon Hooykaas, and Jerry DesVoignes for ongoing nourishment with garden food, insights, and song.

I am grateful to University of Alberta Press for the work of publishing this book and making the internees' and descendants' stories accessible to the public. Thank you to the anonymous readers, whose suggestions I respected. It has been a privilege and a pleasure to work with Peter Midgley, Mary Lou Roy, Alan Brownoff, Joanne Muzak, Duncan Turner, Basia Kowal, Cathie Crooks, and Monika Igali.

Canadian First World War Internment Recognition Fund

ON 25 NOVEMBER 2005, MP Inky Mark's private member's Bill C-331, Internment of Persons of Ukrainian Origin Recognition Act, received Royal Assent. Following negotiations with the Ukrainian Canadian Civil Liberties Association, the Ukrainian Canadian Congress, and the Ukrainian Canadian Foundation of Taras Shevchenko, the Government of Canada provided for the establishment of the Canadian First World War Internment Recognition Fund, 9 May 2008, to support commemorative and educational initiatives that recall what happened to Ukrainians and other Europeans during Canada's first national internment operations of 1914–1920.

This project has been made possible by a grant from the Endowment Council of the Canadian First World War Internment Recognition Fund.

www.internmentcanada.ca

Introduction

I UNDERSTAND reconciliation is a self-reflexive process, a search for the individual within history so that future generations can locate themselves in it. This book creates a space to reflect on the stories of individual internees and their descendants and to consider how lives are shaped by stories that are suppressed. Several of the names of descendants who told me their stories were brought forward by members of the Ukrainian Canadian Civil Liberties Association (UCCLA). Others were recommended by members of the Descendants of Ukrainian Canadian Internee Victims Association or came from leads that emerged unexpectedly when people found out I was working on this book. The stories told are personal. They are told by internees who suffered the consequences of the internment camps and their descendants who continue to learn from the experiences of their kin. The list of descendants is far from complete. With more than 80,000 people who had to carry certificates of registration and with 8,579 interned, that list would be sizeable after a hundred years. Many of those descendants are likely still unaware of this story and its place in their lives.

These stories have been brought together with photographs I took of the twenty-four internment and holding camp sites across Canada, historical photographs, documents of the day, and my own writing. In my writing, I consider where Ukrainian internees had come from and House of Commons debates before the passing of the War Measures Act; I give brief information on the internment and national recognition of the internment, and I dialogue with the internees and their descendants across cultures to model memory work for readers who have the desire to empathetically locate themselves in these stories.

I have focused largely on the internment of enemy aliens in Canada who were civilians from Bukovyna and Galicia, the part of Ukraine that was ruled over by the Austro-Hungarian Empire, which was at war with Britain.[1] In government documents, they were also called *Austrians*, *Ruthenes*, *Rusyns*, or *Ruthenians*, which led to confusion with officials. In this book,

descendants use the terms *Ukraine* and *Ukrainian* because those are the terms with which they identify, despite the fact that there was no state of Ukraine at the time of internment.[2]

Storytelling, Dialogue, and Photography

I have collaborated for close to three decades as part of my desire to contribute to what David Garneau calls "conciliation"[3] between First Nations and settler peoples in Canada. In this book, I work with stories, writing, photography, and the juxtaposition of historical images and texts to encourage the reader to recognize understories that permeated lives of the interned, their descendants, and their cultures. How, I ask, do we get behind national masks to point to something more problematic and human? Can shifting perspectives, including cultural points of view, unsettle relationships between images and texts and open possibilities for experience? My desire is for the reader to synthesize across fragments and gaps in memory and learn uniquely from within the stories, to occupy them. Cultural theorist and filmmaker Trinh T. Minh-ha writes, "Never does one open the discussion by coming right to the heart of the matter. For the heart of the matter is always somewhere else than where it is supposed to be. To allow it to emerge, people approach it indirectly by postponing until it matures, by letting it come when it is ready to come."[4]

The heart of the matter specific to the reader emerges only if and when the reader is ready, and can say, *this is my story*, and, perhaps, *I recognize you in this story*.

As philosopher and literary critic Walter Benjamin wrote, experience is the basis of stories and storytelling.[5] The co-operative, collaborative, and dialogic documentary projects that I have created using photography, text, and video since 1970 question personal, familial, and national stories and open them to be retold from within experience. I have, through the making of artworks, realized Charles Taylor's observations that identity is an ongoing negotiation that depends on dialogue with others as well as with oneself. Recognition—being seen, being understood, being accepted, including self-acceptance—is crucial to the formation of identity.[6] I have told my own stories in dialogue with the stories of significant others. I have photographed across generations with my daughter, Rowenna, learning that play is an articulation of disposition and self in the moment, and with my father, Martin, through four near-death experiences, learning with him how to prepare for his and my own inevitable death. Relationality, how we learn or teach ourselves to be in family, expands outwards to social relations and to democracy itself, to recognizing each other as equals.

Conciliation begins with the personal— we place ourselves in the centre—and moves to the collective. It is a learning

process, a negotiation of identities through listening, speaking, and witnessing. For fifteen years, James and I collaborated across cultures on photographic, text, and video artworks until his accidental death in 2007.[7] Our histories, as a Cree and a Ukrainian Canadian, informed us. James and I recognized that our marriage was, in day-to-day life, an opportunity to make political, social, and psychological structures visible through our art practice. They were stories that came out of our desire to witness each other's experiences of systemic racism, gender inequality, intergenerational effects of historical trauma, and the continuity of familial love, love for the land, values, resistance, and struggle for equality. Our dialogue was grounded in experience and in primary knowledges of place: the complex natural processes and shifts in the land, waters, flora, and fauna, in untold histories, in family, and in community. We saw our works with photographs and text as love stories.

The Stories Were Not Told continues the dialogues with my daughter, my father, and with James, across generations and cultures. It extends that dialogue to the internees and their descendants in a relational way of seeing the world. Their connections with the story, and those of strangers, such as Trinh T. Minh-ha and psychologist Jay Frankel, and friends such as artist Manuel Piña, geographer David Lowenthal, cultural theorist and curator Joan Borsa, and historical figures such as General Otter and Chief Poundmaker appear in unexpected ways as I circumnavigate and move in a story way, weaving pieces together and allowing the story to emerge. Many of the descendants I have spoken with I regard as my Elders. I am learning from them as I continue to listen, and with them, as they share their unfolding stories.

The Land Remembers

The inner landscape that so readily awoke in me as I photographed the mushrooms is what author Barry Lopez calls "a kind of projection within a person of a part of the exterior landscape." We are profoundly influenced in ways we think by "where on this earth one goes, what one touches, the patterns one observes in nature, the intricate history of one's life in the land, even a life in the city, the wind, the chirp of birds, the line of a falling leaf, are known."[8] We are immersed in dialogue with two landscapes, an inner and an outer. It is within our silent conversations with the world that memories are created and stories connect us to place, to questions that give us direction, self-recognition, and recognition of others.

When I walked the land where the internment camps and holding stations were, I reflected on the internees. I looked around for clues to what had occurred, for memory and for understanding. The containment and control of internees echoed

in the present. There was a fence around school grounds at Vernon where teenagers played soccer and around the ballpark at Edgewood. There were fences around the back of Stanley Barracks and Niagara Falls Armoury. There were the monumental contained spaces of the two citadels at Fort Henry and at Halifax. Barbed wire emerged from the core of a spruce tree at Castle Mountain and bound a cedar tree at Revelstoke, giving evidence to fact in time. At the military base in Petawawa, milkweed mirrored the flag flying at half-mast for a soldier recently lost in Afghanistan. Log barracks that once held internees at Camp Otter sagged and were being absorbed by the land. Signs of wolf scat showed where the cubs were playing. And at times — nothing: a young woman gets into a yellow cab on a street corner in Nanaimo, British Columbia, where once a jail held internees.[9]

Increasingly, I would find bronze plaques such as the one at Castle Mountain that state briefly that an internment camp existed there or nearby, which the UCCLA was in the process of installing to counter the internment's erasure. It was one of these plaques that alerted me to the story of Ukrainian internment in Canada.

Memory Work

As readers we each have our own inner landscapes that unexpectedly reveal clues to the questions we silently form. Can we place ourselves imaginatively in the centre of these stories that have been kept secret and denied for so long? Can we integrate empathetic acts with the shards of evidence that remain of the internment to find meaning for ourselves, as descendants have done? This is what British film scholar Annette Kuhn calls memory work. I apply the inquiry that Kuhn uses more broadly to include objects and stories as well as photographs in the prompting of memory. Memory work reconsiders how we can construct the past while being aware of the interpretation process in the deliberate and conscious making of meaning. It is a seeking out of clues and fragments that point to the presences of the past, "to explore connections between 'public' historical events, structures of feeling, family dramas...and 'personal' memory."[10] Kuhn writes that for those whose stories have been marginalized, memory work is not about the momentous historical event but instead offers evidence that can be mined and interrogated for collective awareness, for what has happened after. We actively inquire about the past, actively reconstruct the past as keys to the remaking of ourselves.

Kuhn writes about how secrets provide the necessary conditions that yield for us the will to find clues, remember, and tell the stories of our lives. Desire and need come together to compel us to seek our own truth in a dominant culture that normalizes its stories as truth — in a culture

where our stories may not matter or be denied. She writes, "Memory work is a method and a practice of unearthing and making public untold stories, stories 'lived out on the borderland, lives for which the central interpretive devices of the culture don't quite work.' These are the lives of those whose ways of knowing and ways of seeing the world are rarely acknowledged, let alone celebrated, in the expressions of a hegemonic culture."[11] There are times, Kuhn writes, when families feel compelled to conceal experiences that family members have had from each other as well as from the world. Things will be lied about or simply never mentioned. Sometimes family secrets are so deeply buried that they elude the conscious awareness of even those most closely involved. From the involuntary amnesias of repression to the willful forgetting of matters it might be less than convenient to recall, secrets inhabit the borderlands of memory.[12] An echo may be passed from generation to generation.

When untold individual and familial stories are heard, they may disrupt and fracture societal and national narratives. There is, within those fractures of what has become normalized as true, the potential for a change. Communication opens up to more complex lived possibilities. The tellers in this book knew that their stories would become public, but their struggles to tell their stories were immediate and personal. What would they be passing on to future generations? Many of the memories transcribed here have been told in dialogue with ongoing discoveries of what loved ones may have experienced in the camps.

When I first read the transcripts of stories told to me or written, I was looking for how they would reveal facts and details. I was on the wrong track. Telling, hearing, and reading stories is, first of all, a telling of the story to ourselves. As readers we need to understand this. It is through Valdine Ciwko's initial experience with a single clue—a boat built in a mickey bottle—that she puzzles together, over a number of years, the gaps in her grandfather's story. She demonstrates to me that it is our life's experiences that give direction and punctuality to what we are open to coming to know. Her continued persistence in searching for her grandfather's story reveals an important and respectful struggle against familial denial and silences.

In the film *Jajo's Secret*, filmmaker James Motluk also found a single clue—a parole document wrapped together with naturalization papers—in his grandfather's, Jajo's, belongings after his death.[13] Jajo had lived a middle-class life: raised his family, helped out new immigrants. He was a respectable community member. Motluk's film tells of his own journey from clue to clue to learn why his grandfather had those parole papers. No one knew he had been interned. It is as though our own stories—"the securest of all our possessions"—and the ability to share our experiences is being taken

from us, as Benjamin wrote. To tell a story well, one needs to be open to counsel oneself: "After all counsel is less an answer to a question than a proposal concerning the continuation of a story, which is just unfolding. To seek this counsel one would first have to be able to tell the story (Quite apart from the fact that a man [woman] is receptive to counsel only to the extent that he allows his situation to speak.) Counsel woven into the fabric of real life is wisdom."[14]

The making of this book is a similar process of gathering clues that have been emptied of meaning and forgotten, and then rewoven so that gaps and fractures permit the reader's imagination to allow their situations to speak. The memory work I am interested in is a resuscitation and reinvigoration of the past in dialogue with the present. It is as though Valdine Ciwko reaches back in time to let her grandfather know through her caring that she recognizes what happened to him, and instead of being ashamed she is proud of him for the life he made with and for his family. Through these stories I become aware of containments of mind and heart that affect lives. That is a form of reconciliation that I would like to participate in with this book.

The memories must be respected. An internee may have shared their memories with an attentive spouse or with knowing friends in confidence, or secretly, knowing someday the story would be told. The story may have been overheard by a nosy and loving young son or grandson, told by a mourning mother after the interned father has died, or told on an aunt's deathbed. Just as there were internees who did not tell their memories at all, there are descendants who will not speak, or who ask for anonymity when the stories are told out of respect for their loved ones' silence.

Receiving Counsel from Manuel Piña

What specific economic realities and family stories drove people to immigrate to Canada prior to the First World War? My emotional curiosity lies with those like my great-grandparents who had strong motivation to come to this country. I had to learn to have empathy and understanding through the stories that I was listening to, but empathy did not come easily. It is as though I was indifferent to what I have heard, unbelieving even.

When Cuban Canadian artist Manuel Piña told me about Cubans who attempted to migrate to the United States in the early 1990s, it helped me to imagine how circumstances were for those who left Austro-Hungarian Ukraine before the First World War. In Cuba during the 1960s, the official past was reinvented without recognition of the dark stories people endured. Lives were erased. Piña positioned me before a photograph he made at a popular site in Havana looking out to sea. He asked me to imagine Cubans—young, talented people, women and children—staring

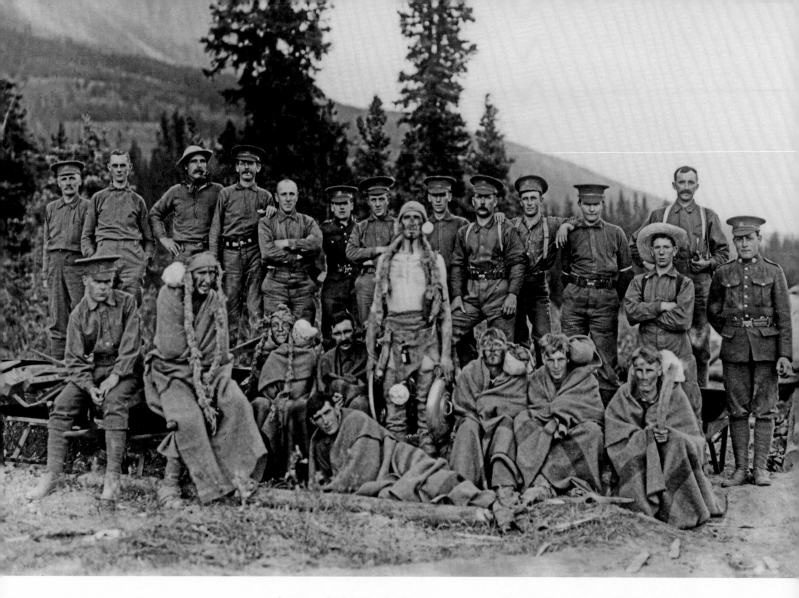

Internees dressed up for "Indian Days," Castle Mountain Internment Camp, Alberta.

[Glenbow Archives, Millican Collection, NA-1870]

out to the ocean, looking to the "promised land," knowing that when they got on those boats to America they were moving from a destroyed collective dream to individual hopes. "It was like a lottery," whether you lived or died, Piña said.[15]

The Cubans, Piña said, held the truth of what had happened in their hearts, silent, as they stared at the vastness of the ocean.

Silent. In that silence of Piña's photograph, I imagined the desperation that lay under its surface.[16]

The particular facts of my story and Piña's are different but I recognize that, in his story, feelings that linger are passed from generation to the next.

There were terrible storms, my Great-Aunt Anastasia said.[17] She was amongst

those who had made the leap into their own vast ocean to come to Canada.

This mess of juxtapositions, of moving forward and backward in time, bouncing from one unique cultural experience to dialogue with that of another culture, is how perception works for me, and how individually we synthesize and learn in unexpected ways over time in a culturally diverse society. One culture, even one human story, provides a counter-situation for the other. We need some level of distance or alienation to simply see, anthropologist Edmund Carpenter said. Carpenter added, "I can swallow the saliva in my mouth because it is 'me,' but I can't swallow it if I put it first in a glass."[18] The challenge is to be able to do both: witness, at some distance, and engage the stories with ourselves in the centre as a part of identity—feeling and making them a part of one's inner landscape.

The Wider Landscapes of Containment and Control

James and I observed in our conciliation work that there are always wider landscapes within which to view a situation. To access the self-esteem and agency needed to see a difficult situation that has secretly impacted our identity, it is useful to consider our stories in relationship to others. It is possible to receive "counsel," to use Benjamin's word, through conversations with others' experiences. Stories of the suppression of the Cree—James's people—and the projection of settler fears on them in 1885, provide a historical context for the creation of the War Measures Act, a registration certificate system, and the internment camps during the First World War. After the Riel Resistance of 1885, a pass system was created to legally control Indigenous Peoples.[19] People were forced to carry passes whenever they left reserves—whether it be to market what they produced, get parts for machines, or visit relatives on the next reserve over.[20]

Unexpected synchronicities startle us into alertness. In 2006, Cree historian Eric Tootoosis told James and me the story of Lieutenant-Colonel William D. Otter's attack at dawn of May 2, 1885, upon the Poundmaker Cree. He took us to each of the sites where the story took place. I knew a General William Dillon Otter from the internment camps story. I was on alert as we drove on trails over cultivated and uncultivated land. We stood where the Medicine Man heard the knocking on the teepee poles and ran to warn his nation. We stood on the rolling prairie wool grassland where the people fled their teepees in absolute silence before the sunrise, saving themselves from the rapid-fire bullets of the Gatling gun. One mother used a knife on her own child to silence the cries. The boy survived to tell the story.

Otter sought to punish the Poundmaker Cree for an attempt at a siege of Fort

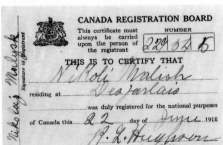

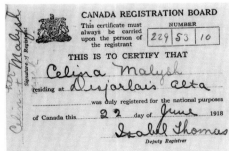

Internees at Castle Mountain Internment Camp, Alberta.

[Glenbow Archives, NA-3659]

Registration cards for "Nikoli Malish" and "Celina Malysh," Desjarlais, Alberta, 1918. Their correct names were Nikolai and Vaselena Malysh.

[Andrea Malysh private collection]

Battleford. According to historian Bill Waiser, Otter led "a misguided attack against the Cree chief Poundmaker."[21] Tootoosis told James and me that the truth was, the Cree were desperately hungry, and Chief Poundmaker and his people were travelling to the fort to pledge allegiance to the Queen. They were not involved in a siege, break-ins, or robberies. That story was also not known. The Cree tricked Otter's soldiers into believing that there were many more warriors than there were and routed the troops. Poundmaker prevented his forces from inflicting greater damage to Otter's men as the column retreated. In *Loyal till Death: Indians and the North-West Rebellion*, Blair Stonechild and Bill Waiser write, "If not for the restraint of the Indians, Canada would have experienced its own Little Big Horn."[22]

Three decades later, at the start of the First World War, it was the same Otter, now a general and a knight—Major-General Sir William Dillon Otter—who was brought out of retirement by the Canadian government to command the internment operations. The newly passed War Measures Act (1914) had given the Conservative government of Prime Minister Robert Borden sweeping powers to suspend civil rights and to act without parliamentary approval. The right of habeas corpus, the right to be innocent until proven guilty, was suspended.[23]

Otter's job was to make sure the War Measures Act was brought into effect.

Another pass system—certificate of registration cards that had to be carried at all times—was developed to control the movements of more than eighty thousand "enemy aliens," the majority of Ukrainian origin, who were born in or had passports from nations that were at war with Great Britain.[24] As a 1915 article in the *Brandon Sun* describes the system, "When first reporting each man is given a card which must be signed every month by the chief of police at the place where he is staying. This a record of the movements of each foreigner is kept." Those who did not report, the article continues, were "hunted up and placed under arrest."[25]

Learning from Japanese Canadians

In her novel *Obasan*, Joy Kogawa writes, "There is a silence that cannot speak. There is a silence that will not speak."[26] I wonder. When interned Japanese Canadians, many of them second- and third-generation Canadians, broke their long silence and openly fought for redress in the 1980s, did their work support Ukrainian Canadians internees and descendants in their struggle to accept what had happened to them during the First World War? The War Measures Act had been invoked for the second time. The Japanese Canadians were taken from their homes and interned; their property was confiscated. Once again, all this without recourse to justice through the courts. There were differences between

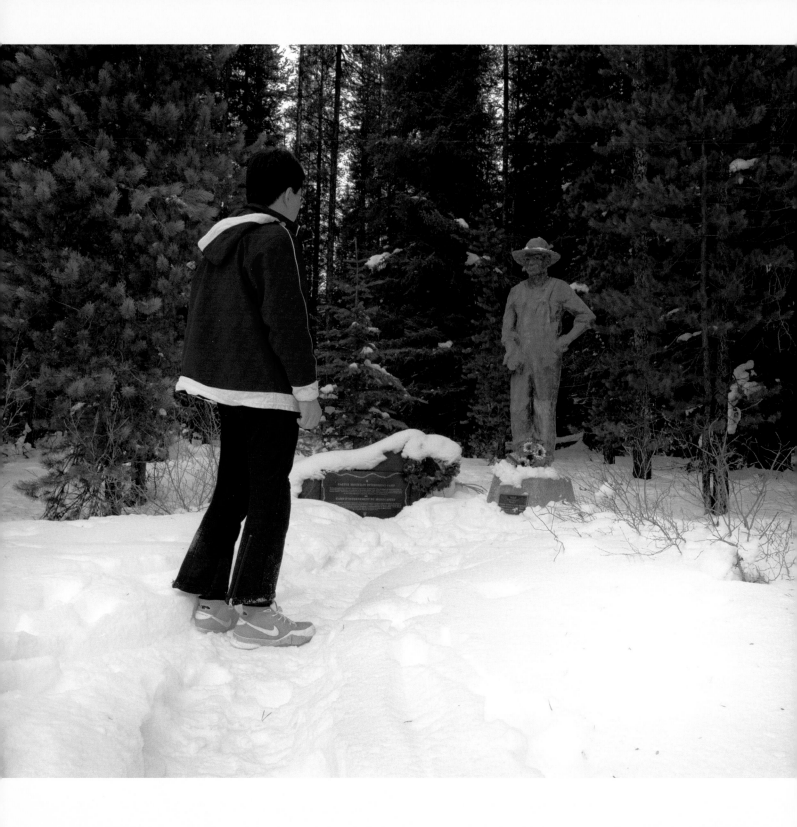

Tourist standing before the sculpture by John Boxtel and the plaque made to honour those interned at Castle Mountain Internment Camp, Alberta.

[Sandra Semchuk]

the Japanese Canadian internment and the first internment, but the political gestures of containment, control, and subjugation were part of a pattern of national behaviour used between 1914 and 1920 and, before that, with Indigenous Peoples in Canada. Japanese Canadians were made helpless to do anything, as Roy Miki explains in his book *Redress: Inside the Japanese Canadian Call for Justice*. Interned with his family, Miki was one of those who fought for redress. He describes the trauma of internment as having stopped time; those interned were left in a permanent state of mourning.[27]

The unprecedented disruption of family unity cut deep in the consciousness of those uprooted. Mothers recounted the details of the precise moment that their young sons had been shipped east to work in road camps. Many who were children at the time remembered — as if it were the day before — the shock of removal from school, their education terminated as they went from being "Canadian" to becoming a figure "of the Japanese race."[28]

Through the insightful stories of the internment of Japanese Canadians told by authors such as Roy Miki, Joy Kogawa, and filmmakers Linda Ohama and Pia Massie, I can, at some distance, make the leap to imagine the inner landscapes home to complex traumas and "secrets that separate" that Ukrainian internees struggled with.[29] The Japanese Canadian stories are counter-situations with an uncanny familiarity, a painful prepping ground for me

as I move out of denial. As member of the second generation born in Canada who does not speak Ukrainian, my process of participation in the collective Ukrainian Canadian narrative, in belonging, has been weakened by assimilation, the breakdown of the extended family, a loss of language, and by ongoing diaspora within Canada. Is it easier, I wonder, for me to become collectively engaged in Japanese Canadian narration of the camps during the Second World War?

What, I asked myself, didn't I want to know?

I didn't even know in the 1980s that the invisible alchemy of experience I learned from my walks with the late Roy Kiyooka, artist and former Japanese Canadian internee, was preparing the ground to begin to empathize with those from my own culture who were interned earlier than he was. I didn't even know the story, but the ground was being laid for me to be able to hear it, to be able to move out from under a national blanket of denial and erasure.

There are still Japanese Canadians alive who were once interned. Descendants can speak with those interned. Not so with World War I. Descendant Fred Olynyk, talking to me from a retirement home, could no longer speak directly with his father. His dialogue was with his memories of his father. Knowing that the Japanese Canadians were treated so badly during World War II in Canada, Fred was able to

think of his father's internment earlier in a new light. He said, "I could see by how the Japanese Canadians were treated that the problem wasn't Ukrainians or Polish or Turkish people in Canada—the problem was the races who thought they were superior."[30] From personal daily experience, he knew the Japanese Canadians who had returned to Revelstoke after the Second World War were good people. "I realized then that I must be a good person, too," he said to himself and to me.[31] Within Olynyk's words was hard-earned wisdom.

Did the "success" of the internment camps of World War I and the silences that followed make it possible for the Canadian government to go further in the internment of Japanese Canadians, to include the blanket confiscation of homes, boats, and property, mass evacuation, and greatly increased containment of whole families? My questions reveal how little I know. During the Second World War, those directly affected by the internment in the First World War would have recognized the seriousness of what was happening to the Japanese Canadians. The past was repeating itself. Were those interned and their families still struggling to overcome racism and intimidation? Would there be a fear that they could be interned again or that to speak out would compromise any degree of belonging that they had established within the nation? Were there internees from World War I who had learned to identify with mainstream Canadian society and were, themselves, rationalizing this new internment as necessary security precautions?

Descendant Jean Gural spoke to me about her father, Nikolai Tkachuk. Tkachuk's life was threatened in a camp during the First World War. He escaped in terror. Tkachuk would not allow members of the family to speak about anything to do with the Second World War or say anything to call any attention to themselves during that war. The whole family was silenced. "That paranoia permeated generations," Jean said. "My father was still afraid." Being invisible was a part of not getting into trouble or staying safe. It was about surviving. "My father was hurt," she realized.[32]

Jean believed that her father was paranoid during World War II as a result of his internment and escape in the earlier war. I have learned from Marshall Forchuk that his father spoke only to those he trusted. Did those fears extend more broadly and invisibly into interned communities? "What concerns me, however," Avishai Margalit writes in *The Ethics of Memory*, "is not the healing power of knowing the truth in the case of the individual but the healing power of knowing the truth in the case of communal memories."[33] That is a step that has yet to be made. When I asked historian Bill Waiser what First Nations, Japanese Canadians, and Ukrainians in Canada held in common, he answered, "They were not regarded as part of the country's Anglo-Canadian ideal."[34]

No. 84

This is to certify that Pete Churla

the bearer of this certificate, a subject of Austria

who was interned as a prisoner of war in Canada at

Morrissey, B.C. , described for identification as

follows:-

Age 31 Height 5' 5" Weight 140

Complexion medium Hair medium Eyes grey

Marks Large lump under left ear

has been discharged from internment subject to the following

conditions:-

　　1. That he shall not leave Canada during the period of

hostilities without an exeat issued by competent authority:

　　2. That he shall observe the laws of the country, abstain

from espionage or any acts or correspondence of a hostile nature

or intended to give information to or assist the enemies of the

British Empire:

JUN 20 1916
OTTAWA

　　3. That he shall report as directed by the Royal

North West Mounted Police.

　　4.

Dated at Morrissey B.C. this 30th day

of August 1916.

Major General
Director Internment Operations.

Reported at Blairmore 8-9-1916

14/9/16

Permission to go to Coleman to work

Reported at Coleman 15-9-16

Reported at Corbin B.C. Sept. 16th 1916. Charles Kerr. Prov. Const.

Reported at Fernie June 16 1917.

Reported at Fernie

Const McDonald

Fernie, March 16th 1917

Fernie Apr. 16th 1917

Fernie May 7th 1917 GW

Fernie June 5th 1917

CHIEF CONSTABLE'S OFFICE
OCT 16 1916
FERNIE, B.C.

Fernie
22/4/18

NOV 15 1916
FERNIE, B.C.

Nordegg 2-11-18 N. McDonald
11-12-18 N. McDonald
4-1-19 N. McDonald
8-3-19 N. McDonald

Permission is given to the bearer to go to Olsen B.C. on the

7th day of May 1917 & to report to the Police at Hosmer on his

arrival who will give him instructions.

G. H. Welsby

CHIEF CONSTABLE'S OFFICE
MAY 23 1917
FERNIE, B.C.

Prov. Constable. Hosmer.

Reported at Waldo June 11-17
Prov. Constable

Young guard, Spirit Lake
Internment Camp, Quebec.

[LAC PA-170454]

How could Canadians, from different cultural backgrounds, who were not interned during both wars, who saw themselves as good people, participate and watch as the internments unfolded on Canadian soil once more? A friend gifted me a book by Bert Hellinger, a psychotherapist, about family constellations and group politics. Hellinger worked to understand the larger patterns that shaped his patients' fears. He writes, "Whenever conscience acting in the service of belonging binds us to one another in a group, it also drives us to exclude those who are different and to deny them membership that we claim for ourselves. Then we become frightening for them."[35] Conscience and belonging are profoundly connected. When we see ourselves as a part of one group, we monitor, adjust, and readjust the parameters of our behaviour to sustain and strengthen that belonging.

In June 1915, workers from British families in the mines near Fernie, British Columbia, one day worked side by side with Ukrainians and Croatians. The next day, the same men went on strike refusing to work with "enemy aliens." The *District Ledger*, a local paper in Lethbridge, Alberta, reported, "Words have been received that the employees of the Hillcrest Mines Co. on the Tuesday morning shift held a meeting at the pit-head and decided not to go to work so long as those of German or Austrian nationality were kept on."[36] Nearly four hundred were interned very

Officers, Spirit Lake Internment
Camp, Quebec.

[LAC PA-170640, credit: R. Palmer]

quickly in the skating arena in Fernie. The
District Ledger story continues: "Among
these interns there are many who have
resided in the district since the first steel
rails were laid through the Pass, and some
of the younger men attended the Fernie
schools as young as the school age permit-
ted."[37] Hellinger writes, we "do to others
in good conscience what our conscience
forbids us to do to members of our own
group."[38]

Moments in history when the politics
of groups re-form or transform, however
momentarily, may also become opportu-
nities for learning and social change to
occur. In Anne Sadelain's story, when her
father, Vasyl Doskoch, saves a guard's life,
that guard broadens his group to include
Doskoch, even if this means he is at a risk
of losing membership to his own group.
The guard not only brought Vasyl fresh
oranges, a luxury unheard of in the camps,
but warned him to move his bed — avoid-
ing a gunshot the following night. That
same guard snuck out a letter addressed
to the Swiss consulate that triggered an
investigation.[39]

Learning that moves us forward as
individuals and as peoples is in constant
motion and flux, forward and backward.
It is a part of identity creation. A clear con-
science may not mean we have been just
where a guilty one may mean that we have
been. Hellinger writes, "We do destruc-
tive and evil things with a clear conscience
when they serve the groups that are

necessary for our survival, and we take constructive action with a guilty conscience when these acts jeopardize our membership in these same groups."[40]

When I read Roy Miki's *Redress*, I was able to engage in dialogue with the internment of Japanese Canadians. It is as though there is someone else there to counsel me. Miki's stories help me make sense of the silences after the First World War.

Identifying with Those Who Oppress

On a daily basis, I listen and watch for clues to help me understand this story. I got an email about a panel discussion called "Psychoanalysis and the Politics of Fear" at Simon Fraser University in Vancouver. The panel focused on the work of Hungarian psychoanalyst and theorist Sandor Ferenczi. I had to go. During World War I, Ferenczi was a medical officer in the Austro-Hungarian Army. I listened closely to one of the speakers, Jay Frankel. Frankel studied Ferenczi's insights into relations between the aggressor and the aggressed. Later, Frankel sent me some of his writing to help me understand the concept of identification with the aggressor.

Ferenczi argues that identification with the aggressor is a traumatic response involving hypersensitivity and automatic, unthinking compliance with an aggressor. It happens "when we [feel] in danger with no chance of escape. What we do is make ourselves disappear...Like

chameleons, we blend into the world around us, into the very thing that threatens us, in order to protect ourselves."[41] I often return to the idea that learning in stories circumnavigates the point rather than coming to the point of the matter, as Trinh T. Minh-ha suggests. Learning shifts, turns in on itself, identifying new perspectives. I listened closely to try to understand Frankel's language that day. I wondered, do we unconsciously and, at times, consciously protect those in power because we are dependent of them for our future? Frankel spoke about silence: "Ferenczi witnessed in his patients that trauma often led to identification with the aggressor, which included different forms of compliance with the aggressor. Silence was one of those forms."[42]

I sat there, alert. Questioning. Once, when I experienced backlash for critiquing an authority, my father said to me, "You made the situation more difficult by talking about it." I was surprised. He raised me to speak out, to be critical, to engage in dialogue with authorities as an equal. Where did his attitude come from? It seemed so contradictory to everything he had taught me. What was worse was that he was right—at least in part. It hadn't been safe to speak in this instance. It made me think about the internees. Was the silence necessary for internees to continue a relationship with this nation rather than be further alienated? Was it for their own security, and out of terror, that they

kept quiet? Were there individuals, internees, and their families in Canada who read the "nation's mind" and act on internalized directives even after the war and up to this day? Was I breaking an unspoken taboo by asking questions and speaking, even now, a century later?

While doing my research for this book, I found communities who did not want to speak about the internment at all. One man who refused to speak said, "Oh, I know what you are going to do." I didn't know what he meant. At the end of Frankel's talk, I asked aloud, "Why, after, all of these years are there families of internees who are afraid of or refuse to speak of what happened in the internment camps? The descendants are a generation or more removed from the experience of internment." Frankel responded to my question by saying that intergenerational transmission of trauma may be operating there. Because of the high degree of mutual accommodation that identification with the aggressor creates, it can be seen as a key ingredient in the universal social lubricant, and indeed as an important aspect of the basic human relationality that silently structures many aspects of society's economic, political, and social life. The threat of social exclusion keeps fear and compliance active.[43]

These unconscious structures of accommodation and compliance could be embedded as a part of the very fabric of a society, invisible and systemic, a part of

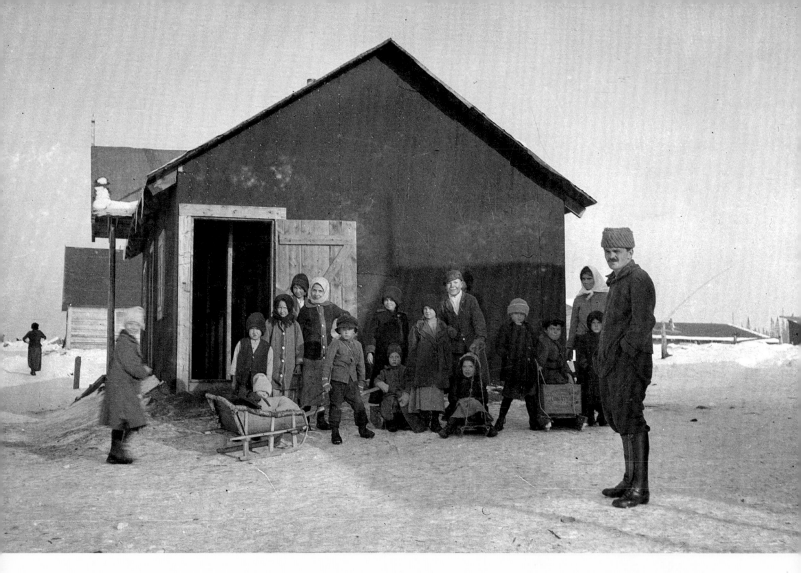

Interned families, Spirit Lake
Internment Camp, Quebec.

[LAC PA-170623]

daily life—accepted and acceptable. One generation could teach the next through their actions across cultures and power structures. Within one culture, one family, one person even, the cycles and effects created by systemic violence are complex, contradictory, and confusing. Hiding the truth may have been a necessity at the time. Then, having been hidden so long, it may have become forgotten, fragmented, or lost.

Many internees sold everything to come to Canada. What they had may have been confiscated or lost once they were interned or unable to meet homesteading regulations. What choices did they have? They were dependent on what goodwill existed towards them as "foreigners" to get jobs and to survive—to remain connected, even if marginalized. The dominant society assumed that that to imprison and enforce

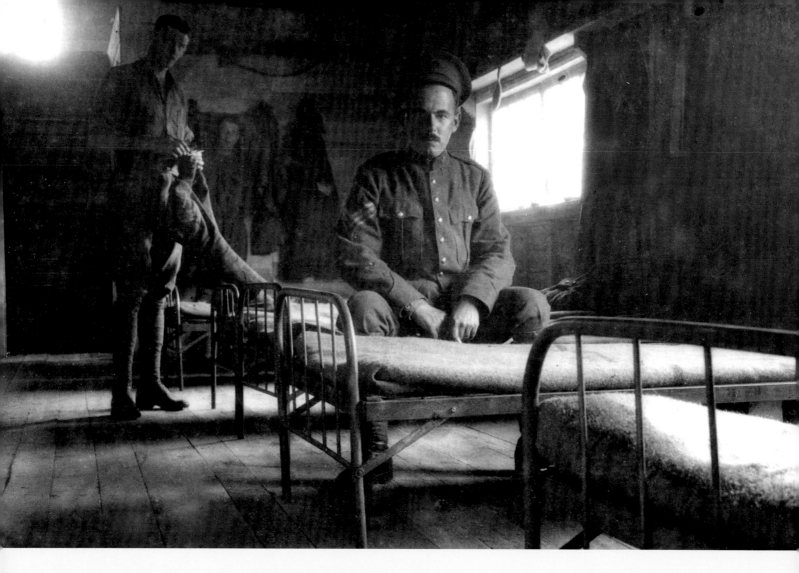

Guards, Spirit Lake Internment Camp, Quebec.

labour were reasonable—even righteous—acts during wartime, and that those who were interned would learn to "behave" and become compliant "good" citizens, and not "complain." As late as July 3, 1919, Sir Hugh Macdonald, police magistrate, wrote to the Honourable Arthur Meighen, then minister of the interior, about making an example of undesirable aliens:

Coming as these men do from countries where such a thing as freedom is unknown, they do not understand generous treatment and consider it is only extended to them because the Government is afraid of them; indeed, fear is the only agency that can be successfully employed to keep them within the law and I have no doubt that if the Dominion Government persists in

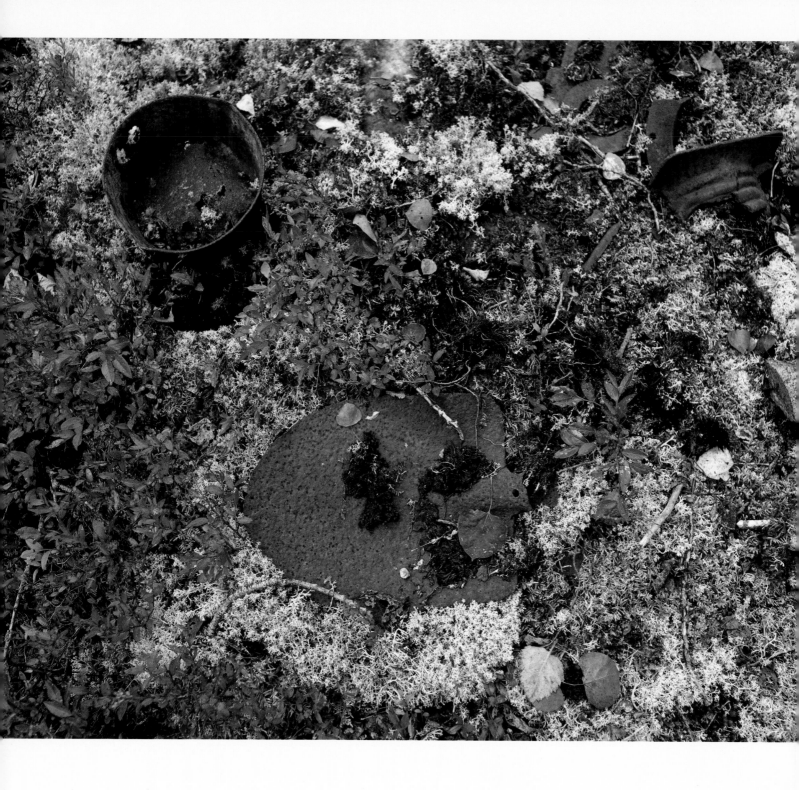

the course that it is now adopting the foreign element here will soon be as gentle and as easily controlled as a lot of sheep.[44]

Nation building was a grand enterprise in Canada at the end of the war. The authorities who oversaw the building of the Spirit Lake Internment Camp in northern Quebec assumed that the internees would be grateful for the opportunity to stay in the area and farm that remote land after the war was over. It was assumed that internees would comply—that they would identify with the needs of the nation to both occupy and make the land agriculturally productive. Instead, those interned left.

Looking Back to Where They Came From

Learning across generations is crucial in the ongoing struggle for democracy. Accepting the past is a part of that struggle. The folk-tale picture book *Silver Threads*, by Marshall Forchuk's daughter, Marsha Forchuk Skrypuch, continues and elaborates on her father's and her internee grandfather's, Yurko Forchuk's, questioning of the internment camps. In *Silver Threads* I glimpse the desperation and the astuteness of a people who have been ruled by a foreign nation, as well as their determination to retain familial love, cultural integrity, ritual, and connections to the more-than-human. A spider has made

its own landscape by weaving a web in the home of a newly married couple in Bukovyna. Ivan is to be conscripted into the Austro-Hungarian military.

"What does the foreign emperor want now?" Ivan asked.

"He needs more soldiers to help him steal other lands as he has stolen ours," she explained.[45]

Based on lived experiences, the characters Ivan and Anna flee Austro-Hungarian Ukraine to Canada to avoid conscription into the foreigner's army, offering a small bit of food for the last time to the spider for luck. Their conversation with this small adaptable predator and weaver of miraculous webs reveals a deep humility in the face of the mysteries of the inner and outer landscapes that shape us. The larger predators in the imagination, the "foreign emperor" Franz Joseph and his generals, were eluded.[46]

Ukrainian provinces had been brought under Austro-Hungarian rule through international agreements before World War I. Serfs—my ancestors in Galicia—in this empire received emancipation in 1848. Historian Orest Subtelny writes that, while abolishing serfdom improved the "legal status and political rights, [it] did not improve their economic position." The peasants felt that economic serfdom had replaced legal serfdom. The costs of land

Remains, site of Spirit Lake Internment Camp, near Amos, Quebec.

[Sandra Semchuk]

transfers were shifted to the peasants, which made them indebted to landlords for their own land as well for the costs of "maintaining schools, roads, etc." Pastures and forest were often claimed by landlords so that "the peasant now had to pay whatever price the landlord stipulated in order to obtain firewood and building materials or to feed his livestock."[47] Borrowing money at high interest rates and the loss of land became serious issues along with alcoholism and despair. "Heartrending migration became a necessity for many," Subtelny writes, for those "that felt an extremely powerful attachment to their native soil."[48] Yuri Babjek lived in Bukovyna. He was strategic in his decision to leave and come with his brothers to Canada. His grandson, Nick Topolnyski, listened carefully to his grandfather's stories:

> From listening, I understood that at that time—1912—before coming to Canada—Grandfather's family members were resigned to the fact that they were going to be forever poor if they didn't have some serious savings. There was no way you could do it at that time in Bukovyna. The country was overpopulated. There wasn't enough land really too. Most of the better land was owned either by the church (the priest was the richest man in Kyseliv) or some foreign owners. Nobody had ever seen them.[49]

Prussian Canadian descendant of a prisoner of war Gerald Kohse said a similar thing about his father's, Frederick Kohse's, experiences in Prussia:

> Those who didn't own the land were simply expendable, I suppose you would say. When he was a young kid, I think they had it pretty rough going. They had maybe a hectare of land or something like that, and that was not enough to raise a family. You see, they had a system there where the people who owned the land would always leave it to the oldest son, and that would go down the generations. Eventually, the land would be in very, very small plots, which were not sustainable.[50]

Was there a disconnect between what Bukovynians experienced inside of themselves—the inner landscape—and the outer landscape that was being reshaped? Except for brief moments in history, the educational system and institutions reflected the languages and knowledge bases of rulers. Cities in Galacia and Bukovyna had come to resemble those of the peoples that ruled over them.[51] Such suppressions of identity degrade; they erode self- and cultural esteem. Social problems exacerbated by poverty, a lack of education, and alcoholism, along with a high incidence of familial violence—all legacies of being ruled over and colonized—increased. Local moneylenders often

"encouraged peasants to drink or buy on credit and, after allowing time for interest to accumulate, would present them with huge bills."[52] Lands were lost to money-lenders,[53] or were divided, as descendants told me, into smaller and smaller plots. Malnutrition, alcoholism, early death, crime, and fear became rampant under such dire circumstances. Ukrainian poet Taras Shevchenko begged his brethren to cleanse themselves. What he wrote in 1845 was relevant long after serfdom was abolished in the Austro-Hungarian Empire as well as in Russian-ruled Ukraine, where he lived.

> Smash asunder all these chains that
> bind you,
> Free yourself from all this madness,
> Unite together as of brothers in a
> brother's love![54]

James and I did a collaborative video work where he read this entire poem by Shevchenko out loud replacing key words with the Cree language. Even though Shevchenko's poem was from an earlier time of serfdom, I understood from what I witnessed Cree family members going through now—in a democratic nation—something of what Ukrainians were going through then. The struggle from one generation to another to sustain language, culture, and the agency to create one's own life without fear is ongoing for peoples who are or have been occupied or colonized.

This struggle was true for Ukrainian Canadians and other cultures that had been interned as well.

"Fear is very much a habit," said Aung San Suu Kyi. "People were conditioned in conquered nations to be frightened. In free countries it is quite normal to ask 'why' if anybody, even a security officer, asks you to do something which seems unreasonable. In an authoritarian state asking questions can be dangerous so people simply do what they are told to do. So those in power get more oppressive and the people get more frightened. It's a vicious circle."[55] Were there echoes of the old country in the new for those who came at the invitation of the Canadian government and found themselves forced to report, interned, and compelled to labour?

The late John Gregorovich, a lawyer and one of the founders of the UCCLA, talked to me about the push to get Canada settled. The generosity demonstrated by the Canadian government in offering hope with free homestead lands to peasants from Eastern Europe was politically strategic, he said. Workers, often single men, were also invited from those nations to do the work that Anglo-Saxons did not want to do. During our conversation, Gregorovich reflected,

> Well, I think all over the world we know that very many people do not have any sympathy for their fellow man, especially people who are unfortunate. And the

Andrea Malysh and son, Matthew Chatterton, where internees built the road, Edgewood Internment Camp, British Columbia.

[Sandra Semchuk]

same thing applied to the situation of Ukrainians in Canada, despite the fact that Ukrainian Canadians were there because the Canadian government wanted to save western Canada from annexation by the United States. They had to get it settled. The farmers were not interested in settling on the bald prairie. The large source of farmers with a heritage which enabled them to survive in those circumstances was in the parts of Ukraine that were ruled over by other countries. It happened that the one that was accessible was Austro-Hungary. The Austrians ruled over western Ukraine. These people had been in effect lured by the government to Canada. The process started only twenty years before 1914. So all of these people had come there at the express desire of the Canadian government and then suddenly the animal turns on them.[56]

The Fight for Recognition

Cultural erasure of the internment has made it challenging for communities impacted by these events to recall and recount their stories. "I have lived with memories of that all my life," child internee Mary Manko Haskett said to Lubomyr Luciuk, professor of political geography at the Royal Military College of Canada in Kingston and a founding member of the UCCLA. "For many years it was almost as if it was all a bad dream, a

nightmare that would best be forgotten, certainly not something other Canadians would want to talk about with us, the victims. I can never forget what was done to my family and me."[57]

There was close to a century of forgetting on the part of the nation. To what degree was that amnesia prescribed by governments to decrease tensions after the war?[58] Geographer David Lowenthal writes, "Suppressing memory of grievances spared England from being crippled by inherited resentments."[59] In Canada, Prime Minister Wilfrid Laurier, in August 1900, spoke about the crucial 1758 Anglo–French struggle for Canada at the Fortress of Louisbourg. The Fortress of Louisbourg had been, Laurier said, "consecrated by the blood of your forefathers, the English and my forefathers, the French." The prime minister expressed concern that "the memory of these conflicts of the last century be forever forgotten."[60] A March 5, 1954 document from the Secretary of State of Canada reads, "The Board, on the recommendation of the Public Records Committee, grants authority for the destruction of the public records created from the operations of the Custodian of Enemy Property during World War I."[61]

Slowly, materials and stories have surfaced. Writers, historians, and researchers such as internee and writer Philip Yasnowskyj, Vera Lysenko, Dr. Myroslav Hladyshevsky, Lubomyr Luciuk, Bohdan Kordan, Peter Melnycky, Frances Swyripa,

John Herd Thompson, Myrna Kostash, Marsha Forchuk Skrypuch, Walter Doskoch, Roman Zakaluzny, and Bill Waiser; researcher and translator Harry Piniuta; film and video makers Yurij Luhovy and Marusya Bociurkiw, James Motluk, and Ryan Boyko; exhibition coordinators and curators Svitliana Medwidsky and Bohdanna Cmoc; and archivists such as Myron Momryk, Julie Latimer, and Shirley Nickerson, along with significant others, have worked to get the story told. As a part of redress, to have the story remembered, the UCCLA placed commemorative plaques and several statues by John Boxtel at the sites of the internment camps.[62]

The desire to reconcile the past in the present is a way of reaffirming the values of a democratic society, write Bohdan Kordan and Craig Mahovsky: "Indeed, the Ukrainian-Canadian effort at redress has not been about specific or individual compensation. Rather it aims at restitution and the reconciliation of one community with past and present leaders, looking not to air individual grievances but to heal old wounds still lingering in the country's judicial, political, and social fabric."[63]

This book is a part of a larger process of acceptance and recognition that an internment existed in Canada during World War I that affected thousands of lives. It exists as a result of the legal formalities of redress and settlement between the Government of Canada and Ukrainian Canadian associations. While it is not the purpose of this book to give the complex history of the internment or to debate redress, it is important to acknowledge the significance of the agreements in 2005 and 2008 to the ongoing work of recovering of stories and correcting blind spots, denial, and gaps in Canadian education, storytelling, and history.

Japanese Canadians successfully negotiated a redress settlement in 1988 for internment during the Second World War when the War Measures Act was used for the second time. Despite that precedent, government co-operation and understanding was difficult to achieve for Ukrainian Canadians seeking redress for internment during the First World War.[64] The Ukrainian Canadian redress movement included "negotiations with three Canadian Prime Ministers, six Ministers of Heritage, five Secretaries of State for Multiculturalism and seven Directors for Multiculturalism in order to achieve an honourable settlement," notes Andrew Hladyshevsky, president of the Ukrainian Canadian Foundation of Taras Shevchenko.[65] The difficult work involved several organizations including the Ukrainian Canadian Congress, the UCCLA, and the Ukrainian Canadian Foundation of Taras Shevchenko.

The year 2005 was the turning point in the active pursuit of public remembrance and reconciliation. Pressure came from Ukrainian Canadian organizations as well as then Member of Parliament Inky

Mark, a Chinese Canadian. This was the year Mark's private member's Bill c-331, the Internment of Persons of Ukrainian Origin Recognition Act, passed. The act's objective was "to recognize the injustice that was done to persons of Ukrainian descent and other Europeans who were interned at the time of the First World War and to provide for public commemoration and for restitution which is to be devoted to education and the promotion of tolerance." Bill c-331 called on the Government of Canada to negotiate an agreement with the Ukrainian Canadian Congress, the UCCLA, and the Ukrainian Canadian Foundation of Taras Shevchenko concerning measures that might recognize the internment. These negotiations included the funding required for "the development and production of educational materials that cover Canada's past internment policies and activities and their distribution to schools, colleges and universities, with the objective of widening understanding of the harm of ethnic, religious or racial intolerance and discrimination, and the importance of the *Canadian Charter of Rights and Freedoms* in protecting all Canadians from such injustice in the future."[66] Bill-c331 was assented to November 25, 2005, just before the fall of Paul Martin's Liberal government. Mark exclaimed, "It was a miracle, a miracle."[67]

Lubomyr Luciuk of the UCCLA helped spearhead the redress movement. He looked for guidance from two internees, Nikola Sakaliuk and Mary Manko

Haskett. Luciuk recalls, "In speaking with Mr. Sakaliuk and Mrs. Haskett I was struck by the fact that neither of them was particularly bitter about what had been done to them, no matter how wronged they had been. Instead, all they asked is that we remember their experience, their sufferings."[68] Haskett became the honorary chair of the National Redress Council of the UCCLA. She was not concerned about an apology or compensation. She felt that it was most important to remember and learn from what had happened so that it would not occur again. Haskett advised the creation of a fund that any Canadian could apply to for artistic, cultural, creative, and educational work.[69] An apology was not requested.

On May 9, 2008, witnessed by Luciuk of the UCCLA and Paul Grod of the Ukrainian Canadian Congress, Andrew Hladyshevsky, president of the Ukrainian Canadian Foundation of Taras Shevchenko, signed a funding agreement with the Conservative government of Stephen Harper. This agreement led to a $10 million endowment known as the Canadian First World War Internment Recognition Fund.[70] As Luciuk explains, "Membership on the Endowment Council administering this fund is inclusive of the many communities harmed by these internment operations and related state-sanctioned censures."[71]

I began to photograph the sites of the internment camps in 2006. MP Inky Mark's private member's Bill c-331 had

already been signed. The excitement of the recognition of the internment in the communities that fought for redress compelled me to move across the nation listening to descendants tell their stories and photographing the sites where the camps had been located. I stood on the sites silently and photographed to honour the internees by remembering them. When I listened to Mary Bayrak tell her story about being born in Spirit Lake Internment Camp, I thought about how her security came from her mother and father who were with her. It was a child's resilience that informed how I saw the images that I had made at that camp. When I listened to Anne Sadelain speak about how her father kept fighting for justice as he was moved from internment camp to internment camp, I found myself thinking of camps at Mara Lake, Morrissey, Vernon, and Kapuskasing as sites of resistance. When I stood on the paved parking lot outside of the closed Safeway store in Brandon with Albert Bobyk, I watched as he cried, remembering his father being punished in the black hole there. I knew then that cruelty was a part of the story and looked below the surface of the photographs I had made. When I put my hand on the barn that Andy Antoniuk's uncle had built, I remember his uncle's silent humiliation. The humiliation of being mistrusted was to affect the cultures of those interned for a long time.

1 Learning from the Past

The War Measures Act

I STRUGGLE TO LISTEN. I struggle to hear. I struggle to read, to write. The hundreds of mushrooms at the site of the Castle Mountain Internment Camp inspired James and me to collaborate on a photographic and video installation called *Enemy Aliens: Castle Mountain Internment Camp*. In it, James asked, in Cree, a question of the government of Canada: "*Tanisi ehticik oko ithiniwak? Wesam etoke mistahi eke wahpahtakwaw enotinikaniwahk?*" (What was wrong with these people? Had they seen too much war?)[1]

In the years leading up to the First World War, Galicians and Bukovynians from the Austro-Hungarian Empire were recruited to settle and develop Canada's West. In the early 1900s, many people also immigrated to Canada to work so they could send money home to buy land. According to historian Bill Waiser, they came "to serve as a temporary industrial workforce. In fact, it is one of the great myths of Canadian history that only immigrant farmers entered Canada during the boom years of the early twentieth

century."[2] As the recession of 1912 hit, followed by the war, many of these immigrant workers lost their jobs and wandered into the cities looking for work and relief. They were racialized, writes Waiser, as "Canada's 'pauper immigrants'—'ignorant foreigners' at the best of times, the 'scum of Europe' at the worst. And those who regarded themselves to be native Canadians were afraid not only that this imported proletariat could not be assimilated, but also that it would drag down western society and destroy forever the British character of the country."[3] Historian Desmond Morton explains that, by the time the war began, many Ukrainians in Canada were regarded as "surplus to the national need." They were seen as a danger, hanging around and doing nothing.[4]

Canada was a dominion at the start of World War I. It did not have control over its foreign policy, even though it had been asserting independence from Britain for some time. When "Britain declared war Canada was also at war," writes war historian Tim Cook; however, "as a

Right Honourable Robert Borden and the Honourable Winston Churchill, 1912. [LAC C-002082]

self-governing dominion, the Canadian people would choose the extent of their commitment."[5] Those who governed Canada saw it as British and French with deep ties to those nations. They desired "maintenance of the prestige, power and world action of France and England."[6]

No one could have imagined the horrors that were to affect Canadian troops abroad, or the tragedies that would shape the lives of those on Canadian soil who would soon be called prisoners of war and enemy aliens. In his reply to the governor general's Speech from the Throne on August 19, 1914, two weeks after the war had broken out, Conservative Member of Parliament for South Oxford Donald Sutherland said, "Rumblings of distant thunder have been heard and dark and threatening clouds have been visible on the horizon for several years. These have at last burst forth like a tornado, and threaten the whole world with the most terrific and devastating war the world has ever seen. The greatest disaster of recorded time is at hand; many millions of men are now engaged in one of the most desperate and fearful struggles the mind of man can conceive of."[7] Canada had committed itself to war abroad.

On the same day, the House of Commons expressed its sympathy to the German people for "the dangers brought upon them by their ruling classes, by their oligarchic, insane, military government."[8] It was recognized that there were many people of German extraction

in Canada, including the speaker him-
self, who "are loyal subjects of His Majesty
the King."[9] Prime Minister Robert Borden
also asserted on that day that people born
in Germany or Austria-Hungary and who
have come to Canada "as adopted citizens
of this country, whether they are natural-
ized or not, are entitled to the protection
of the law in Canada and shall receive it,"
with the exception of those aiding or abet-
ting the enemy or leaving Canada to fight
for the enemy.[10]

Again, on that very day—August 19—
the Honourable C.J. Doherty read the

proposed War Measures Act for the first
time. The act proposed that the govern-
ment be given sweeping powers and
responsibilities "for the defence and
security, peace, order and welfare of this
country during the troubled times through
which we are called upon to pass."[11] For
the duration of the war, this bill would, if
passed, give government the power of
censorship, control, and suppression of
documents and means of communication;
the ability to arrest, detain, exclude, and
deport; control over harbours, ports, and
territorial waters and movements of

vessels; control over transportation; control over trading, exportation, importation, and manufacturing; and the ability to appropriate, control, forfeit property, and the use thereof.[12] Furthermore, section 4 of the act stated that "no person held for deportation or under arrest or detention as an alien enemy or upon suspicion, or to prevent his departure from Canada, shall be released upon bail or otherwise discharged or tried without the consent of the Minister of Justice." Section 5 would amend the Immigration Act to forbid residents of Canada to abet his Majesty's enemies from landing or remaining in Canada. Section 6 provided for additional manpower to carry out the measures.

This was all happening very fast. There were members of Parliament who were clearly conflicted between what was seen as loyalty to Germany and those, like Ukrainians from lands ruled by Austro-Hungary, in Canada, *and* the perceived need for security. The Honourable William Pugsley stood up in the House of Commons to say that the section 4 of the proposed War Measures Act silently suspended the Habeas Corpus Act. He explained, "It takes away, with regard to persons who may come under its provisions, the right of every man to appeal to the courts, and to have those who are depriving him of his liberty compelled to show before a court or a judge the reason why his is being deprived of his liberty and is being kept in prison." Pugsley went on to say that

this resolution "strikes at the dearest liberties of a British subject."[13] The act would take away the right to be considered innocent until found, through evidence, guilty. This was shocking. Doherty responded, "It is only after giving it very serious consideration that we have put it forward. But still we shall be glad to have the benefit of its further consideration by a special Committee."[14]

The War Measures Act was amended in committee in minor ways and passed by Borden's government on the third reading at 6 p.m. on August 21, two days after the first reading. The act "gave the federal government sweeping emergency powers that enabled the cabinet to administer the war effort without accountability to Parliament or existing laws."[15] While the War Measures Act was created to ensure security during wartime, the August 31 Order in Council, PC 2283, imposed restrictions and sanctions on enemy aliens through stringent controls on their possession and use of firearms and explosives. The boundaries of democracy were being gravely tested.[16]

As a result of the War Measures Act, the Orders in Council, and the procedures that were developed in response to these legislative initiatives, thousands of people in Canada were labelled prisoners of war or enemy aliens. Major-General Otter—the same man who, as noted in the Introduction, had led the attack on the Poundmaker Cree in 1885—was brought out of retirement to become the director of

The Order-in-Council of 28th October (issued as a Proclamation in the Canada Gazette of same date) provided for the appointment of Registrars of aliens of enemy nationality, to be under the immediate direction of the Chief Commissioner of the Dominion Police. The Registrar was to examine each enemy alien attending before him and register his name, age, nationality, occupation, desire or intention to leave Canada, and the name of his wife or children (if any) in Canada, and obtain such other particulars as might be considered necessary. Every alien of enemy nationality residing at or within twenty miles of a city or town or place where Registrars were established was to attend and register. No enemy alien was to be permitted to leave Canada without an exeat from the Registrar or from the Chief Commissioner of Dominion Police, who also had power to cancel exeats given by the Registrars. Exeats were only to be given if the Registrars were satisfied that the enemy alien would not assist, by active service, information or advice, the forces of the enemy. Any alien of enemy nationality who was refused an exeat was to report monthly to the police of the city or neighbourhood in which he was registered though if it was not considered desirable that the enemy alien should be allowed to remain at large he was to be interned as a prisoner of war. Names of all those allowed to remain at liberty were to be reported to the Chief of Police of the city or neighbourhood in which they were registered. Failure of an enemy alien, who came within the terms of the proclamation, to register within one month rendered him liable to internment and such other penalties as prescribed by law. Wives and children were permitted to accompany interned aliens. The military authorities were to make provision for the maintenance of interned aliens and prescribe the work that might be required of them. Canadian nationalization might be given to registered enemy aliens under certain circumstances.

Canada's internment operations. He was "authorized to take any military action necessary to carry out the provisions of his mandate. His duties included the physical care of interned enemy aliens, as well as the direction of the work prescribed for them. The Department of Militia and Defence was to make military forces available as required, while the Royal North West Mounted Police [RNWMP] and Dominion Police were to provide police and secret service aid when needed."[17] Enemy aliens "were issued with identity papers that had to be carried at all times, the penalty for noncompliance was being arrested and possible imprisonment."[18] This registration system kept innocent people on a tether of enforced local reporting, limiting their mobility and freedom to choose when and where they could travel. They were forced to report to local police or to the RNWMP. American historian Roger Daniels calls this kind of reporting a form of house arrest.[19] These were innocent people who were targeted because they happened to have come from or have had

passports from countries that were at war with Britain. Some had become naturalized as Canadians. Shifting borders between countries in Eastern Europe complicated the documentation of national identities further. Ukrainian Canadian lawyer John Gregorovich spoke to me about how people had to report:

> Those people were no longer free. It was a form of illegal imprisonment. They could go back to their farm and work but they were not free to hop on a train and take a vacation at the other end of Canada.
>
> They weren't free to go someplace else to hunt for work. They could but they were taking their chance that they would be picked up and thrown into a concentration camp. So that some 88,000 men, of whom probably 80,000 or so were Ukrainian or a higher percentage, were effectively under false imprisonment. The law justified it because they could do it under the War Measures Act, but by any standard of morality that was not something these people deserved. And they had no resources with which to fight it. They didn't have [and] they couldn't afford lawyers, and the War Measures Act was never challenged during that time, to my knowledge.[20]

"Dismissal from work became a common trial facing enemy aliens in the prevailing climate of fear, panic, resentment, and spite," writes Bohdan Kordan in *No Free Man: Canada, the Great War, and the Enemy Alien Experience*.[21] Thousands of people were taken away from self-determined lives; their properties were lost or confiscated. In "The Internment of Ukrainians in Canada," historian Peter Melnycky writes,

> By Otter's own calculation not more than 3,138 of the 8,579 men who passed through the camps could be classified as prisoners of war—"captured 'in arms' or belonging to enemy 'reserves.'" Of this number, 817 had no prior connection with Canada, being German sailors and merchant seaman transferred for internment from Newfoundland and British colonies in the West Indies. Only 1,192 Germans from within Canada were actually interned as opposed to 5,954 Austro-Hungarians, and only 2,321 of the 7,762 internees from within Canada were bona fide prisoners of war.[22] The rest were civilians who, under discretionary powers vested in the Canadian government, could be interned if the latter considered them to be either "agents" or of potential service to enemy powers.[23]

They were interned behind barbed wire under armed guard in over twenty-four internment and holding camps across Canada. When I spoke with descendant

Gerald Kohse in Nanaimo, I understood that those interned were often respected and some were naturalized citizens of this country. They had worked, farmed, run businesses, worked as professionals, raised their children, and created lives that contributed to nation building.[24] Once arrested, they had no recourse to justice through the courts because of the suspension of the Habeas Corpus Act, which evolved to "mean that no person should be deprived of freedom without Due Process of Law."[25]

Enemy Aliens

The 1907 Hague Convention, an international set of protocols for wartime, protected prisoners of war from forced labour.[26] The convention "allowed prisoners of war—except officers—to work at various tasks, as long as the projects had no connection to the war effort, the labour was not excessive and the men were paid at a rate equivalent to that of soldiers."[27] The British government urged Canada not to act indiscriminately against subject nationalities of the Austro-Hungarian Empire who were in fact friendly to the British Army and hostile to Austro-Hungary. Despite this caution, however, civilians from the Austro-Hungarian Empire were interned and treated differently.[28] Many enemy aliens had been doing hard physical labour under very bad conditions in Canada prior to war. It made sense, "from the federal government's point of view, to call upon them to perform the same kind of demanding work during their detention."[29] The interned civilians identified themselves as Ukrainians, Poles, Italians, Bulgarians, Croatians, Armenians, Kurds, Serbians, Hungarians, Russians, Jews, Slovaks, Slovenes, Czechs, Romanians, and others. Most were ethnic Ukrainians—Galicians and Bukovynians—whose lands were being ruled over by the Austro-Hungarian Empire.[30] This created a class system within the internment camps with some Germans being prisoners of war who did no forced labour and often lived under better conditions in camps such as Fort Henry, Kingston, Ontario; the Citadel, Halifax, Nova Scotia; Vernon, British Columbia; and Amherst, Nova Scotia.

As one of the thousands who had to carry identity papers and report each month, former internee Nicholas (Nick) Lypka describes his experience in Yurij Luhovy's documentary film *Freedom Had a Price*: "I felt like a criminal. No one understood why I had to report to the police, every month, get my registration card stamped. I felt that I had lost all my freedom." He recounts how five hundred unemployed workers gathered in Winnipeg when they heard that there was work in the United States. The younger men decided to go on foot, walking lawfully to the side, so as not to block traffic. When they reached Emerson, the Mounted Police were waiting for them. Lypka

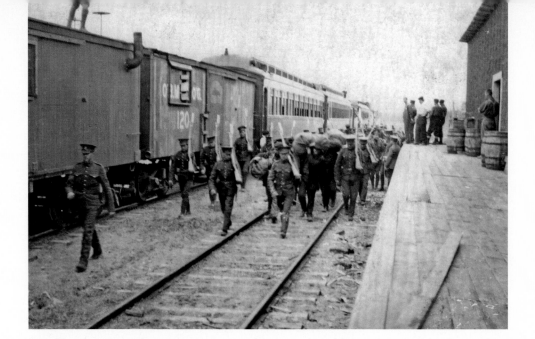

Soldiers marching internees into Kapuskasing Internment Camp, Ontario. [Ron Morel Memorial Museum]

thought that perhaps they had work for them, but "Instead they fed us and took us to Brandon Detention camp. There were four hundred men, one hundred to a room, in single beds. The lights were left on all night."

They were stripped of what few possessions and money they had. Maksym Boyko lost everything, including a watch he brought from the old country, when he was picked up in Ottawa. Yurko Forchuk lost this homestead while imprisoned and then hid out after his escape. Enemy aliens were forced to labour at twenty-five cents a day, one-fifth of the going rate. Many did not receive money owed them, even upon their release. They became a form of cheap labour and a way of bringing dollars into communities that were struggling during the war. Also in *Freedom Had a Price*, Morton explains, "In a lot of

communities Ukrainians were interned because they were a threat and a charge on the local taxpayers and their rights were of no great significance. The work gave the local citizens a pretext to set up an internment camp with some corollary benefits, of course, that there would be contracts to build a camp, build the buildings, feed the people and so on, so that the local people, particularly of the right political stripes, could make a little money on the side."

In the winter, the internees were forced to get up early in freezing weather to labour cutting trees and clearing the land. The government did not want them to be seen to "laz[ing] about at government expense while Canadian soldiers lost their lives on the battlefields of Europe."[31] Dominion Parks Commissioner James Bernard Harkin could make use of their time and strength. He had a vision of

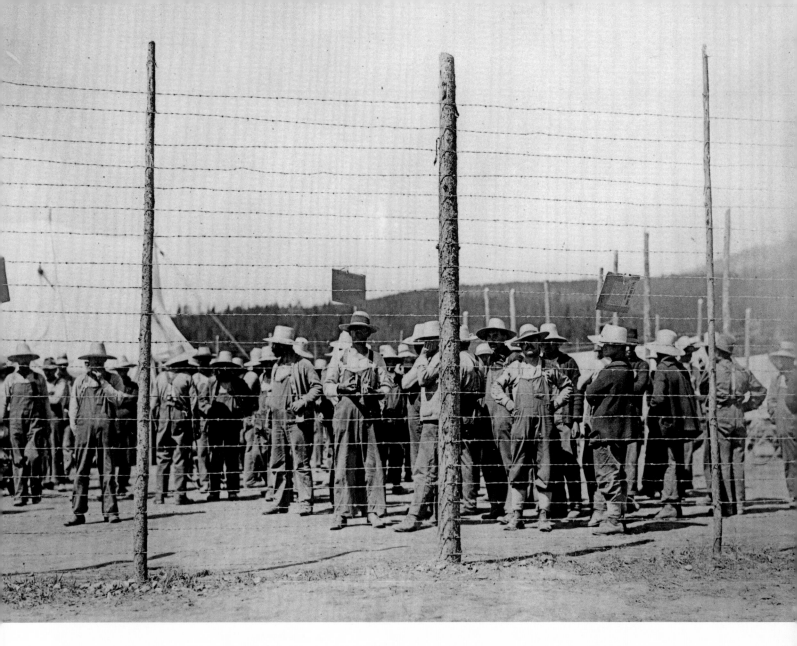

Behind wire at Castle Mountain
Internment Camp, Alberta.

[Glenbow Archives, NA-1870]

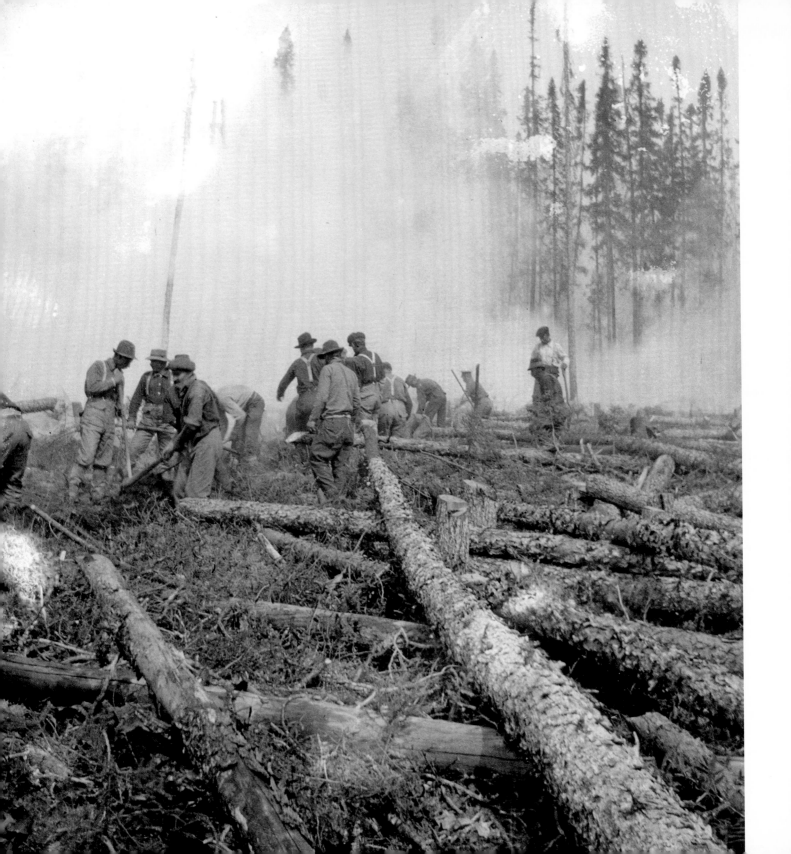

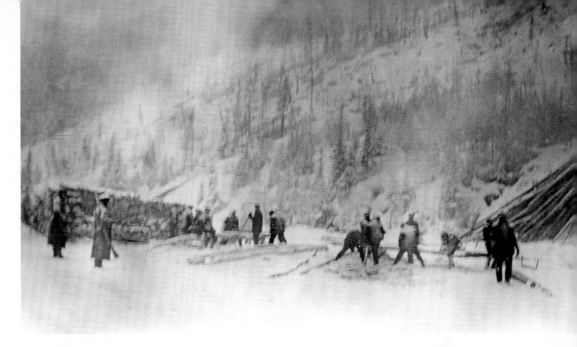

Canadians' access to wilderness as a kind of tonic to help heal the Canadian soul after the war. With parks' budgets slashed in half when war was declared, Harkin made a deal with General Otter to use enemy aliens' labour to build roads and facilities in the mountain parks.[32] The road around Lake Louise was built by internees with shovels and picks. It opened that area to tourists.[33] The Banff *Crag & Canyon* published an article on September, 2, 1916 called "Banff to Castle Mountain" that extolled the beauty of the area: "Three miles up further along the trail and the internment camp, a veritable white city, is reached." The writer goes on to describe staying overnight in the camp and awakening to a fine breakfast: "A substantial breakfast in the officers mess, followed by the run to Banff in the fresh, cool air of the morning makes one think that this

old world is a mighty pleasant place to be." The internees' reality was very different. Internees laboured under guard all day with picks, shovels, and wheelbarrows, and were inadequately fed.[34]

Each of the camps across Canada had a different agenda and designated work for the internees both for the camp itself and the immediate community or area. Shelter for the internees was provided by government buildings at Fort Henry in Kingston, the Citadel at Halifax, and the amouries in Niagara Falls, Ontario, and Beauport, Quebec; in civic buildings such as the arena in Brandon, Manitoba; a hotel in Morrissey, British Columbia; and railway cabooses at Eaton, Saskatchewan, and Munson, Alberta. Where buildings were not available to house the internees, they were forced to build their own barracks or bunkhouses and to cut the wood

to keep themselves warm. The town of Kapuskasing began as an experimental farm, cleared by the internees. Internees from Morrissey and Mara Lake worked to build roads through the mountains. Bridges, ice palaces, golf courses, railroads, and roads were constructed. With soldiers sent overseas, a shortage of workers in Canada made it lucrative to parole internees out to private businesses, companies, and farms at less than market rates.[35] Farmers in the Brandon, Manitoba, area requested that internees work for them. Albert Bobyk spoke to me of how a woman farmer would ride a horse carrying a whip to keep the internees in line as they worked in the fields. Slave labour, he called it.[36]

Of 309 attempted escapes, 136 were recaptured. Gwen Cash, a former reporter for the Vancouver *Province* and an officer's bride in the Vernon camp, wrote about the break from monotony that escape attempts created. One athletic German sailor jumped the wire entanglements and surrounding ditches just at the time that children from the city were being released from school. The guards didn't dare fire and he got away.[37] Cash writes,

> Under the leadership of a young civil engineer, the prisoners tunneled from under the dining-room of the second-class prisoners. They used, we found afterwards, to carry loose dirt out in their pockets and put it down the holes in the floors of their shacks. The tunnel was about sixty yards long—went way under the barbed wire and ditches, which in summer were dry. One dark night the engineer leading the way escaped, but the second man, fat anyway, tried to take too much dunnage with him, dislodged some dust and sneezed. He, with eight others, was caught in the tunnel. After this the shacks were raised on piles but the prisoners, ever hopeful, started another. This time the authorities knew all about it from the beginning. Used to in fact go along it and inspect its progress. The prisoners were furious when, in the course of time, they found they had been allowed to dig to "keep them happy."[38]

The authorities were astute in their psychological manipulation. For the prisoners, a sense of agency, being able to do something for themselves, would have helped them endure incarceration. The often-sophisticated attempts to escape in camps such as Amherst, Brandon, Castle Mountain, Lethbridge, Vernon, Kapuskasing, and Spirit Lake were an indication that internees were willing to risk their lives to get out of the camps. Ivan Hryhoryschuk was shot dead after escaping from the Spirit Lake Internment Camp on June 7, 1915. Eighteen-year-old Andrew Grapko was shot dead as he tried to get through a stable window in the Brandon arena. "In the wake of Grapko's death, the

incidence of escape and insubordination at Brandon declined sharply," Melnycky writes, "as Ukrainian internees accepted their daily routine without great opposition. Other internees were controlled with the use of the pitchfork."[39] Some, such as Yurko Forchuk, succeeded and changed their names to make new lives for themselves.

In the 1980s, my father spoke of the struggle First Nations in Canada endured. He talked about the creation of dependence as a national strategy: "We have done everything we can to put First Nations down and are doing everything we can to keep them down. By taking away their means of making a living and excluding them from the current economic model in Canada we made them dependent on us," he said.[40] Control over time and the means for survival—food, shelter, and what the internees did on a daily basis— made internes dependent upon those who saw themselves on the side of the law. Dependence erodes self-esteem, the will to act on one's own or with others. Andy Antoniuk's uncle was the senior man in the family and a member of several community boards one moment, contributing to family and society, and then imprisoned in Jasper the next moment. Authorities questioned even harmless acts. Nick Lypka picked up shells from the bullets an officer had been arrogantly shooting off in the internees' dormitory. For that act he was put into a black hole for three days. The guard checked up on his prisoner to see "how he was liking it," Nick Lypka said. "Then one of our fellows came to see if I had a blanket. I slept on the floor without anything—there was no bed, no chair, no window, nothing. They just brought me a cup of water and one ration of bread: here, eat, like a dog." Lypka spoke of telling stories, "anything not to be alone, not to fall apart. But some of them did. Thinking about this is so painful. But we endured it. Who didn't live through it would not understand. War is good for no one."[41]

We can see from Nick Lypka's story that dialogue between prisoners, authorities, and guards were defined by relative roles.[42] If internees—and at times whole families—avoided rocking the boat, life was managed and could be manageable, albeit within severe limitations. Or internees could create "opportunities" if they had confidence in the fact that they were being unjustly held, which Philip Yasnowskyj did by tricking authorities into believing that he was incapable of manual labour. His cunning got him an easy job picking up bits of garbage in the camp. In his story "Internment," Yasnowskyj writes of how internees worked all day cutting brush in the woods, but in the evenings they reclaimed at least a portion of their freedom:

> There seemed to be no end to the
> number of songs they knew. I joined in,
> too, to take my mind off our

Internee with arms up.

imprisonment, at least for the time being. In other barracks, the Ukrainians made music on different instruments and danced the Kolomayka and the Hopak. In one barrack, the young fellows were learning their parts for a theatrical performance. They were rehearsing *Swatania na Honcharvisi*. One could not help admiring their perseverance in such an undertaking under such adverse conditions. When the play was staged, I went to see it. It went off well even though the fellow who played the role of the young lady could not, for the life of him, change his voice to sound like a young woman's, and neither the skirt he wore nor his wig of braided hair were of any help.[43]

The complex ebb and flow of humanity, expressions of generosity, learning from one another across generations and cultures, honouring culture through speaking your own language, music, song, drama, and dancing, playing baseball and other games, picking and drying plant medicines, spirituality, ceremony, cunning and humour, the making of meals on rations, skillful tending of gardens, caring for the sick or injured, making and remaking clothes and gifts such as mitts, the reading and writing of letters to loved ones, even if censored, even if you didn't get a reply because the ships that carried them did not arrive, and writing to organizations and nations that could help, planning

Internee accordion player.

and executing escapes, snaring rabbits and trading with local First Nations, "making hooch from anything they could get hold of, from potato paring to raisins saved from cake, and gambling with canteen tickets" are a part of this story, along with the degradations of incarceration.[44] Individuals had many opportunities to have values, knowledges, warriorship, generosity, and patience tested. Battles for love occurred. One man in Vernon died by accident as a result. About twenty babies were born in the Vernon camp.[45] Mary Hancharuk was born in the Spirit Lake camp. A crow mascot made everyone in the Vernon camp—guards and internees alike—laugh at its antics, tricks, and use of language.

The authorities refused to honour holy days in at least two camps—Petawawa and Kapuskasing. For peoples, such as Ukrainians, who had shed their blood in the nations they had come from so that they could worship as they wished, this was unacceptable. It was this disregard for holy days that, in Kapuskasing, during the strike against work turned to revolt.

Throughout the war, and for a long time after, prejudice against immigrants and the demand for security were very high. My father's experiences as a child made sense to me. The racism he endured was a part of this larger story of the internment of Ukrainians in Canada. The Government of Canada had followed up the 1914 War Measures Act by passing the Wartime Elections Act in 1917. Ukrainian

Canadians, and those from nations at war with Britain, including naturalized citizens who were proud of being British subjects, were disenfranchised.[46] That is, they were stripped of their right to vote. Sir Wilfrid Laurier stood up in the House of Commons on September 10, 1917 to protest the Wartime Elections Act. He stated that Canadians would regret the act; he knew its ramifications:

> When the war is over, when peace is restored, and when we come to normal life, when we shall send our Immigration agents to Europe again as we did before, do you believe that our Canadian immigration agents, when they go among the Galicians and Bukovynians that these different races will be disposed to come to this country, when they know that Canada has not met its pledges and promises to these people, who have settled in our midst...If it be said in Canada that the pledges which we have given to immigration when inviting them to come to this country to settle with us, can be broken with impunity, that we will not trust these men, and that we will not be true to the promises which we made to them, then I despair for the future of this country... I have been supporting the government on the war issue up to the present session. I am sorry that the occasion arose during this session when I had to discontinue my support for the Government on an issue of great importance. I am sorry that I have to again dissent with the Government on this measure, but I believe, and we shall all be judged someday by our actions here...that in this instance the Government is taking a step which will cause serious injury to the country.[47]

Families in Danger

Women and children were interned at two camps—Vernon and Spirit Lake. At Spirit Lake Internment Camp, they were not housed in the camp proper but in an adjoining "Prisoners' Village." They were not forced to labour. Their work was in the bunkhouses or barracks that were their homes, in the gardens, caring for and educating the children, and in hauling wood and water. In details from photographs of the Spirit Lake camp, we see women clustered together, holding their children close. They are wearing traditional babushka headscarves and aprons. White and impeccably clean. A guard stands behind them. They are waiting for something. In one photo, a young girl, maybe ten years old, in a wool hat stands with her arms hung limp at her side. Some of the descendants I spoke to thought they recognized their kin in these photographs taken at the Spirit Lake camp.

When the war started, many women from countries that were at war with Britain were dismissed from their jobs

because they were enemy aliens. Women who were not interned, who were alone, or whose husbands had been interned found it difficult to sustain and protect themselves and their children. They were vulnerable. Physical circumstances, social attitudes, and racism were harsh. Mothers were paid poorly for long hours in jobs that took them away from their children. One woman, Catherine Boychuk, left alone without husband and family, resorted to minor theft and was sentenced to a month in prison. Her eight-month-old baby was sent to an orphanage and died eight days later. Melnycky notes, "While Mrs. Boychuk's case may be extreme, it suggests that the 348 women and children for whom the government provided some assistance represent but a fraction of those who desperately needed it."[48]

A *Calgary Daily Herald* article called "Alien Women in a State of Distress" published February 29 [sic], 1917, describes a pledge by women of the local "tuberculosis auxiliary" to help "distressed alien women." Auxiliary members were set to interview the mayor and city council about "some steps to relieve the distress among the Austrian women and girls of the city." The article explains,

> This distress shows prospects of becoming acute ere long and is the result of numerous dismissals from places of employment in the city. These alien women claim to be loyal Canadian subjects and their cause has been taken up by a number of prominent women of the city, not on the ground of loyalty, but on the ground of humanity and the preservation of their womanhood. In the majority of cases the ladies have found on investigation that they have no homes, bank accounts or source of income whatever. This matter came up as an appeal by these women to the president, Mrs. W.M. Carson, and Mrs. Harry Ballantyne was appointed to interview the mayor and city council as to what can be done. If nothing can be done the delegation will ask to have the women interned.

Appeals to Calgary Women.
A petition was drafted by the applicants and placed in the hand of Mrs. Carson, who, through her connection with the night school for foreign-born women, was closely in touch with them. The petition is self-explanatory and reads as follows:

> "We, the undersigned, Ukrainian and Austrian women, wish to bring before the notice of the women of Calgary and this province that our country was treated by the Austrian government 73 years ago as Belgium has been treated by the Germans. We came to this country to make Canada our future home. We are not spies. Thousands of our men are fighting under the British

and Russian flags. We have been discharged from work because we are considered aliens, but we are loyal to Canada. What are we to do if we cannot get work? Are we to starve or are we to be driven to a life of vice? Will not the women of Calgary speak for us?"

(Signed): Annie Barlin, Olga Kranoka, Mary Kaskin, Mary Zebrowka, Dinah Dobrika, Mary Zechn, Annie Crashiski, Mary Prolowsky, Mary Antomowsky, Mary Prochkin, Olga Duskin, Mary Brochka.[49]

It is clear from the Lethbridge internment camp documents at Library and Archives Canada that there were policies in place to help women and children in distress when their husbands and fathers were interned. There were Canadian authorities who made an effort to help families who reached out. One letter between military officials, for example, reads, "Urgent—I have the honour to request that you will have a statement immediately prepared showing the married prisoners of war who have wives and families in Canada, together with the composition of their families and addresses, so that arrangements can be made to assist the families if assistance is required."[50] The financial help offered may not have been enough to get by. Fear, language barriers, and simply not knowing what to do may have prevented many women from

reaching out. We also don't know if all camps were as concerned about the destitute wives and children of the interned. In November 1916, Mr. G. Willrich, US Consul at Quebec City, inspected the Spirit Lake Internment Camp and received a testimony from H. Domytryk. Melnycky writes,

The most compelling case to appear before Consul Willrich was POW #1100, H. Domytryk, a father of four children (aged nine, seven, two and a half, and one), who was arrested in March of 1916 in Edmonton where he worked for the Swift Packing Company and was paying off a small house he had purchased. Forced to leave his family with but a few dollars to live on, Domytryk was initially interned at Lethbridge and later transferred to Spirit Lake, over two thousand five hundred kilometres away from his home and family. The prisoner feared that his wife was forced to beg for bread and that his children were starving and suffering from exposure in their small house. Willrich described his first meeting with Domtryk when the "poor father" handed him a "pathetic letter" written in English by his eldest child, nine-year-old daughter Katie.

My dear father:
We haven't nothing to eat and they do not want to give us no wood. My mother has to go four times to get something to eat. It is better with you, because we

That is all my money that I have, what you
have sent to me. I don't know what I shall do. I
was in the City Hall asking for support, for myself
and for my child. They sent me to the Government
Office and they told me to go to work and give my
child to the creche - (Zaklad).

Now I write you to ask you what I shall
do. Shall I give our dear child to a creche (or home)
"perhaps she may mean the Charities)- or not. Also
I write you that those men who were released at
Lethbridge, have told me that perhaps you could be
released too. Why don't you ask for it? If you don't
want to come home I will come to you, because I cannot
stand any more.

 Your loving wife,

 Jose Mudry.

Address; 649 2nd, Ave., Riverside, Calgary, Alta.

had everything to eat. This shack is no good, my mother is going down town every day and I have to go with her and I don't go to school at winter. It is cold in the shack. We your small children kiss your hands my dear father. Goodby my dear father. Come home right away.

Katie Domytryk[51]

When internee Nick Nikyforuk wrote to the secretary of the Associated Charities in Calgary, he said that his wife and two children, two and five years old, were destitute, and they had been already been attempting to live for months on an average of two dollars a week relief from the government. General Secretary E.A. McKillop responded,

"Mrs. Nikyforuk has never made any complaint at our office, as far as we could judge has always seemed perfectly satisfied with her weekly allowance."[52]

There were women who followed their husbands to the camps; to split up the family would compromise their ability to survive. Vernon and Spirit Lake internment camps provided support for "eighty-one women and 156 children."[53] Hilda Kohse, a British-born woman, chose to be with her Prussian husband, Frederick, when he was interned in Nanaimo and Vernon. Pamela Kohse listened to her mother-in-law's stories. "The camp he was in was at the head of the Gorge—near Victoria, British Columbia—evidently, so she decided to, despite all the advice

everyone gave her, that she would go too. So she got in her rowboat and put baby Fred in it too, all wrapped up and rowed up the Gorge. All by herself to join her husband. She put herself in jail. She put herself in camp." "What were her alternatives," Pamela asked, "a woman alone with a baby?" And, she was British! Six years later, in Vernon, she used tennis to convey key information to the world outside the camp; she would stuff the tennis balls with notes and hit them out of bounds to a civilian woman who agreed to share her letters. These strategic games of tennis contributed to the closing of the camp in 1920.[54]

For most of the camps, there were no women. Many, if not most, of the men were single. Visits by loved ones rarely occurred.

Kapuskasing, Ontario, and Vernon, British Columbia, were the last two internment camps to close on February 24, 1920 and February 20, 1920, respectively, two years after the war had ended.[55] By the end of the war, 88,000 carried certificates of registration, and 8,579 were interned. Of the internees, 2,009 were Germans, 5,954 had been from the Austro-Hungarian Empire (mostly Ukrainians), 205 were Turks, 99 were Bulgarians, and 312 were regarded to be miscellaneous.[56] These prisoners were held in over twenty-four different internment camps all across Canada. The first camps to be open were at Montreal and Kingston. By the end of September 1914, Winnipeg, Halifax,

Nanaimo, Brandon, and Lethbridge were also sites of internment. Women and children were held in Vernon and Spirit Lake, which opened in the cold month of January.[57]

Historian Desmond Morton, the grandson of Sir William Otter, writes, "Although there were very few incidents of sabotage or espionage on home front during the war, enemy aliens soon became the object of intense Anglo-Canadian hostility."[58] It became patriotic to dismiss enemy aliens from jobs, heightening the concern that the unemployed were a serious problem. Internment camps controlled and contained that problem. By 1916, Canada began releasing non-dangerous prisoners as cheap labour under contract to mining and railway companies. Dominion Iron and Steel Corporation enthusiastically welcomed internees, saying that "there was no better way of handling aliens than to keep them employed in productive labor."[59] Working conditions on the railways and roads were often dangerous, and complaints or striking could lead to imprisonment for breach of contract.[60]

As I travelled across the country, I met descendants who remembered that loved ones were held and forced to labour building roads through the mountains of British Columbia and Alberta, ice palaces in Banff, farms under the supervision of a whip, and bunkhouses; to do kitchen duty; and cut wood for fires and clearing land. Many internees attempted to escape, which

suggests how difficult conditions and circumstances were. In 2005, James and I did a video and photographic installation on the Castle Mountain Internment Camp.[61] As James, a residential school survivor, ran through the trees, the names of those who attempted to escape, who escaped and were recaptured, or who escaped and died were called out. I sought to learn how the past, the internment camps during the First World War, affected internees, their communities, and their descendants intergenerationally. Standing and photographing where the internees stood was a performative way to enter those memories.

"I do not know the language, culture or stories of my people. What have I brought forward of that which you value, Dad?"[62] I asked. Dad responded with a clue that I reflect on to this day. There had been a sacrifice of identity made by many internees in order to survive during and after internment.

That is an effect of xenophobia, incarceration and a loss of control of one's life. Intergenerational effects impacted cultures where internment had occurred whether the stories of the internment were known or not. I realize that now. I recognize with more clarity now the effects on James and other First Nations of colonization and the residential schools in Canada. During the drought years in Saskatchewan, I watched my father slowly and steadily create pathways in the earth for the water to flow freely to the trees he planted for each of three children. Dad said that there were Ukrainian Canadians who learned to reinvent themselves when they were put down. They were responsive to possibilities and acted in unexpected ways to secure their futures. Many of the descendants I spoke with knew how to do that.

—Sandra Semchuk

Certificate of release for Domitru
Blavichi, Montreal, Quebec.

[LAC, Custodian of Enemy Property and
internment operations records, e010775942]

> List of Internment Camps.
Montreal, Winnipeg, Toronto,
Niagara Falls, and Sault Ste.
Marie were receiving stations
where prisoners were only kept
until they could be sent to a
permanent camp.

[Based on William Otter, *Report on Internment
Operations: Canada Internment Operations,
1914–1920* (Ottawa: Printer to the King's Most
Excellent Majesty, 1921, 6)]

This is to certify that I, DOMITRU BLAVICHI (*Demetru Blowrith*)

the bearer of this Certificate, a subject of _____ Austria _____,

who was interned as a prisoner of war in Canada at _____ MONTREAL, P.Q. _____

_____, described for identification as follows:—

Age 23 yrs; height 5' 7"; weight 150 lbs; complexion medium;

hair brown; eyes gray; laborer; 5 years in Canada. Was employed

BY Laurin, Leitch & Co. Montreal,

have been discharged from internment subject to the following conditions:—

 1. That *I will* not leave Canada during the period of hostilities

without an exeat issued by competent authority:

 2. That *I will* observe the laws of the country, abstain from

espionage or any acts or correspondence of a hostile nature or intended to

give information to or assist the enemy:

 3. That I will notify the Montreal authorities of where I
intend residing and will report once a month to the nearest
Police authorities.

 4.

```
FOURTH DIVISIONAL AREA
    APR 26 1915
4.D.
```

 5.

 Dumitro Blahovici.

Witness..Signature

Dated at *Montreal, que* this *twenty fourth* day

of *April* ———— 1915.

2 Standing Where the Internees Stood

Camp Name	Opening Date	Closing Date	Description
Montreal, Quebec	August 13, 1914	November 30, 1918	Immigration Building
Kingston, Ontario	August 18, 1914	May 3, 1917	Fort Henry
Winnipeg, Manitoba	September 1, 1914	July 29, 1916	Fort Osborne & Fort Garry
Halifax, Nova Scotia	September 8, 1914	October 3, 1918	The Citadel
Vernon, British Columbia	September 18, 1914	February 20, 1920	Provincial Government Building
Nanaimo, British Columbia	September 20, 1914	September 17, 1915	Provincial Government Building
Brandon, Manitoba	September 22, 1914	July 29, 1916	Exhibition Building
Lethbridge, Alberta	September 30, 1914	November 7, 1916	Exhibition Building
Petawawa, Ontario	December 10, 1914	May 8, 1916	Militia Camp
Toronto, Ontario	December 14, 1914	October 2, 1916	Stanley Barracks
Kapuskasing, Ontario	December 14, 1914	February 24, 1920	Bunkhouses
Niagara Falls, Ontario	December 15, 1915	August 31, 1918	The Armoury
Beauport, Quebec	December 28, 1914	June 22, 1916	The Armoury
Spirit Lake, Quebec	January 13, 1915	January 28, 1917	Bunkhouses
Sault Ste. Marie, Ontario	January 13, 1915	June 29, 1918	The Armoury
Amherst, Nova Scotia	April 17, 1915	September 27, 1919	Malleable Iron Works
Monashee-Mara Lake, British Columbia	June 2, 1915	July 29, 1917	Tents & Bunkhouses
Fernie-Morrissey, British Columbia	June 9, 1915	October 21, 1918	Rented Premises
Banff-Castle Mountain Cave & Basin, Alberta	July 14, 1915	July 15, 1917	Dominion Parks Building at Cave & Basin; Tents at Castle Mountain
Edgewood, British Columbia	August 19, 1915	September 23, 1916	Bunkhouses
Revelstoke-Field-Otter, British Columbia	September 6, 1915	October 23, 1916	Bunkhouses
Jasper, Alberta	February 8, 1916	August 31, 1916	Dominion Parks Building
Munson, AB-Eaton, SK	October 13, 1918	March 21, 1919	Railway Cars
Valcartier, Quebec	April 24, 1915	October 23, 1915	Militia Camp

< Unemployed and homeless.
Salvation Army blanket,
St. Antoine Street, near site
of Montreal Receiving Station,
Quebec. [Sandra Semchuk]

^ St. Antoine Street, Montreal,
Quebec. [Sandra Semchuk]

25

Fort Henry, Kingston, Ontario.

[Sandra Semchuk]

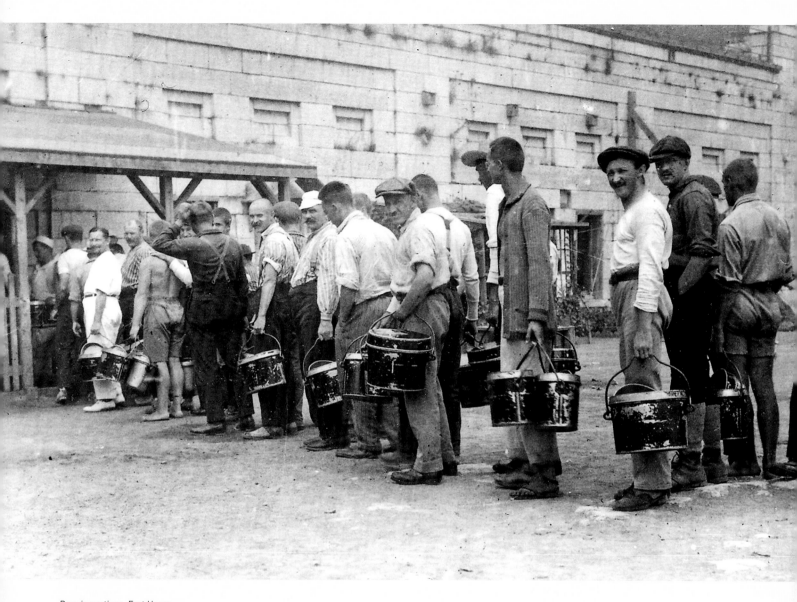

Drawing rations, Fort Henry
Internment Camp, Kingston,
Ontario.

[Fort Henry National Historic Site of Canada]

< Statue of Taras Shevchenko and plaque
memorializing internees, Manitoba
Legislature grounds, near site of Winnipeg
Receiving Station, Manitoba. [Sandra Semchuk]

^ Tourists at the Halifax Citadel
National Historic Site, Nova Scotia.

[Sandra Semchuk]

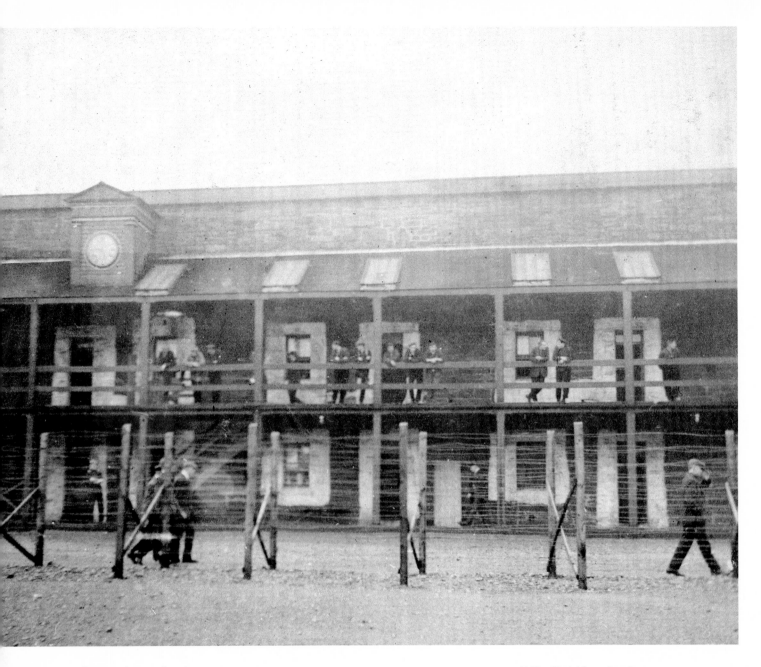

^ German prisoners of war in
compound at the Halifax Citadel,
Nova Scotia, 1915. [LAC PA 112434]

> Halifax Citadel Barracks, where
internees were held, Nova Scotia.

[Sandra Semchuk]

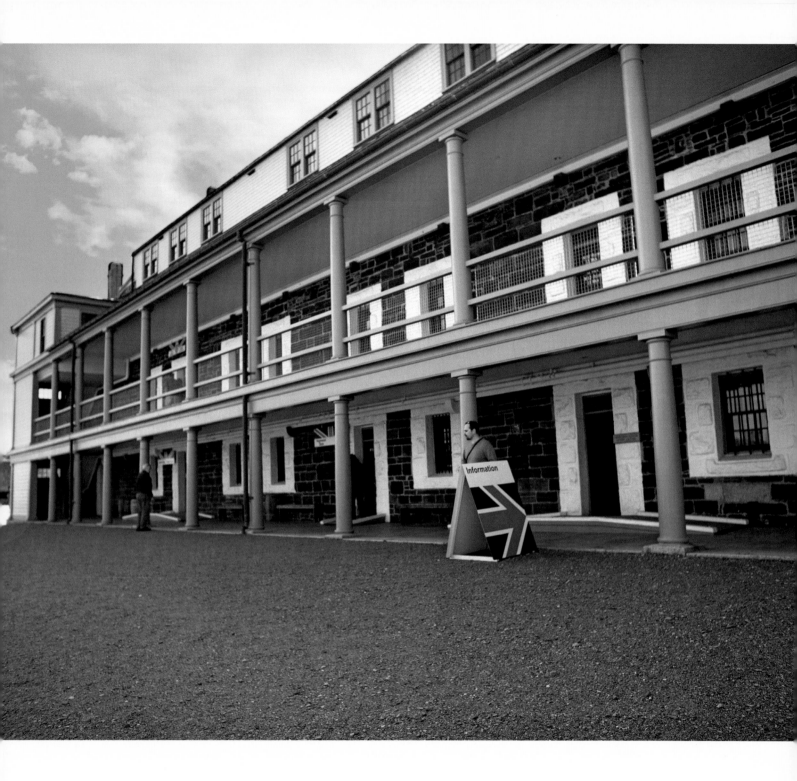

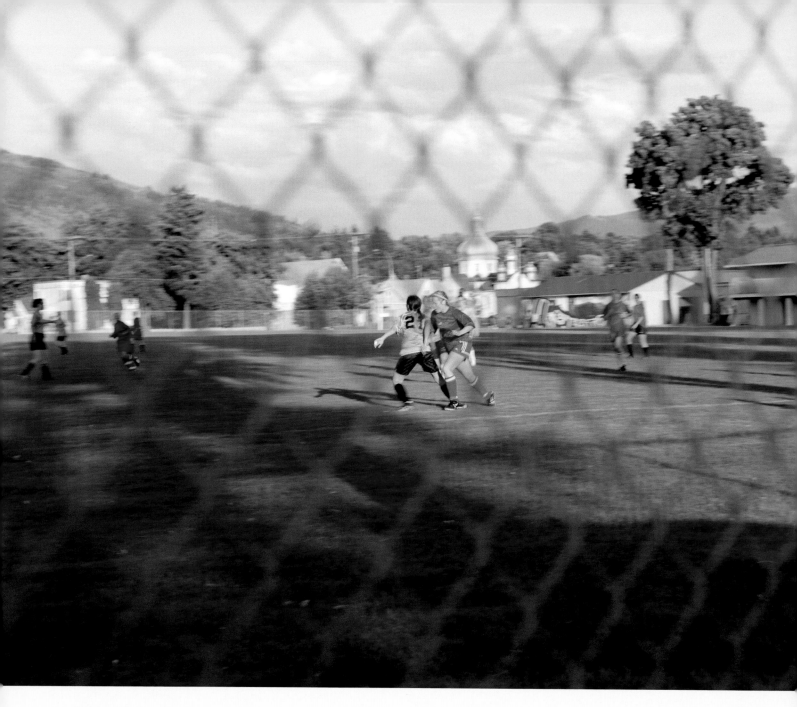

Schoolyard, students playing

soccer, Vernon, British Columbia.

[Sandra Semchuk]

First-class prisoners of war,
Vernon Internment Camp, British
Columbia. [LAC C-063491]

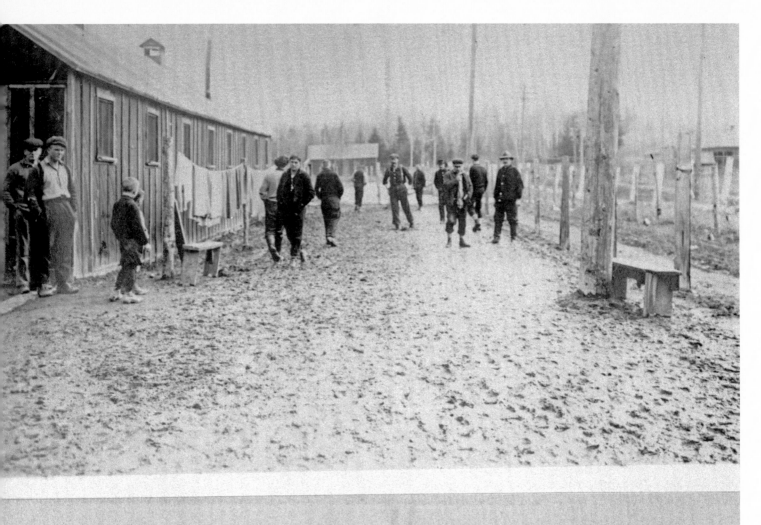

Camp Street.

^ Camp Street, Vernon Internment
Camp, British Columbia.

[LAC PA-127103]

> Safeway parking lot, site of
Brandon Internment Camp,
Manitoba. [Sandra Semchuk]

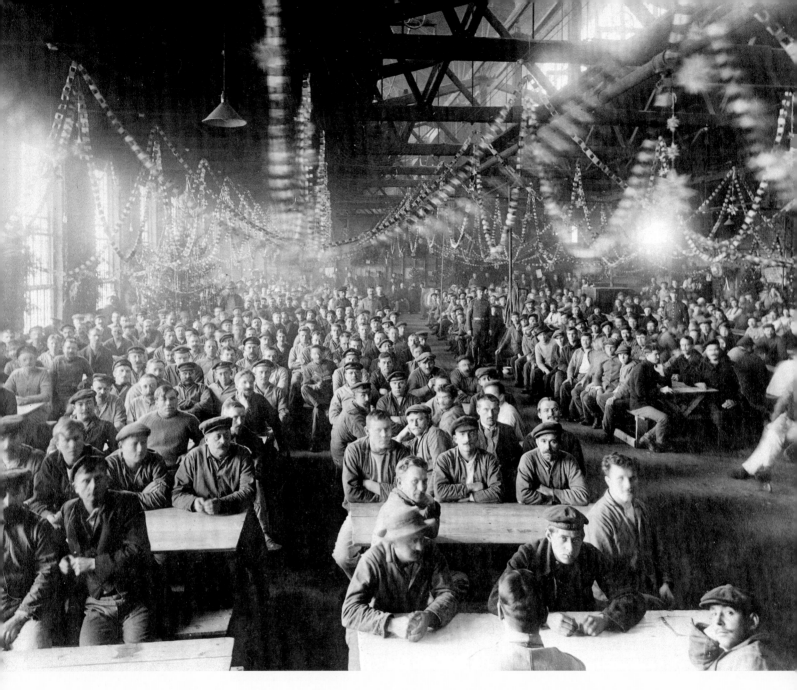

Christmas celebration at
internment camp, possibly
Brandon Arena, Manitoba.

[LAC C-014104]

Nanaimo cab, site of the jail used
for internment during the First
World War, Nanaimo, British
Columbia. [Sandra Semchuk]

4th Is their camp sufficiently spacious to admit of
 proper exercise and effectual sanitation?

5th Are their quarters well heated and lighted?

6th How are the men clothed? Who provides their clothing?

7th. How are the men fed?

8th Have the doctors and clergy free access to the men?

9th Are the men supplied with reading and writing materials?
 Are they allowed recreation, If so, of what nature?

10th What provisions have been made for the families of the
 men detained?

11th. Is there any other information you would like to add?

 In conclusion, I am making bold to remind you that your
position as Commandant is " National service" in the highest
sense of the words. The opportunity thus afforded you of
lightening the bitterness of the men's incarceration and of showing
the true meaning of human brotherhood cannot fail to have its effect
on those, who will, in all probability, remain to form the German
element in Canada when the war is over. In this connection it is
unnecessary to add anything further in that the honor and good
conscience of the British are , and have always been, inseparable
from a generous treatment of their hostages.

 Yours very sincerely,

 Emily F. Murphy

^ Excerpt from a letter from
Emily Murphy, National Council
of Women of Canada, to Military
District 13, Calgary, Alberta, with
regards to Lethbridge Internment
Camp, June 9, 1915.

[LAC, Internment Camp, Lethbridge,
RG24 4694, 448.14.20, vol. 2]

> Exhibition grounds, site of
Lethbridge Internment Camp,
Alberta. [Sandra Semchuk]

< Milkweed at half-mast,
honouring the dead in
Afghanistan, Canadian Forces
Base Petawawa, Ontario.

[Sandra Semchuk]

^ Soldier, Canadian Forces
Base Petawawa, Ontario, site of
Petawawa Internment Camp.

[Sandra Semchuk]

41

^ Stanley Barracks, site of
Receiving Station, Toronto,
Ontario. [Sandra Semchuk]

> Stanley Barracks, Toronto,
Ontario. [Sandra Semchuk]

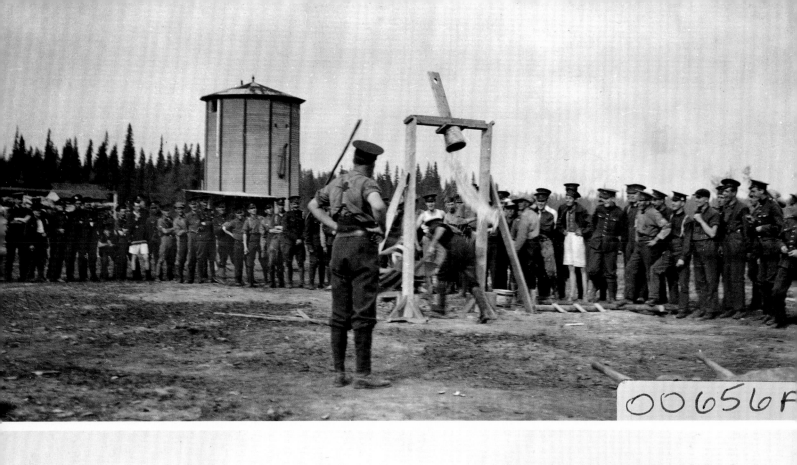

00656A

00286A

< Water games (top) and potato
farming (bottom), Kapuskasing
Internment Camp, Ontario.
[Ron Morel Memorial Museum]

^ Experimental Farm, site of
Kapuskasing Internment Camp,
Ontario. [Sandra Semchuk]

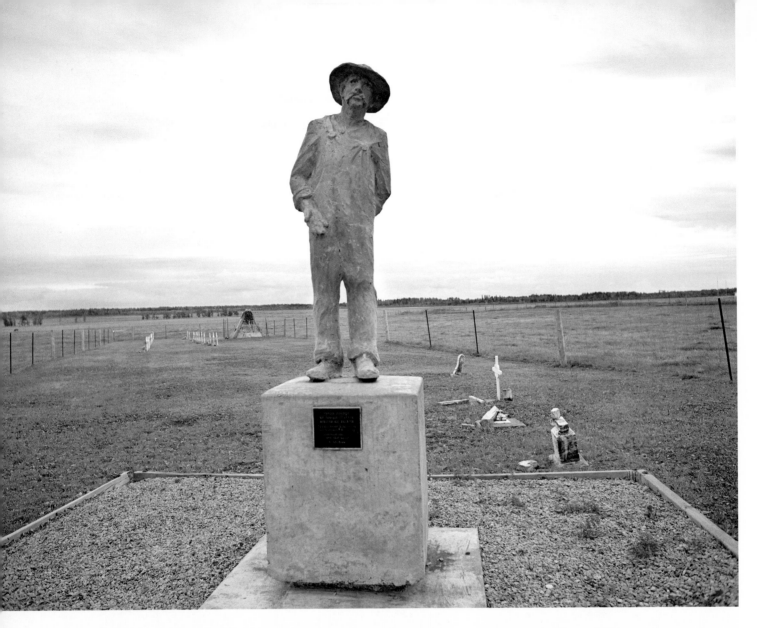

^ Statue by John Boxtel at
the entrance to the internee
graveyard, Kapuskasing, Ontario.

[Sandra Semchuk]

> Original grave markers, internee
graveyard, Kapuskasing, Ontario.

[Sandra Semchuk]

< Internees' view from the second
floor, site of Niagara Falls Armoury
Receiving Station, Ontario.

[Sandra Semchuk]

^ Site of Niagara Falls Armoury
Receiving Station, Ontario.

[Sandra Semchuk]

^ Beauport Armoury, site of
internment camp, Quebec.

[Sandra Semchuk]

> Ukrainian Canadian Civil Liberties
Association ceremony, plaque put up
to honour the internees at Beauport
Armoury, Quebec, October 2006.

[Sandra Semchuk]

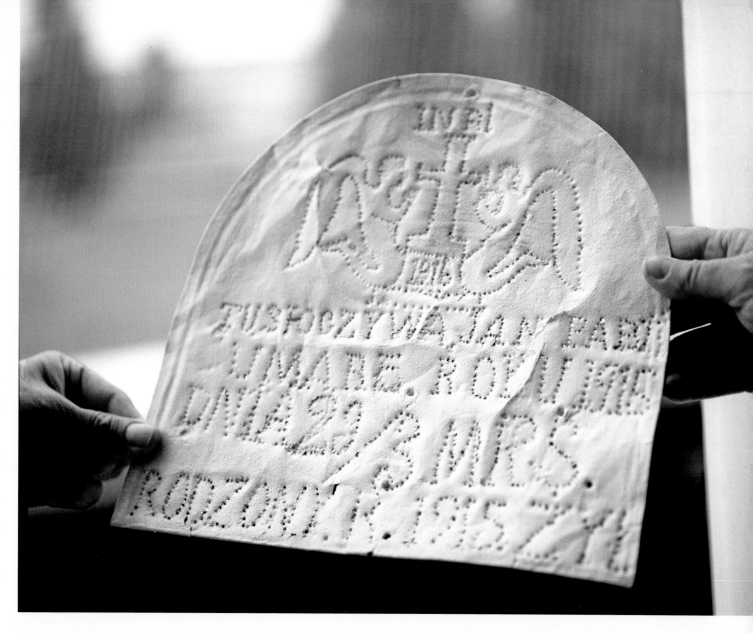

< Barn, site of Spirit Lake
Internment Camp, near Amos,
Quebec. [Sandra Semchuk]

^ Marker for a child's grave,
site of Spirit Lake Internment
Camp, near Amos, Quebec.

[Sandra Semchuk]

^ Railway that brought internees
to Spirit Lake Internment Camp,
Quebec. [Sandra Semchuk]

> Women and children under
guard, Spirit Lake Internment
Camp, Quebec.
[LAC PA-170662, credit R. Palmer]

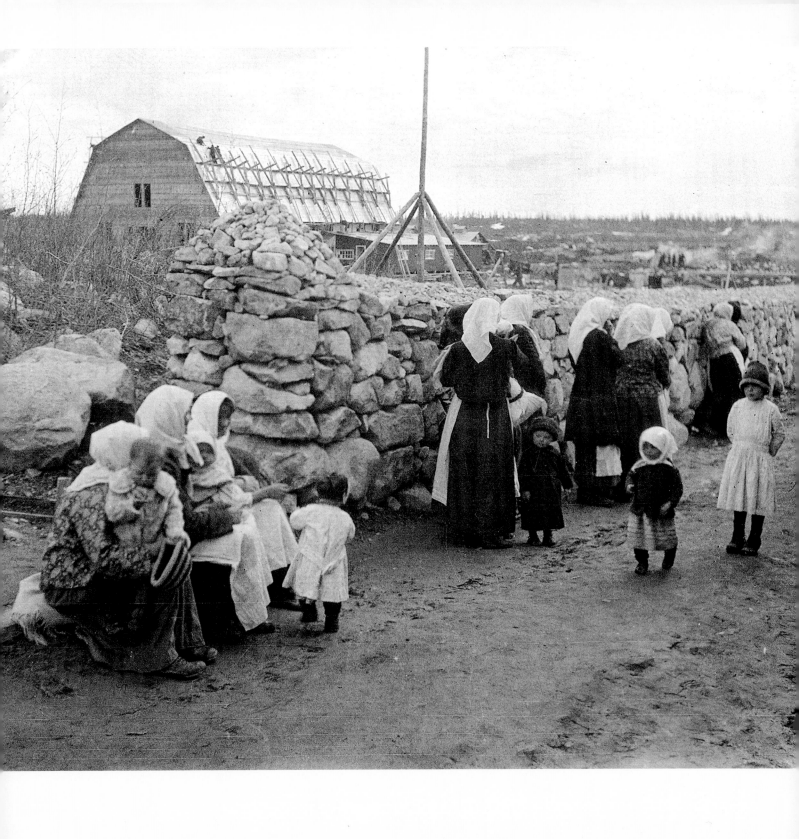

^ Looking towards where the
arena held internees, Sault Ste.
Marie, Ontario. [Sandra Semchuk]

> The federal building that
was used to process internees,
Sault Ste. Marie, Ontario.

[Sandra Semchuk]

< Whitefish Island, where
internees were held, Sault Ste.
Marie, Ontario. [Bruce Lenton]

^ Cement factory, site of Amherst
Internment Camp, Nova Scotia.

[Sandra Semchuk]

^ Cement factory, site of Amherst
Internment Camp, Nova Scotia.

[Sandra Semchuk]

Copy of letter from O.C. Amherst dated May 5, 1917.

"Confidential

#1097 G. Melintchansky
 1098 L. Trotsky
 1099 G. Tshoodnooski
 1100 L. Fisheleff
 1101 N. Muchin
 1102 K. Romanchenoo

Sir:-
 I have the honour to report for the information
of the Russian Consul General, should you think it desirable
to forward this letter to him, that the 6 Russian P.O.W.
(names as per margin), who were interned here under instructions
from the British Admiralty on April 3rd., and were placed on
board a Steamer for Petrograd via Christiania a few days ago,
are strongly opposed to the present Russian Government and are
advocates of an immediate Peace being made.

 Of course I am well aware that the opinions of half
a dozen men may be of little or no importance, but Leon Trotsky,
the leader, is a man holding extremely strong views and of
most powerful personality, his personality being such that after
only a few days stay here he was by far the most popular man in
the whole Camp with the German Prisoners of War, two-thirds of
whom are Socialists.

 I have therefore considered it advisable, to bring
this matter to your notice in case you should think it
desirable to inform the Russian Consul General.

 (Sgd.) A. MORRIS
 Col.
 O.C. Internment Station.

< Trailers at site of Mara Lake
Internment Camp, British
Columbia. [Sandra Semchuk]

^ Firepit at site of Mara Lake
Internment Camp, British
Columbia. [Sandra Semchuk]

Two Mile poppies,

Mara Lake, British Columbia.

[Sandra Semchuk]

< Where the skating arena used
to be, site of Fernie Internment
Camp, British Columbia.

[Sandra Semchuk]

^ Forest, site of Morrissey
Internment Camp, near Fernie,
British Columbia.

[Sandra Semchuk]

Englich Copy of letter addressed Mr. Beni R. Iseli,
Consul General of Switzerland ,

Montreal.

To the Consul General of the Swiss Republic,
Mr. Beni R. Iseli,

Montreal.

With the request, to send this letter to the following address :
To the
Imperial German Foreign Office ,

Wilhelmstrasse,

Berlin.

We, the undersigned Civil P.o.W. feel it our moral duty against our
fellow prisoners at the Morrissey Detention Camp, to give the Imperial
German Foreign Office the following notice :

On April 2nd, 1918 we were sent from the Morrissey Detention Camp to
the Detention Camp at Vernon/B.C.

We can testify under oath, that since the middle of January 1917
German and Austrian Civil P.o.War at the Morrissey Detention Camp at dif-
ferent times have been cruelly treated by guards and especially by the Camp
police. Some fellow prisoners have been arrested under false charges and
taken to the guardroom by the camp-police. On the way to the guardroom and
inside of the guardroom they were hit with fists and kicked by guard or
Camp-police. Several of these prisoners fell sick in consequence of such ill-
treatment, especially No. 335 and 186. No. 335 is at present in the isolated
hospital in a hopeless condition(tuberculosis). Both these prisoners were
with some others put into close confinement in April 1917, because they
refused to do work outside of the wire fence, work which was notfor the
interests of the inmates of the Camp excl. While in the cells, they were
treated in the most brutal manner. Other civil P.o.W., who refused to do
such work, were often sentenced to close confinement too, and during their
time in the cells brutally treated and forced to do the most degrading kinds
of work for the guards under the threats of bodily punishment if refusing to
comply. Some prisoners, who called the O/C's attention to the condition
were told that the prisoners were liars. n

In spite of the fact, that we have told this to the Swiss Consul,
Mr. S. Gintzburger, during his first and last visit he paid to the Camp
during our stay there, on August 24. 1917, and notwithstanding our vain effe
orts to keep in touch with the Consul the treatment of the prisoners has not
materially changed since that time. Only a few days before we left the Camp
on March 28th. 1918 prisoners were brutally treated by the Camp-police.

The civil prisoners at the Morrissey Camp are not allowed to laydown
on their bunks during the daytime, even if they feel ill, tired and hungry,
without a permit of the medical sergeant, who gives his opinion whether the
prisoner is sick or not. Prisoners, found on their beds at daytime, were
punished with as much as 6 days in the cells at half rations and in spite
of their feeling unwell immediately arrested and forced to do humiliating

work for the guards in the guardroom. Anybibody refusing to do this was threatened with bodily punishment.

We have done everything possible to better the conditions of our poor German and Austrian fellow-prisoners, who are detained at the isolation barracks or at the hospital. Fresh milk, the chief-nourishment for sick people, is not to be had at these hospitals and when we received $ 100,- from a Mrs. Schroeder, Winnipeg for the benefit of the Camp, the prisoners resolved, that this money should be used to buy milk and other proper food for the sick. The Camp Medical Officer, when told of our intention, replied, that no fresh milk were obtainable even if we paid for it ourselves.

In this matter we do not expect any help from our legal representatives, the Resp. Consuls of Switzerland or Sweden. During the week of Febr.24. 1918 we requested the Swiss Consul, Mr. S. Gintsburger, in 15 different letter, to at last visit the Camp, but up to this time we have received no answer whatever.

Therefore we sincerely request the German Foreign Office to immediately cause the necessary measures to be taken by the Imperial German Government, to put an end to this ill treatment. Furthermore we beg the I.G.Foreign Office to make these facts known to the K.& K. Austr-Hungarian Government, in order that similar steps may be taken.

We declare voluntarily, to support these our statements with an oath.

Very respectfully

^ Internee graveyard, near Fernie,
British Columbia. [Sandra Semchuk]

> *paranoia permeates generations*,
collaboration with descendant Jean
Gural, a series of three images,
site of Castle Mountain Internment
Camp, Alberta. [Sandra Semchuk]

paranoia

permeates

(the need to intern was never clear)

generations

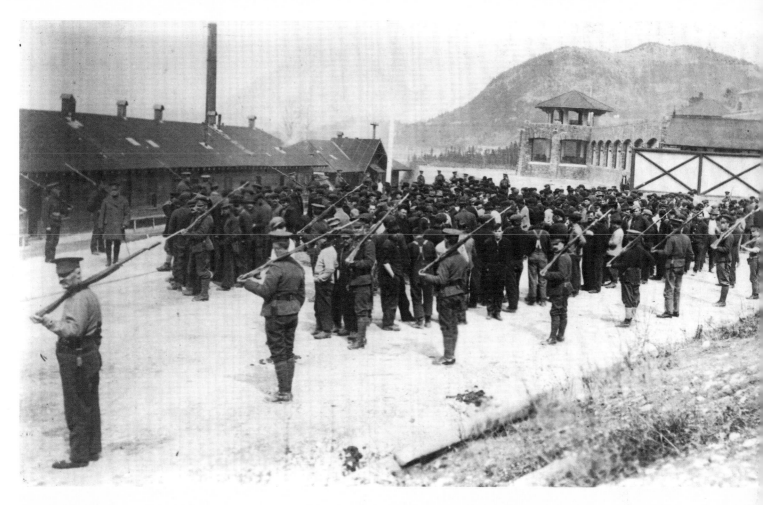

< Site of Cave and Basin

Internment Camp, Banff, Alberta.

[Sandra Semchuk]

^ Internees under guard,

Cave and Basin Internment Camp,

Banff, Alberta.

[Glenbow Archives, Gushul Collection,

NC-54-4336]

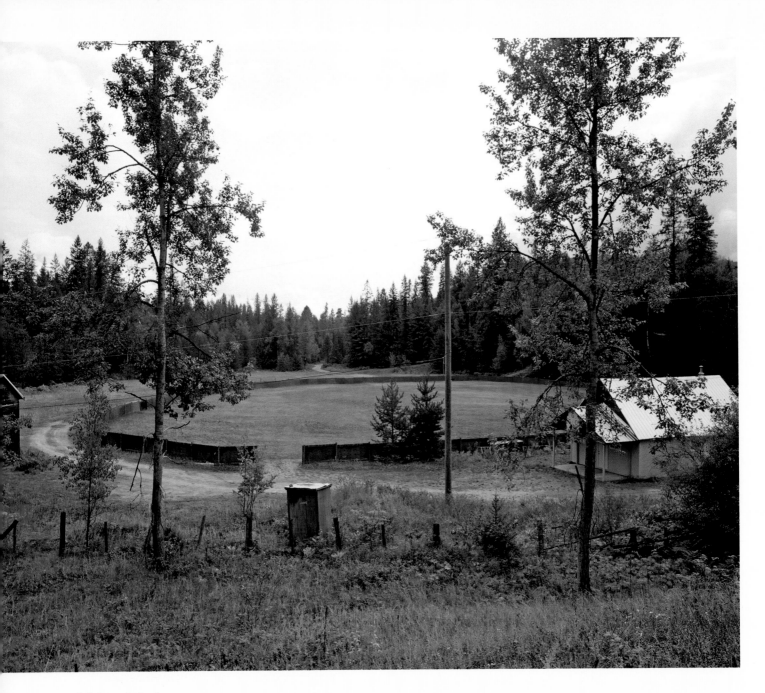

Ball diamond, site of
Edgewood Internment Camp,
British Columbia.

[Sandra Semchuk]

Community photo album showing
the internment camp and
internees working at Edgewood,
British Columbia. [Sandra Semchuk]

^ Ukrainian Canadian Civil
Liberties Association ceremony
to install plaque to honour the
internees at Edgewood, British
Columbia, October 2009.

[Sandra Semchuk]

> Remains of bread ovens,
site of Revelstoke Internment
Camp, British Columbia.

[Sandra Semchuk]

< Chain, site of Revelstoke
Internment Camp, British
Columbia. [Sandra Semchuk]

Swagger stick carved by internee,
housed at Revelstoke Museum and
Archives, British Columbia.

[Sandra Semchuk]

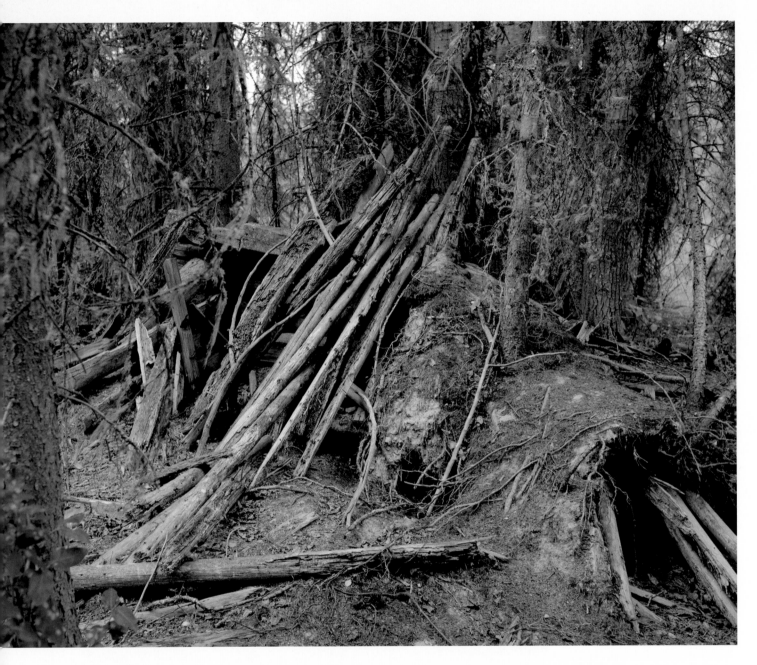

Collapsed bunkhouses, site of
Camp Otter Internment Camp,
near Field, British Columbia.

[Sandra Semchuk]

Where wolves play, site of
Camp Otter Internment Camp,
near Field, British Columbia.

[Sandra Semchuk]

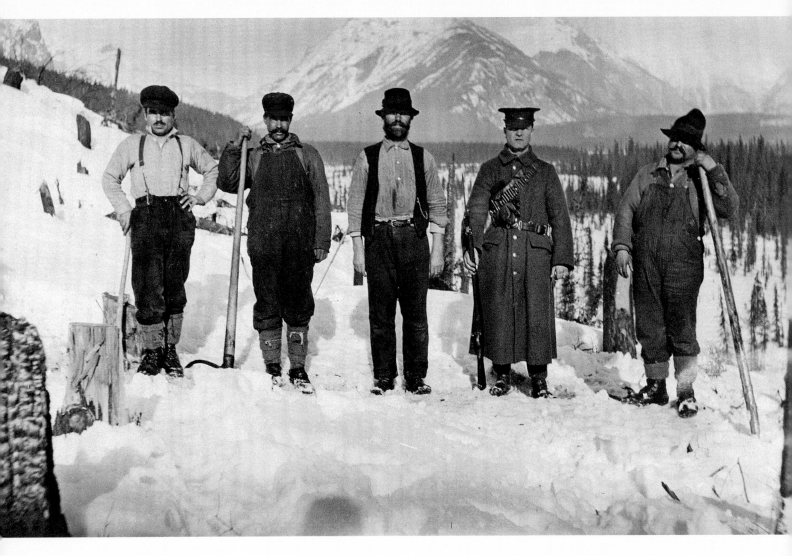

^ Camp Otter Internment Camp,
Yoho National Park, British
Columbia, 1916. [LAC C-081360]

> Site of Camp Otter
Internment Camp, near Field,
British Columbia.

[Sandra Semchuk]

Site of Jasper Internment Camp,

Alberta. [Sandra Semchuk]

Site of Jasper Internment Camp,

Alberta. [Sandra Semchuk]

^ Site of Munson Internment
Camp, Alberta. [Sandra Semchuk]

> Memorial sculpture, *Fortitude*,
by Grant McConnell, site of
Eaton Internment Camp, near
Saskatoon, Saskatchewan.

[Sandra Semchuk]

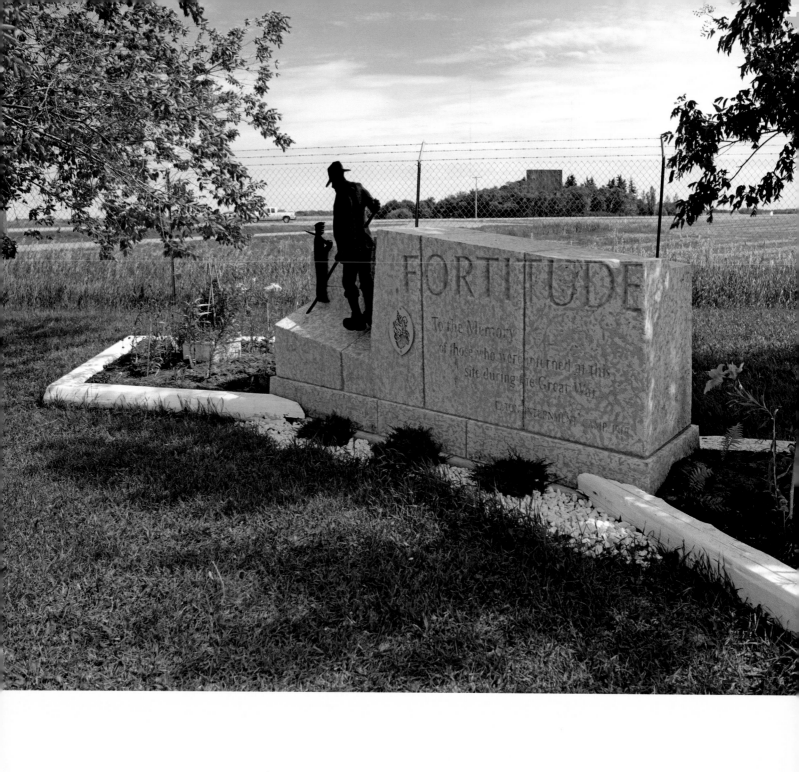

< Site of Eaton Internment Camp,
near Saskatoon, Saskatchewan.

[Sandra Semchuk]

^ Blueberries, site of Valcartier
Internment Camp, Canadian
Forces Base Valcartier, Quebec.

[Sandra Semchuk]

Sniper from Canadian Forces Base
Valcartier, helping locate the site
of Valcartier Internment Camp,
Quebec. [Sandra Semchuk]

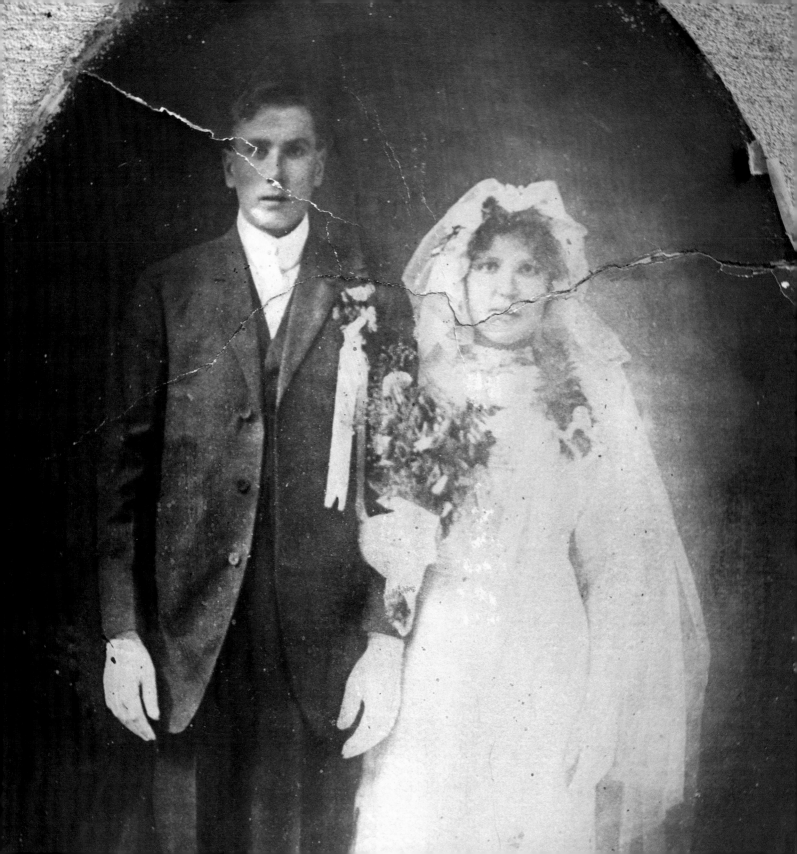

3 Stories from Internees and Descendants

Mary Bayrak

Daughter of Nikolai and Felicia Hancharuk and sister to Edward
Born in Spirit Lake Internment Camp[1]

My parents, Felicia and Nikolai Hancharuk, spent their "honeymoon" in the camp. They were picked up in Montreal. I was too young to think about the internment camps. You know little kids they love their mom and dad. That's all that they need. They don't care about the environment or different things around you. I was always with my brother, Edward, and jumping off things.

My mother used to say it was hard. She used to tell me I was born in the camp. Dad wasn't at home. A chaplain came in and blessed me. Everything was rationed so they got extra rations when I was born.

Edward and I were listening to Dad talking to somebody else...the house wasn't big. We heard the adults talking. The government was saying that those interned weren't Canadian citizens. They took my parents up north to Spirit Lake. The men were working logging and did something that they shouldn't have. The soldiers used to punish them by making them carry water in pails taken from one place to another and digging holes. Dad said, "I am not doing that."

Edward and I thought it was a terrible thing to be in a camp. We thought it was for doing something wrong. That's what we thought. Why would they put anybody someplace and keep them there if they didn't want to stay there? Hard for kids to understand. We thought, we had come from someplace else and weren't liked and were put in a camp.

I just never told anybody about it.

Jerry Bayrak

Grandson of Nikolai and Felicia Hancharuk
and son of Mary Bayrak

(*Internees at Spirit Lake, Quebec*)

This history is coming alive again. I get angry. I have to speak out.

There was an epidemic of tuberculosis in the Spirit Lake camp. They built a huge circular incinerator out of rocks to burn clothing and bedding in. There were three women interned in my family who got tuberculosis. My great-grandmother, Anna, my grandmother, Felicia, and my mother, Mary. My grandma died in her thirties as a result of TB. I didn't get the chance to know her.

I do get angry thinking, knowing my grandfather, and remembering him. I was quite young and everything, but, still, it makes me angry to think what he went through and I know he was a proud man, but what happened in there or how it changed him I don't know. I think it's something that's got to be told and the anger put to rest because it's been too long and it's been buried and ignored and shunted to the back burners and nobody ever talked about it. Family never talked about it; friends never talked about it. So, yes, I'm really pleased that all of this is coming into the open.

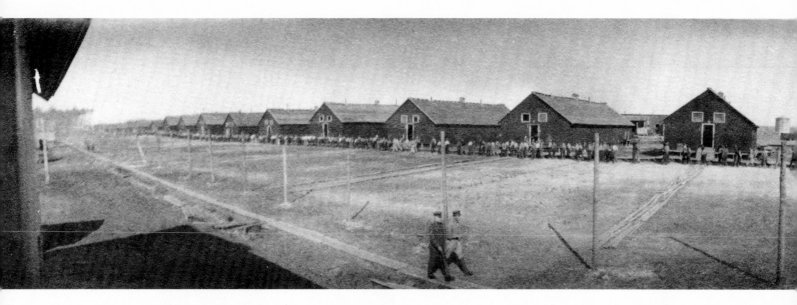

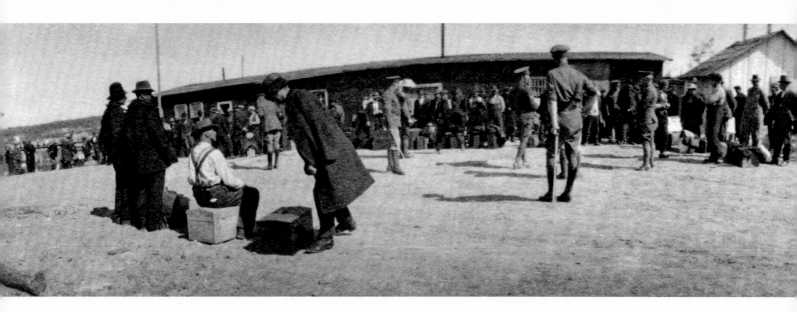

Internment Camp, Kapuskasing,

Ontario. [Ron Morel Memorial Museum]

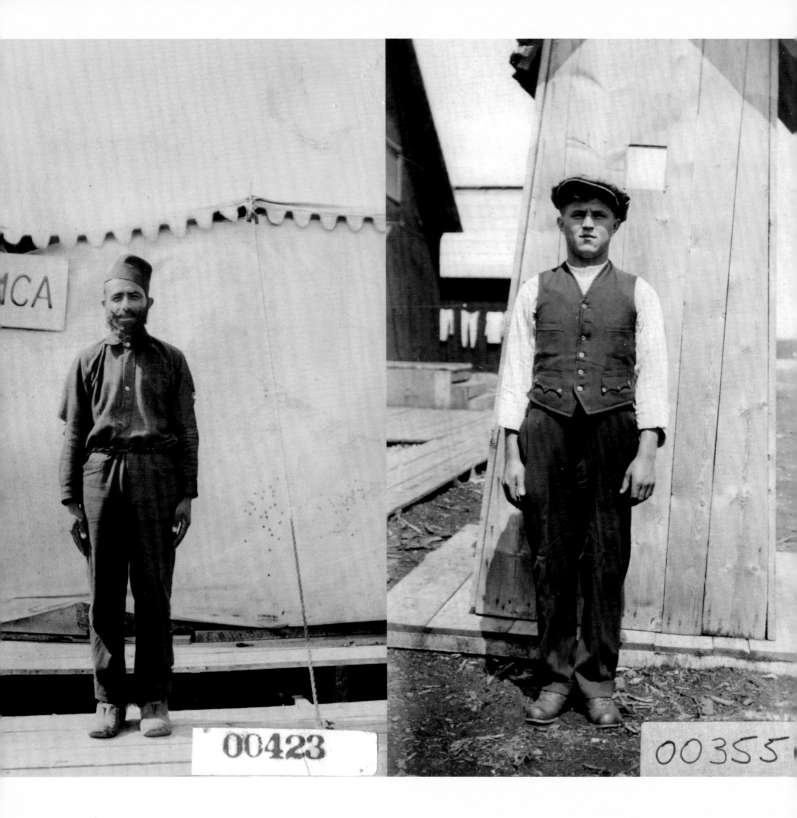

Philip Yasnowskyj

Interned at Stanley Barracks, Toronto,
and Kapuskasing, Ontario

Excerpt from "Internment"[2]

The men sought entertainment and whatever else would take their minds off their sorry lot, but this was next to impossible under barrack conditions. And yet, not all of them were interested in gaiety. In one barrack, I saw a man sitting on his bunk reading prayers from his prayer book and not paying attention to the merrymaking that went on all around him.

Or take the forty-year-old Ukrainian from Zalischyky whom I shall never forget. With only a couple of small pocketknives, he produced a variety of exquisite carvings of very high artistic quality. Among them were not only picture frames but also a violin made from 365 pieces of wood glued together. To look at this man, one would get the impression that he was just a useless slouch. But he possessed a most remarkable talent for carving pictures and figurines. His carved figure of Hetman Khmelnytsky mounted on a horse with a mace in his hand reminded one of the statues of Khmelnytsky in Kiev.[3] This man was a true master of his art, by the grace of God.

We had only one newspaper, the Polish *Dziennik Ludowy*.[4] But we could not learn much that was of interest from this paper. We were permitted to write letters, even to the old country, but no one ever received an answer. We complained to the major about not receiving letters from our families though we had been writing to them frequently. The major replied, "We see to it that your letters are sent overseas, but it is not our fault that the Germans sink the boats."

Maybe our letter had been sent out, but we did not ask him how many boats had been sunk. There must have been quite a number of them, since not one of us had ever received a single answer to our letters.

Slowly but surely, the winter was drawing to an end. In the clear spaces where the trees had been cut, one could see stumps three to four feet tall, and a mass of felled trees resting on these stumps. It was a dreary spectacle. Only an occasional raven winged his way over this desolate scene. The sky remained overcast, but one could detect a breath of warmth in the air. In the camp, there was an anticipation of Easter.

Finally Easter Sunday came, gray and dull. And it went by like any other Sunday with one significant exception—there was no work for us that day. To hold a service of worship was out of the question as there was no priest. The men sat the day out in the barracks, silent, depressed, and wrapped up in their own somber thoughts. Only now and then someone would softly strike up "Khristos Voskres."[5] Each one was weighed down by his own misery. The thought that gnawed most fiercely at all of us was "How long is our punishment going to go on? When are we going to be out of here, free once again?"

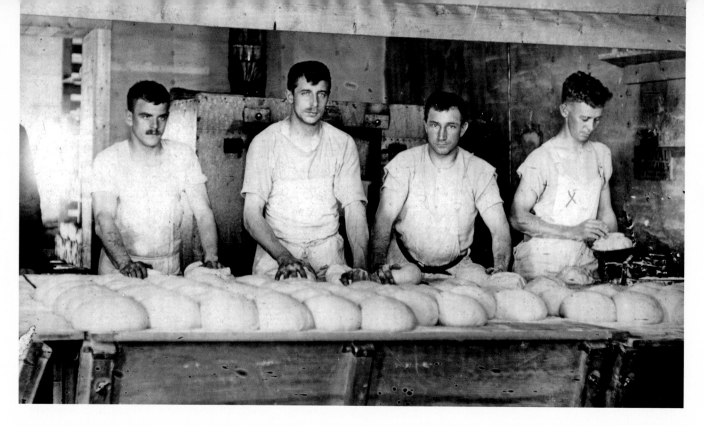

Portraits of internees baking bread, Kapuskasing Internment Camp, Ontario.

[Ron Morel Memorial Museum]

There was no observance whatever of either Easter Monday or Easter Tuesday.[6] We were all forced to work on those days as on any other day.

The resistance that brought us freedom

There was no more snow on the ground, and once again I went back to my job of picking up litter. There wasn't much litter around, and I spent more time just going through the motions of working than actually working. But no matter what I did, I could not shake off the sense of captivity which depressed me.

One day, barrack number four was ordered to vacate. Its inmates were assigned to other barracks. We were told that number four was to get 100 new occupants.

And, indeed, one afternoon a couple of days later, a train arrived with a transport of new internees. As soon as they got off, they were taken by the guards to the vacant barrack number four.

We were appalled by the appearance of these men. Their faces were yellowed and emaciated, and they all looked haggard—old and young, without exception. It was a frightful sight. We tried to find out from where they had been rounded up. Their speech was hard to understand, for they all spoke with difficulty—some through tears. They complained that they had not yet had a morsel of food in their mouth that day.

We got busy and collected several coupons to buy food for them. Each one of us donated as many as he could, and we

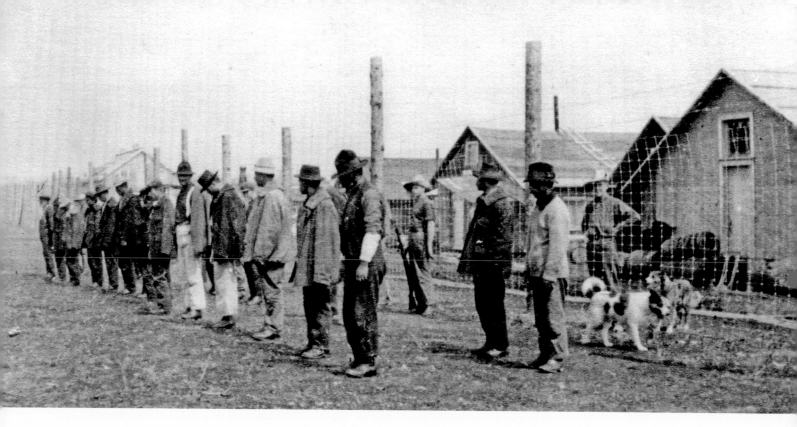

Roll call, Kapuskasing
Internment Camp, Ontario.

[Ron Morel Memorial Museum]

exchanged them for a couple of oranges and a chocolate bar for each of the new arrivals. That was all that was available in the canteen.

For supper, they were served the same kind of meal as we were, but some of them had lost their appetites completely and did not eat at all.

After supper, we listened to their stories about their hard lot. They had been interned at the camp near Petawawa. There were 600 of them in all. All were forced to do hard labor. When the Feast of Annunciation rolled around, the internees at the camp asked for a day off from work to observe the holy day.[7] But it was not to be. No one paid attention to their request. The commander of the camp responded with, "To hell with

your holy day," and the internees were all ordered to go to work that day.

The next day, no one turned up for work. All of them, to the last man, stayed in the barracks. The camp officials summoned them one by one to the office and demanded an explanation of why they refused to go to work. The one most important question, which was asked of each internee, was, "Why don't you want to work?"

They all had a ready answer. One replied, "You did not capture me on the battlefield. I came to Canada not to fight a war, but to earn a living and to enrich this country with my labors." Another argued, "I am already forty years old. I always observed that holy day in the same way as did my grandparents and my great-grandparents. My ancestors

shed their blood for the privilege of observing this and other holy days, and here you are forcing me to commit sacrilege by going to work on a holy day. I would rather be put to death on this day than trample upon my faith."

A third one had this explanation: "Before I came to this country I heard that there was freedom of religion and speech here, that everyone had a right to abstain from work on his holy day. But you would not let us observe our holy day, and you mock us, besides. Not one of us whom you have locked up here is responsible for the war in any way. But you have desecrated a holy day, and for that you will answer before God."

Others fell back on the Third Commandment for their defense and declared that God's Commandments take precedence over orders from camp administration and that no one is a slave forced to work on a holy day. And all men vowed that they would rather suffer persecution than work a holy day.

In the end, one of them declared in the name of the entire group, "Because you are forcing us to work on a holy day, we are not going back to work ever."

At eight o'clock in the evening, an officer visited barrack number four and gave the newcomers a short talk. He told them that other men at the barracks had worked faithfully over the past two years and obediently discharged their duties. They received good meals, clothes and pay, and they were satisfied. When he finished praising the former

inmates of the barracks, he reminded the men that there was a war on and one must obey wartime regulations passed by the government. Then he asked, "Will you go to work tomorrow?"

From all around came the resounding answer, "No! No! No!"

The officer stalked out of the barrack.

We were perturbed by their story. We asked our new comrades in captivity whether it was worth their while to lay themselves open to further persecution. They replied, "Calm yourselves; we are not afraid of persecution." And they recounted the instances of persecution they had experienced every time that they refused to work.

"Our food rations were immediately reduced by one half, the straw from our bunks was removed, and our warm clothing was taken away from us. We were forced to run, fall to the ground, and rise to our feet again repeatedly while we were being flogged. We were forced to carry fifty-pound bags of sand a distance of thirty miles. Our daily food ration continued to be progressively reduced until we had only bread and water. One hundred of us were transferred to this camp. What is going to happen to the ones left behind we do not know. But we are not going to work here either."

Deep down within us, we admired their decision and their determination to stand up for their rights. Their spirit was praiseworthy. They put us to shame for our submissiveness and slavish acquiescence to servility. In our hearts, a new spark of

indignation was kindled, but we remained silent.

The next day, the guard unbolted the door of barrack number four and ordered the men to work. Not a soul stirred. In the brief moment of silence which ensued, one could have heard a pin drop.

Around ten o'clock, all the occupants of barrack number four were chased out and summoned one by one to the major's office. Each one individually was asked why he did not want to go to work. Some pleaded sickness. They were sent back to the barrack. Others replied that since they were not captured on the battlefront, they did not consider themselves prisoners of war, and no one had the right to force them to work.

Out of 100 men, only the nine who pleaded illness were allowed to return to the barrack. The rest of them were punched and pushed and shoved forcibly out of the office by the soldiers. They were assembled in one spot where they were arranged in files of four. Soon, more soldiers arrived from the barracks and surrounded the captives on all sides. The major, the captain, the lieutenant emerged from the office and ordered the men to proceed towards the barrack.

This unique parade moved slowly forward as some 300 of us watched on. As the procession approached us, a young voice suddenly called out from among the spectators, "Hey, fellows, these men are being marched to their torture. They are our brothers; let's protect them!"

In fact, that was exactly how every single one of us felt, but none had dared to make the first move. Now that call, like a marching order, prompted an immediate response from us. We all rushed to block the advance of the procession. It ground to a halt. One Polish fellow from our group strode up to within a step of the major. The major pulled out his revolver and fired a shot into the air. He then used it to hit the Pole on his bald head and knock him to the ground.

The men raised an uproar, yelling, shouting, and whistling. In the midst of the clamour, one could hear their calls of "Shame! Beat him up! Stone him!"

There was confusion among the troops. The major gave the signal to sound the trumpet, and the soldiers rushed at us with fixed bayonets. We scurried away and headed for the barracks.

The incident was not without its toll. Several of us were wounded, and before we managed to reach the barracks, the pursuing troops had left their mark upon each one of us. A bayonet grazed my right arm, and for several days, I felt the pain, though the wound was not serious. Those with minor wounds treated themselves in the barracks. Nine men were seriously wounded and had to be hospitalized.

This incident was a turning point for us. We all resolved to ignore every order to go to work. Needless to say, I never again showed up for my job of gathering litter. We were ready to suffer the same fate as our comrades from barrack four. Our food

rations were reduced by half, but we did not worry about that. Persuasion did not move us, and threats did not scare us.

A few days later, a special commission arrived to investigate the incident. At the inquest, we all stressed the point that we were not prisoners of war and therefore would not submit to forced labor. In defense of our stand, we were ready to shed our blood again.

News of the incident spread far and wide. News items and editorials appeared in Canadian and American newspapers, with reverberations in all parts of the world. Ukrainian readers can find the story in detail in the yellowing pages of *Svoboda*[8] published during those memorable days of the years 1916 and 1917.

Shortly after the investigation, we were all set free. This convinced us that freedom can be won if we are ready to shed blood for it. We should never take freedom for granted.

At first no one wanted to leave the camp. Some said they would not move from the place until they were paid two years of their lost time. Others demanded that they would be returned to the jobs from which they were torn away.

The administration of the camp was helpless; for a long time, the inmates refused to abandon the camp. Eventually, however, the camp began to break up, and the inmates left one by one, each going his own way. Memories of the camp gradually began to fade away. But one could never really forget it completely.

Nikola Sakaliuk
Interned at Fort Henry, Kingston, Ontario
—An Interview by Lubomyr Y. Luciuk

"WWI Internment Account of a Ukrainian at Fort .Henry"[9]

When World War I broke out I was in Montreal. I had originally headed west in Canada, to Saskatchewan, where I had relations. But in 1914 I was in Montreal, working at the Canadian Car Foundry. When war came they started letting us go. I went for over a month without a job.

Well, word got out that jobs were available in the Unites States. We jobless fellows talked it over. It was hard to get across the border, you know. I thought that I could make it if I bought a train ticket to a place near the border, thought I could just walk across. I got as far as St. Jean, in Quebec. But I went on the wrong train. A conductor found this out and he called an inspector. That man spoke German and so he could tell who I was. He told me that I would have to return to Montreal. It was Saturday night. I could sleep overnight in Montreal in the immigration office there. On Monday I would be able to leave. So I went back. On Monday though they took me upstairs in the building and filled out a report. I ended up spending fourteen days there. Then they took me and a lot of others...all Austrians as they called us...and sent us to Fort Henry, in Kingston, Ontario.

Germans were sent along too. There were already some of those in the Fort, mainly

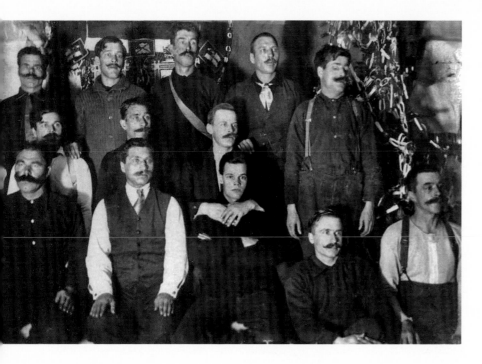

Internees, Fort Henry,
Kingston, Ontario.

[Fort Henry National Historic Site of Canada]

men who were working on German ships captured by the British.

I lived in Cell no. 19 of Fort Henry. Right inside the compound. There were two rows of rooms, on two floors. I was upstairs. There was a canteen, a bathroom, a kitchen and an eating room. When I was there about 500 men were with me. I'd say about 130 to 150 of these were Ukrainians. The rest were Germans from Germany and real Austrians. I got to Kingston on the 17th October.

The following autumn I was moved to Petawawa. Montreal was overcrowded with prisoners. There were about 300 Ukrainians there. So one night they took the Ukrainians from Fort Henry and those from Montreal and moved us by train north to Petawawa, to a large Army training base. It was almost all Ukrainian there, although a few Poles were mixed in with us and some Romanians. All were called Austrians.

After a month or so we were offered work, cutting the bush, uprooting trees, building training for the Army. We even cut out a twelve miles long artillery range for them.

At first you could work or not as you chose. You had that freedom. But such conditions only lasted about one or two months. After that everyone had to work. And if you refused you were put on bread and water. If you wouldn't work then they just cut your food off. I felt that they didn't have that right. So did about thirty others.

So we got together as a group and tried to organize against this move on the authorities' part. Well they soon found out and broke up the group by moving some of us, me included, back to Kingston. Among the Germans. The rest were worked hard after that and pacified.

Back in Kingston you could work too, for twenty-five cents a day. It was all recorded in a little book you kept. You could then go to a small canteen and buy what you wanted extra—food, candies, tobacco, whatever.

We were well guarded. There was the fort's wall, then a deep ditch. Very deep and wide! Inside the fort there were fully armed soldiers marching around at all times. And they were careful. There were twelve cannons on the walls, on tops of the buildings.

I must say that the fort wasn't in good shape. There were holes all over. You could even see through the walls at some points.

We had to fix those. There was even a danger of some of the walls collapsing.

By the second year they removed the cannons and placed a second row of guards about us. Wherever you looked, guards. They were strict. They'd yell at you if you didn't look where you walked. And you had to move if they yelled, or they might shoot.

When they moved us to Kingston it was a period of trouble with the Germans there. They were organized. They felt that we so-called Austrians were getting better treatment than they were, being kept in cold and damp quarters. They wanted to be moved out of the fort. Eventually, many of them were sent to Kapuskasing. I hear about 1,600 people ended up there.

People were later let out to work on various jobs: in the mines, in lumber camps, on the railroads. They only kept in those who ganged up and tried to organize. I was sent to Kapuskasing. It was a pleasant enough place, the woods were nice, and there was a river. We got there in the spring. Kingston was left almost empty. We worked pretty poorly, goofing off most of the time. We'd pretend to be working while really we were relaxing in shifts.

I should tell you one more story about Kingston. While I was still there, a few Germans, who were supposed to be fixing a sewer, instead started tunneling out of Fort Henry. It took them a long time, two summers I believe. But just before I was sent to Kapuskasing they were caught. They hadn't taken a careful enough measurement of the distance they had to go. Dug out too close to the fort. A watch guard fell into their escape hole and his gun went off. He raised an alarm and we were up all night.

I was paroled in Kapuskasing when a contractor came to the camp, looking for workers. I put down my name and he came and took me and some others to work. I spent six months in the bush before I went to better work, making railway ties. Got $20 a day. I later worked near Timmins and back up at Kapuskasing. All in all I spent thirty-one months in internment camps before I managed to get back down to Toronto.

They told me that I had been arrested because I was trying to illegally escape Canada and because there was a war on and I was an Austrian. I told them that I was not an Austrian. They then asked me where I came from and I told them: as well I let them know that I was a Ukrainian. They just repeated that as an Austrian citizen I was their enemy. I lost all of my rights. They didn't doubt where I said I came from but they found it useful to look upon us all as enemies.

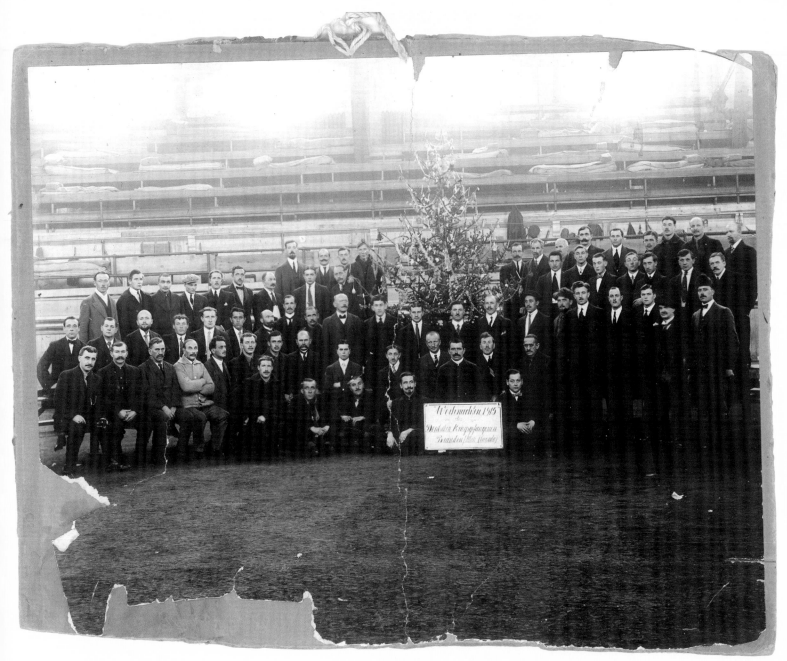

Ferdinand Zieroth (front row, third from left) and other prisoners of war, Brandon Arena, Manitoba.

Ferdinand Zieroth

Interned at Brandon, Manitoba

—As told by grandson David Zieroth

the photographer

...at the edge of this group of alert men
—all men—in the concentration camp, all
wearing ties because it's Christmas Eve
(so says a propped sign with Gothic letters)
German emigrants collected
by the War Measures Act in 1914
Oh, Canada! you do not know
the silences you have bequeathed unto
generations because no man here could breathe
knowing the outgoing air would shatter
all beliefs with the violence of its yell

sitting two men away from my grandfather
at the end of the row where he's just
nipped in, the photographer is pert, peering
into his own camera set up to take in
these lines of prisoners, their tinsel tree
the bent mattresses in the bleachers
of the fairgrounds where they sleep
some leaving behind a corpse
swinging, which internees see first
come morning and cold and gruel from
other-accented guards with Ross rifles
and long-reaching bayonets

my grandfather sits here, shocked rigid
what of his wife on her own, on the hard farm
and with children? I see his panic
the mark of betrayal on his face
that he was invited (like many)
to occupy the West, that he left
his ancestral home not knowing
the drift of history would ensnarl him
and, today, he's determined to show
that whatever the camera captures
it is not humiliation swelling within

Albert Bobyk, son of internee
Wasyl Bobyk, Brandon, Manitoba.

[Sandra Semchuk]

Wasyl Bobyk

Interned at Brandon, Manitoba
—As told by son Albert Bobyk

My dad was an educated man. When a lot of
people came from Europe who didn't know
how to read and write, he was teaching
them. He was the one that knew what was
going on.

I was about seven or eight years old. 1928.
I remember he said, "You have to know
what happened." And then he told me the
whole story. When they were leaving that
prison they were told, "Don't mention any-
thing what took place or else it will be tough
for the men that spoke about it." Everybody
kept quiet. They were afraid to speak about
it. Dad had to report at a certain time, report
to lawyers. Dad really wanted to tell me the
whole story because he kept telling me,
right along, year after year, everything that
took place. Yes, he kept telling me the story.
How he couldn't move because they were
watched. They weren't free. They were told
not to say a word about what was going on
in the camp when they let him out.

My dad was a man of strength, you
know; you could take him two ways [*long
silence*]—that strength was in the way he
was telling me. He wanted to be able to con-
tinue to feed the kids. I have four sisters and
myself. He was telling me the story *steady*
because he had to keep the kids going, with
school and everything. So the story—and
there is something in the telling of the story
that gave him strength. Yeah, yeah.

He wanted to tell the story because he
was told not to say it. That is the other way
he was strong. They were told not to reveal
the story that took place.

Back then Dad had to report to the law-
yer at a certain time. And that lawyer called
everybody who was reporting Jack. If your
name was Bill or Joe or something else—it
was Jack. So one time Dad came there and
this lawyer say, "Well, how's everything,
Jack?" Dad said, "Not too bad, Pete." And the
lawyer said, "My name isn't Pete!" And my
dad says, "My name isn't Jack either!" Yes.
I'll never forget that. He said that lawyer
changed his tone altogether. There were no
more "Jacks."

Dad was interned right here in Brandon.
He was single at the time. There were 1,800
internees in the Brandon arena, many
Ukrainians, Orthodox and Catholic. That's
where they were interned all those years.
There a stockade with guards and every-
thing—oh, that was guarded good. Uh huh.
He got picked up on the farm, just close to
Brandon. And life wasn't very sweet there.
They were watched and heavily guarded and
exercised. He said, "There were times we

109

woke up in the morning, take a look in the arena there, and there would be somebody hanging."

Then they sometimes were—not that they had done something wrong—thrown in the black hole. Some for twenty-four hours or so in just a little hole...the thing was four by four. I still remember that black hole because after I grew up—after the hockey game we would see it—that black hole was still there. Dad told about how they were thrown in there, in the black hole.

As Dad's story goes, there were times when I guess the boiler room wasn't always working to heat the prisoners' quarters. If the arena got cold, they were taken out

Albert Bobyk standing where the black hole was, Safeway parking lot, Brandon, Manitoba.

[Sandra Semchuk]

of the hole. They were so weak—but *then* they were forced, yet, to shovel coal to provide heat for the other men and *then* they were put back in there in that hole. He said it was something horrible just to see the men when they came out. They didn't care. If you were sick or what, it didn't make no difference.

Then, he said, "Every morning was exercise and they took the height of you—how tall you are. They stand you up and then the board comes onto the top of your head. When the board hit your head the one that do it will give you a good fist right in the stomach; in the chest." Dad said, "When we have to get that 'height' every second day, we had a fist in our chest. He just pounded us." Dad said that he suffered in his chest for a long, long time. He knew exactly...he's gonna be hit. Everyone's hit like that. That's how they were.

Then, when the harvest came, all the farmers were picking up the prisoners. The farmers—all of those, from here to Rivers, thirty miles, the richest farms...oh the worse part of it was—those rich farmers came to Brandon, took those people from the concentration camp. Took them out on the farm and worked them like dogs. Everyday. There was one farmer—Dad was telling me there were about nine of them—the woman that owned the farm with her husband—she had a horse and a snake whip. She drove between the prisoners there—watching with a snake whip on the farm. So do you get that! What kind of people are they?

They'd bring them to Victoria Ave and 24th, not far from where I'm living now—that's where they lined them up, and marched them all the way up Victoria and 28th. That's where the farmers picked the workers. Dad said they got paid just enough for "Just a little bit of tobacco. That's what it was." And they were worked steady. The whole harvest and [*long silence*]...

Dad didn't go out there. He was a butcher for the "big boys." He used to cut up the meat for them—steaks and that. But the prisoners never saw that. And Dad never had a chance to go out there on the farms because he was in what was called the "white outfit," looking after the big staff there. So that's it. The food that the internees ate wasn't much to it. Just food you would call it, but none of this real meat and all that...*that* was out completely.

The guards. Some guards would get other guards to get in between the prisoners, trying to stir something up...like to say...make a run for it...to get away from that place. There were always those kind of people who were placed in between to find out what the prisoners were talking about. There were some that were friendly and gave extra food or something like that—bribed them in some way to see what was taking place. Anybody that said that they were going to make a break away for it—they were punished. That black hole was waiting. Yes. That's so they would know who's the next one in there!

They were cruel.

Emile Litowski

Internment location unknown

—As told by niece Christine Witiuk

We lived on the homestead near Hadashville, Manitoba, for ten years, very close to it, and we were the third last to leave, out of those who homesteaded there. Everybody left in the end. It was that bad. No roads, nothing; just like the path, you know, where animals would walk. That's where people walked but only when they were, because of water and weather, able to walk.

They had to pull the trees down themselves, dig with the digger. They didn't have wheat very much. We once had the little bit of wheat but there wasn't anybody to make flour out of it. So mother just cooked wheat and we ate wheat. If we had cornmeal, we had only cornmeal and sour milk or if we had potatoes, potatoes and sour cream, however much there was. Mother cooked in a pot. We had no dishes, no plates. We ate with spoons that dad made out of wood before this. That I remember.

My father got a job on the railway but he had to walk ten miles one way and ten miles back. So he'd come home Saturday and then leave Sunday to go back to work. At that time, there were no little bags like ten pounds, fifteen. Everything was fifty or one hundred pounds. And flour, he'd carry fifty pounds of flour on his back for ten miles when he was coming to see mother. But he did not come every weekend. They took turns for the weekends. Sometimes he stayed away for two weeks before he came and mother ran out of flour. We had no bread then so we ate potatoes. I remember times that we had no potatoes. We didn't have anything. No bread; dad didn't come because it wasn't his turn to come. All we had we finished—chicken eggs and duck eggs. I remember I couldn't eat duck eggs because they smelled too wild [*laughter*]. That is all we had.

One thing I'm going to say about my older sister. When my dad and mother first came to the homestead they made—what do they call this?—a horse saw or sawhorse, made out of trees. They put branches together and trees with grass on the top for a roof and grass underneath for a floor. Mary was only months old. They put her in the centre and they slept on each of the sides. It rained that night. Mary, my sister, never got wet but my mother and dad got wet. So the next day dad

really fixed a big one up so if it rained they wouldn't get wet again. He had to pull trees down to make a little hut out of wood and put clay around it; you know, fill the holes up so they'd have a place to stay. He had to clear brush himself to plant the potatoes. Where they got the potatoes I don't know, but they got the potatoes.

Here is the story from World War I. It is late at night. The two men knocked on the door and they walked in and they asked dad's name. The younger brother was there. His name was Emile—they asked his name, asked for the last name, and then they told my dad and my uncle that they have to come with them. They are taking them because they expect war in Europe and they want them to defend "Ukraine" because they are Ukrainian. They were going to take them both that same night. And they started to cry, my dad and mother, because it's winter time, it's cold, and dad says that he can't leave mother alone with children because she won't survive. And those men said that is not their problem. The problem is to pick them up and take them to defend their own country.

Then finally, Dad and Uncle got them to wait to morning—they'll go in the morning. They didn't want to go because this was already dark at night. Those men went with lanterns. But Dad did not go in the morning. My Uncle Emile went alone and they took him and they never came for Dad; never picked Dad up.

Dad was supposed to report but he didn't. There were no roads. No roads at all. There was a path just like you'd find like animals have a path, going back and forth.

Before mother died I asked her what happened to Emile. This is exactly what she said. Dad didn't go and they never picked him up. Emile went like they said. There was a rumour that they were taking them as spies. They were putting them in internment camps. So that's probably it, but Dad never got picked up. Emile never came home. My dad wrote three letters that took a whole year to arrive because ships, it took them a long time to go one way and the other, and on the third letter, a year later, he got a letter from a home, from his parents that Emile never arrived in Europe. So where they took him we don't know.

I remember they came at night. I remember I started to cry. We were scared because they hammered hard because it was a—Dad made a door of logs—and they hammered hard. We cried. They were talking with Dad and Mother, and both cried. Dad and Mother were crying. They were talking but we didn't know what was going on, we were too young. Even if we heard exactly what they said, we were young. I only know what was happening through what I've seen and what mother said after.

I was old enough to remember. I still see the two men talking and both my mother and dad crying.

[Christine's daughter Elaine interjected]: I think given that fact that Elsie was a baby, and there is only one year difference between you, that you were not very old.

Oh yes Elsie, she had a bath, she was supposed to be in bed.

Vasyl Doskoch

*Interned at Morrissey, Mara Lake,
and Vernon, British Columbia, and
Kapuskasing, Ontario
—As told by daughter Anne Sadelain*

My father's Ukrainian name was Vasyl
Doskoch. He came to Canada in 1910 with
his brother, John. His brother was just a year
and a half older than he was. They were very
close. My father was only sixteen when he
left his village in Lazy, which was at that time
in Austro-Hungary. They came to Canada
because they had heard great things about
this country, especially from their older
brother George, who had arrived in Canada
in 1905.

Regularly they sent money back to their
father in Lazy so that he could buy land.
William (Vasyl) and John came from a large
family and they were not rich. They did not
have a lot of land. Their father worked as a
village carpenter when he wasn't doing his
farming. As was done there at the time, land
was divided as the children married. So that
would have given each child very, very lit-
tle land. They found jobs quite easily in the
coal mines. They learned the trade very,
very fast and they were good miners: intui-
tive, sensitive to their surroundings, to the
environment.

Now, my Uncle John and my father
worked in mines in both Alberta and British
Columbia. Their ease of finding jobs did
not last though. Canada was, in 1913, enter-
ing a recession and, all of a sudden, jobs
were hard to find. The mine my father was
working in, close to Vancouver, was shut
down. So both he and my Uncle John went
to Vancouver. John very quickly landed a job
in a place called Phoenix, British Columbia.
It was a copper mine. So he went off to
Phoenix and my father stayed in Vancouver.
My father waited for a word from his
brother saying that he had a job in Phoenix
and it just didn't come. He was very dis-
appointed because the two brothers had
vowed to always stay together.

Tragically for my father, one day when he
was walking down the street in Vancouver,
he was accosted by someone who turned out
to be a Royal North West Mounted Police
operative. He was asked to show his papers.
He was single and he was jobless. This was
exactly who the authorities were looking
for to put into the camps. My father was
arrested immediately and very soon ended
up in a camp in British Columbia called
Morrissey.

Well, these men did not feel a loyalty to
the Austro-Hungarian Empire or to Emperor
Franz Joseph. The brothers hadn't left espe-
cially good conditions in Austro-Hungarian
Ukraine. When the call came from Bishop
Budka to support the homeland, my father
would not have heeded it.[10] My father tried
to get ahold of international laws regard-
ing prisoners of war and tried to use what
he learned in some way. He became a real
anathema for the guards. He was often pun-
ished. Sometimes that would be by cutting
his food rations. Or, sometimes, he would

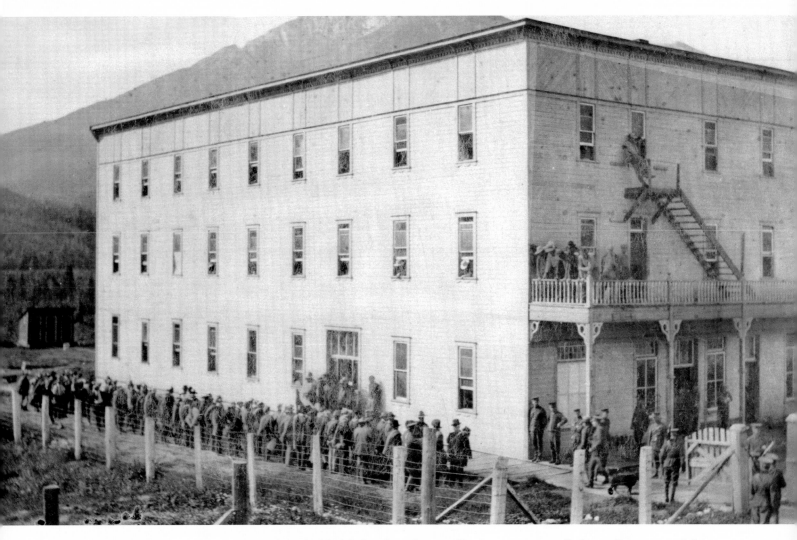

Morrissey Internment Camp,
British Columbia.

[LAC PA-127067]

be put into the black hole, where they would get bread and water.

If someone in the camp fell ill, they had to visit the medical officer, who often had no medical training whatsoever. If the officer decided that an internee was not too ill and could go to work, men who were ill were sent to work. If the internees stayed off work anyway, they were punished, sometimes with the black hole. The injustice the

men were suffering really got to my father. They had insufficient food. Milk was almost nonexistent. Fruit never. The only vegetable that they really got was watered down potatoes. He decided that someone had to try to do something about it, so in order to improve conditions he would urge his fellow prisoners to rebel or strike. He wrote letters, sometimes with the help of representatives of the YMCA. He wrote to the

Y.M.C.A. SERVICE FOR PRISONERS OF WAR

CARRIED ON INTERNATIONALLY BY MUTUAL AGREEMENT OF BELLIGERENT
NATIONS UNDER THE DIRECTION OF THE INTERNATIONAL COMMITTEE
OF NEW YORK, THE NATIONAL COUNCILS OF THE VARIOUS
COUNTRIES INVOLVED CO-OPERATING

WRITTEN AT _____ DATE April 19 th 191_8

Prisoner.sof War. Camp Committee
 Internment Camp. Vernon B.C.

 We beg to inform you that our fellow Prisoners, in
Internment Camp at Morrissey are exposed to the very brutal
treatment of the Canadian soldiers and non-commissioned
Officers doing police duty there. As we know that it is im-
possible for them to write to you stating the facts, and that
complaints to the Officer Commanding at Morrissey results

only inworking things worse for them, we must request you,
for thesake of humanity, to inform the Royal Consulate of
Sweden, the legal Representative of our Interests in Canada
of xx these Conditions and to beg him to exercise his influ-
ence to have a stop put to the cruel treatment of Prisoners
of War in Morrissey.

 Wm Doskoch 385
 Josef Hnatky 808
 Frank Parvik 147
 Peter Suchal 603
 Sam Sichon 445
 Ywan Lebunka 819

Swedish, Swiss consulates and to the YMCA asking for their help and imploring them to try to improve conditions for these people. After all, they were there only because they were Austro-Hungarians. They had done nothing illegal. Why did they not have recourse to justice?

In 1918, the year the Great War ended—he was released from Morrissey but he was sent on to yet another camp. It was the Vernon concentration camp. Vernon concentration camp was certainly easier for him to be there than in Morrissey. It was peopled by mainly German prisoners and they were considered as real prisoners of war, not as the Austro-Hungarians, [who] were enemy aliens. Those from the Austro-Hungarian Empire did forced labour. The Germans did not as prisoners of war.

My father found that there were a lot of educated Germans there who had books and time for hobbies. The prisoners worked with wood, carving and building for recreation. He wasn't constantly harassed by his guards in Vernon, so it was more free. Very important for my father—he found the books that he could read and discuss with people. It was there he first learned about Karl Marx and the *Communist Manifesto*. Another book that he brought from the camp and I still have it. It is called *Socialism and the Ethics of Jesus*. It was one of the first books he read when he was in the camp and he really treasured it. It was a time when ideas, socialist ideas, were taking hold in Canada too, although he certainly wasn't

part of the Canadian fabric, being in that prison. But the ideas were getting to him too. He was a thinker and cared about the people around him.

And it was during this time too that he also found out that his beloved brother John had died of the Spanish flu in Phoenix. We have a letter, a very tragic letter that he writes to his brother George in Bruderheim. I think it was a very tough time for my father. From Vernon, Father was sent off to the internment camp at Kapuskasing in Northern Ontario.

The story was largely told—what my brother Walter and I know—by my mother. Then my brother, Walter, went to the archives in Ottawa and he found some of the letters my father had written. He found the release paper that my father signed and other information about this ordeal that my father went through for five years. I do remember mother was always very sad when she told these stories about my father. She thought he was a marvelous human being and he certainly was. I believe he was kept in prison after the war ended in 1918 because of his dissident ideas and the important work he had done in the camp, urging prisoners to fight for better conditions and leading them on to fight for their rights.

He evolved the understanding that you had to do something political to change the system. I think this was coming through to him. He was arrested when he was twenty and he was now twenty-six when he left

the prison. They hadn't kept him down completely. So he had evolved. He was a fighter. He felt this grave injustice for himself and the others that were in prison with him. He hadn't done anything illegal that would have put him there. It was only because of his passport, because he was an Austro-Hungarian. He never ever was able to swallow this whole. It was always a fight, within him, and so, the fight without. He did something about it. He was like a resister during the war because, in a way, this was like a war on him and his fellow prisoners, wasn't it?

From Vernon he was sent to Kapuskasing in Northern Ontario. He stayed there until 1920. I know it proved to be another hellhole. They were treated as badly as they had been at other camps or worse sometimes. It was a very cold area and their clothing for the winter was inadequate. His shoes, my father said, were often worn out. He would stuff paper in the sole, for the soles of the shoes. This was winter. And the food was horrible. Sometimes it was so horrible it had a stench. In summer there were the black flies. They molested these people. And they laboured long hours and hewed trees for logs, most of the time, clearing the land for the experimental farm.

My father was more content to be in Kapuskasing. For one reason, he found books there again—papers and comrades—some of them German comrades with whom he could discuss what he read. And he had this newfound interest in politics. This was the positive side of Kapuskasing for him. Always an activist, along with others, he protested against that terrible food. They went on a hunger strike. This proved to be lethal for him because after the hunger strike he became ill with pneumonia. There were no antibiotics at the time and he certainly wasn't coddled by the prison authorities. He did get better but his health was always compromised after that. I think that it affected his heart.

He had an experience in Kapuskasing that he talked about. It was one morning in early spring when he was going to work in a group. My father was the last in the group. They were followed always by their soldier guard with his rifle and his bayonet. And they came to a creek, a rather deep creek. There was no bridge but there was a plank across the creek to get across.

The guard was an elderly man, you know, many of the guards were elderly. They had been soldiers in the Boer War. And this guard, he wasn't very stable and he was kind of afraid of this plank. When the plank moved as he was crossing, he fell into the water. My father was across already but he did immediately go back and he pulled the man out of the water with his bayonet and his gun. He stood the guard up on the land. The guard was very grateful. The next day he brought my father a bagful of oranges. Something my father hadn't seen in such a long time! And the two men began to talk.

The man became a friend. One day my father worked up the courage to ask this

Extract of the International Law, given to
Pris of War. at the Mara - Lake Int Camp
by the American Consul, J. C Woodward,
on Aug. 27ᵗʰ 1916.

No, pris, of war should under the present
Conditions accept any employment in
Canada. or in any British - owned Colony.
Reason: In time of war no British subject
is bound to pay any alien enemy for
services rendered, or, if transacting business,
is not bound to pay for the goods delivered
during the war. Further is no pris. of war
bound nor can be forced to pay taxes or
duties of any kind. Taxes and interests
have to wait for their continuation till
after the war. Private property is not
confiscable. Everyone interned has the
right to claim damages if it was
the fault of the government to keep
them back at the outbreak of hostilities.
Then the sovereing declaring war
can neither detain the person nor
the property of those subjects of the
enemy who are within his (domination)
(dominion)

soldier to send a letter for him. It was a letter my father had written to the authorities in Ottawa, explaining the terrible conditions, especially the food. My father, of course, couldn't send this through the camp because everything they wrote was censored. The soldier guard agreed to do this and soon after there was a commission that came out. There were some improvements in the camp thereafter. But, just after this, the guard came to see him and said, "Bill you shouldn't be sleeping with your cot facing the window." He didn't tell him why.

But the man my father had saved had heard things amongst the guards. And so, Bill did what his friend said. He put his bed under the window instead of facing the window, the way he liked to sleep. My father liked to get the early morning sun. And lo and behold—I don't know if it was the same night or just after—a shot came through the window and it ended in the wall where my father would have been sleeping. So he knew that somebody was out to get him because of the letter. My father didn't hear much about it after. There was never, never any commission that came out to look into why he was shot at. Soon after that he was released. And it was January 1920 when he was released. And when we think about it, the war had ended in 1918. He was finally released!

He was a bitter man about these five years. Five years of his youth that he had lost in this prison. He was released with practically no money. He still had a brother

in Alberta, in Bruderheim, Alberta—his brother George. So he had to get to see him. And to get from Kapuskasing in Northern Ontario with very little or no money, it was no easy thing.

So he rode the rails. And during this ride he met many immigrant rail workers. And he was amazed. He thought, "You know, their conditions aren't much better than our camp, except they had a choice." They had the freedom to choose. They could leave if they wanted to. They lived in boxcars that were along the sides of the major tracks. They travelled on little machines called speeders and they would pump them to make them go. Anyway, he was quite amazed at their working conditions. They were all immigrants too. I think this made a big impression on him though, the living conditions of these immigrants. And they weren't all Austro-Hungarians. There were Italians, and Chinese, and others. When my father finally got to Bruderheim, he didn't stay there very long. He came to Edmonton where he met and spent time with comrades from the internment camps who were also living there. He met friends that had come to Canada from Lazy in Poland. They came after the war.

He found too that he had a talent for public speaking. He was getting pretty good at it. His English had improved and this served him well. He got a job with the Canadian Brotherhood of Railway Employees. It was a job organizing these very railway workers that he had seen on these extra gangs, as

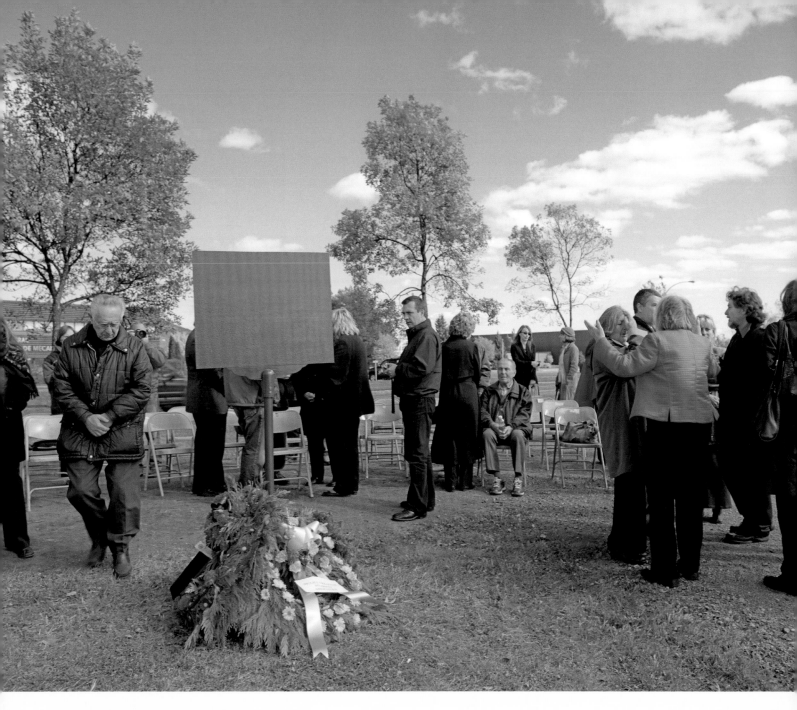

Members of Ukrainian Canadian Civil Liberties Association,
Descendants of Ukrainian Canadian Internee Victims Association,
and guests, putting up a plaque to honour internees, site of
Valcartier Internment Camp, Quebec, October 2006. [Sandra Semchuk]

they were called. He walked, took rides on these speeders from Alberta to Manitoba, organizing these men. He was always urging them to strive better working conditions, better living conditions. During this time, he did not always live very well either. He lived like they did: very poorly.

It was during this time, when he was working with the Canadian Brotherhood of Railroad Employees, that he met a girl from his village in Lazy. She had come to Canada in 1921. And they were married soon after that. Lazy was no longer a village in Austro-Hungary. Lazy was now a village in Poland. The borders had changed. My mother came from the same village as my father but she came on a Polish passport. I think the next few years after their marriage were probably the happiest of my father's life. He was organizing and he felt vital. He was doing something good for humanity and he had his family. My sister was born in 1924, my brother in 1926.

He was a happy, fulfilled man for the first time in his life. I am so happy he had that period because he died very young. He died at forty-seven. In 1941, it was Ukrainian Christmas day. After being blackballed for political organizing, he was finally working in a mine again, in a place called Rosedale, Alberta. It was, it's close to Drumheller, and he suffered a heart attack. It was a terrible shock for my mother and our family.

Kim Pawliw, granddaughter of internee Stepha (Mielniczuk) Pawliw. [Sandra Semchuk]

Stefa (Mielniczuk) Pawliw
Interned at Spirit Lake, Quebec
—As told by granddaughter Kim Pawliw

Tribute to My Grandmother

Canadian
But of Ukrainian origin
Your freedom was taken away
Your belongings were confiscated that day

They took you and your family
Moved all of you to Abitibi
They brought you so far
To an Internment camp at a time of war
It was misery
You worked there for no money

We must remember this story
To keep it in memory
For it is all true
Dear Baba, I will never forget you[11]

Petro Witrowicz

Interned at Kapuskasing, Ontario
—As told by by granddaughter Valdine Ciwko

A Ship in a Bottle

That old mickey bottle with a ship inside had a place of honour in Baba's china cabinet on the top shelf with the glasses we used only at Christmas or Easter. It always seemed oddly out of place among the few very Ukrainian belongings and treasures my grandmother had lovingly carted with her from the old country. Its sea blue colour drew me in, and the detail on the ship made it look so real.

They said my grandfather got it when he was in prison. Imagine what that would conjure up for a seven-year-old child. My mother and her two sisters never wanted to talk about the bottle. And even if my baba would have, I, a typical third-generation, couldn't have asked her in the language she could have told the story in. At that year's Christmas Eve dinner, the table set with the special dishes, amidst the stories about how my grandfather would put straw in the corner of the room and throw a spoonful of *kutya* (the sickly sweet buckwheat, honey and poppy seed mixture I hated but had to eat) on the ceiling to foretell whether it would be a good or bad year, I ask about the bottle and its connection to my grandfather. The answer is short and curt.

He went away to prison. Someone he was in prison with made it and had given it to him. When he returned he gave it to Baba. End of story.

This is how I learned that there is a dark time in my family's history, a time not to be remembered openly, or talked about. The conversation quickly returns to happier memories. But the bottle keeps drawing me back.

At twelve I get a few more details. I want to know again. Why, I persist, had my grandfather been in prison? Perhaps because I am older now, my mother and aunts feel I can have a few more details and this is the story they now tell me:

It was during the 1919 Winnipeg General Strike. Your grandfather and Mr. Simcoe went to a meeting. They were picked up by the Royal North West Mounted Police. Mr. Simcoe had children so they didn't take him. Baba and your grandfather didn't have any children so they took him away. It was because he was Ukrainian. He was sent to a work camp in Kapuskasing, Ontario. He wrote letters to Baba sometimes. They were fed beet peelings and potato water. They were building a highway. He was gone for almost three years and Baba was all by herself. Baba was ashamed and didn't want to talk about it.

Yes, of course he was Ukrainian, but what did that mean? What did he do to be sent to prison? Why did he have to go?

At seventeen I am still troubled by the story but have a better sense of history and time. Sitting drinking coffee with my mother and aunt in what used to be my baba's kitchen but is now my aunt's since Baba's death, I calmly ask, "Mom, who is Auntie Mary's dad?" She and my Auntie

123

Nettie look at me like the devil has spoken from my mouth. "What do you mean? Our dad, of course. What's this all about?" "But it can't be, you see. If your father was sent to Kapuskasing in 1919 during the Winnipeg General Strike, and Auntie Mary was born in October of 1920, then he couldn't possibly be her father." Dumbfounded looks upon their faces. A family's history is rattled.

We puzzle it out. Counting back from Auntie Mary's birth, and examining more closely their recollections of the few details they remember hearing from their mother, we determine he was actually sent to prison two years earlier, making it the year of 1917. I am really intrigued. The connection to the Winnipeg General Strike had always given his imprisonment more legitimacy; there were so many people who had been arrested during that time. For the first time I begin to realize the huge burden of shame his arrest had been for both my grandfather and my baba. It was something they decided their daughters needed to know little about. The true family history would begin with the birth of their children. I phone the RCMP thinking his imprisonment would be on file. "We have no record of that. We don't keep records that far back." Click. End of conversation.

It is 1981 and I am in the Winnipeg Centennial Public Library microfiche room. I scour the headlines of the *Winnipeg Free Press*. His arrest had been in May, of this my mom and aunt seemed sure. The black and white microfilm blurs before my eyes —

I don't even really know what I am searching for. Buried at the bottom of one of the last pages of the paper for May 17 is a tiny article about a strike at a plant in Transcona (in the northeast part of Winnipeg) to which the RCMP were called. "Aha!" I exclaim, and make a note, suddenly remembering that Transcona was a detail my mother gave me. I search the rest of May and well into the summer of 1917 to see if there is any mention of who was arrested and what happened to them, but there is no word. At least the family folklore is beginning to fit the historical record.

By 1998 I have lost the drive to dig for the details. I am now living in Ottawa and one cold January evening, while reading through the gallery listings in the *Ottawa XPress*, an announcement of an upcoming exhibit catches my eye. At the gallery in Ottawa's City Hall there was going to be a show commemorating the lives of Ukrainians who had been interned during the First World War. Had I read this right?[12]

It is one of those bitterly cold Ottawa days and there are only a half a dozen other people besides me, my companion, and our guest from Toronto, whom we have dragged along with us. The exhibit is rather stark, mostly images enlarged in black and white with enlarged text beside them. There is a display of one family's photo collection, models of the camps that appeared in various places across Canada, and letters to loved ones sent home from the camps. A display of battered kitchen utensils, the few

personal items that families had saved after all these years, and then we see them. Big bottles, small bottles, and another mickey bottle that looks like the one of my memories, all with ships inside. Building boats in bottles, a sailor's art, somehow became a pastime in the work camps of Kapuskasing to keep cold hands busy and pass away endless nights. At the far end of the gallery there is a black and white arch through which we walk. Inscribed on its walls are names written in red, as if with blood—Petro Witrowich—his name leaps out at me from the list and I am crying.

And now I can finish his story.

After being picked up in Transcona on May 17, he is taken to the local jail in downtown Winnipeg. His friend, who already has children, is released. My grandfather is held in Winnipeg for a few days before being sent off to Kapuskasing, one of the twenty-four work camps across the country. He would spend the next two and a half years of his life there as a forced labourer, building logging roads through Northern Ontario. His letters home are censored—he can't reveal the hardship he endured, though there are hints of maltreatment and malnutrition.

When my grandfather returns home, he returns home with a ship in a bottle. Who gave him this gift? And why, years after my grandfather had died, hadn't my baba thrown it away?

It is a chilly, gray day, Sunday, October 11, 1998, a year and a half before my mother dies, I stand proudly with her on the west lawn of the Manitoba Legislature. She steadies herself with the walker she must now use since her stroke, but she is determined to be here. We are among about two hundred others, mostly older people, to witness the unveiling of a plaque in memory of the "thousands of Ukrainians and other Europeans unjustly interned as 'Enemy Aliens' during Canada's first national internment operations of 1914 to 1920."

I stand as a witness to my family's past. What once sat as a reminder of shame for my baba and her daughters—the boat in a bottle—serves as a symbol of pride for me. I am proud to be the granddaughter of a Ukrainian immigrant. He was not a criminal. He was persecuted for being who he was, a worker and an immigrant. By chance of birth and circumstance, he was forced to spend two and a half years of his life paying for this crime.

Anonymous

Interned at Stanley Barracks, Toronto, Ontario
—As told by a grandson

Innocent, Yet Interned:

My Grandfather's Predicament

Grandfather was sitting on the stairs to his house while Uncle Tom was sitting on a bench nearby. I was wheeling an eight-inch steel hoop that I pushed around with an upside down "T" control stick that was about twenty-six inches long.[13] I was quite proficient at making the hoop wobble at slow speeds and making extremely sharp turns and circles without allowing the hoop to fall down. I was not yet nine years old, so in my childish way, I thought that I was showing off my proficiency on the path toward the steps where Grandfather was sitting with Uncle Tom nearby. However, Uncle Tom and Grandfather were too intent in their conversation to pay attention to me. While they were discussing some very serious concerns, I was playing with a hoop. Either they thought that I did not hear what they were saying or perhaps they presumed that I was not paying attention to them just as they were not paying attention to me.

Nevertheless, I overheard Uncle Tom ask Grandfather, "And, how did it happen that you were rounded up? You had a homestead, and it seems to me that people with homesteads were overlooked."[14] Grandfather began to explain:

As you know, before a homestead could be productive enough from which to make a living, one needed to buy cattle, horses, and machinery, etc. To earn money with which to do that, I became employed by an already established farmer not too far away. The farmer was raising horses for sale, and I was good at domesticating colts and fillies, to make them obedient for riding and for pulling wagons or machinery when they were fully grown. In addition, that farmer was into mixed farming. Consequently, I did a variety of things around his farm.

When one day I became concerned over the holes that I had worn through my pants, I asked the farmer if sometime, whenever next time he will be going into town, would I be able to get a ride with him to buy myself another pair of pants? With enthusiasm the farmer replied, "Why don't we go tomorrow? I have some potatoes that I want to sell in town. Why don't you load up a wagon full of sacked potatoes, then you can help me unload them for my customers when we sell them in town? There should be time for you to buy yourself new pants afterwards while we are still in town."

The next day the farmer and I took a horse-drawn wagonload of sacked potatoes into town. After having sold the potatoes to various customers, the farmer and I tied up the team of horses to a hitching post in town with the horses still harnessed to the wagon. The farmer had some business to attend to, so he went off in his direction telling me I was free now to go buy myself some pants. We were to meet at the wagon for the ride back to the farm.

After buying pants, when I was approaching the wagon, I saw two boys tickling the flanks of the horses with some tree branches. The horses were jumping around, and one had already jumped over the wagon's hitching tongue. They entangled the harness. I shouted at those boys, and began running toward the wagon to calm down the horses. The boys threw down their branches as they ran away along the boardwalk. At the corner of the block was a policeman. He stopped the boys, and asked why they were running. They said something like, "That foreign bohunk[15] is after us!"

The policeman approached me. "Show me your foreigner's identification card." I did not know what identification card he wanted me to show him. I know now that I should have had an identification card as all new immigrants were supposed to obtain after the war began. However, being illiterate, and not reading newspapers, I did not know that I was to have such an identification card, that I was to carry it with me at all times, and that I was supposed to report to the town's police station periodically with that card. I was thoroughly perplexed when immediately I was placed under arrest and taken away.

I was fortunate, however. My internment lasted for only about three months. Later, my employer farmer told me that when he came back to the wagon, he had to unhitch and re-hitch the horses. He waited, and waited for me to return. However, he had to give up waiting for me because time was running out for him to get back to his farm before sunset. He said that his first thoughts were that I had quit the farm to do something elsewhere. However, when he looked into the bunkhouse where I was lodged while working on his farm, he was surprised to see all of my things there with no evidence that I was not intending to come back.

Curious to know what had happened to me, the next time the farmer came into town, he asked around if anyone had seen me anywhere. Someone told him that on around the day that I had disappeared, a number of new immigrants had been rounded up and sent away to internment camps. Perhaps I was among them. The farmer proceeded to contact the authorities to find out if I was among those that had been rounded up for internment and where could I be located. He wanted to get me back to work on his farm. It took three months before I was released and sent back to his farm. I will always be very grateful to this farmer for his concern and effort on my behalf.

However, because of my internment I lost title to my original homestead quarter section. I had to reapply for another homestead, which I obtained. But it was a long way from the original one. So I had to start all over again clearing land from trees to be able to plough the required number of acres within the allotted period of time to qualify for a title to the new homestead quarter section.

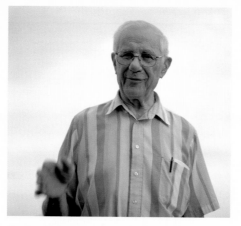

Uncle's Story

Interned at Jasper, Alberta

—As told by nephew Andrew Antoniuk

When my father, Nick, got his first car in
1937, we went to Jasper. He showed us the
area where his eldest brother said that he
had worked clearing the forest in an intern-
ment camp. It was east of Jasper, just around
where the road was being cleared. It was
not on a riverbank. It was the old highway
we used to go on, not the new one. It was
quite a unique thing for me. Initially, when
he first showed it to me, it didn't mean that
much, but now as I am reviewing the his-
tory I see the place again and I think about
it. "Oh, my God," I think, "what an activity
he had to go though." I realized that he was
forced to do the labour. Uncle was an active
community member one day and a criminal
the next. He hid it so well, family members
did not know.

When Grandfather died Uncle became
the senior man in the house for two fam-
ilies. My father was the youngest brother.

My father always looked up to Uncle. I
thought for years and years that Uncle was
his father. Until later when I grew up and
matured and started to realize, "No, he's
not my father's father; he was his eldest
brother." That changed how I was when
talking with him.

I remember being here in this yard. My
four uncles were talking about different
experiences. I was about fourteen, fifteen
years old and I remember asking Uncle,
"You were in prison. Where were you in
prison in Canada?" Oh, he was so infuriated
with me that he didn't want to talk and he
walked away from me. I walked to my father
and I said, "Dad what's wrong with Uncle?"
He just simply said, "He doesn't want to talk
about the experience he had in the intern-
ment camps during the First World War.
He doesn't want to talk about that. Nobody
knows about it. He just won't tell anybody."
I had a difficult time accepting that, but
later on I realized why he didn't want to talk
about it.

Well, it was so disgusting because the
family was invited to come to Canada. They
were invited to start up agriculture, to farm
the land, and this is precisely what he did.
He was a hard-working individual. Criminal
activity was not part of his life. He was
interned as a Ukrainian foreigner yet he
was invited to come to Canada.

Quite a few years later I was with
Uncle—we were on the farm field—and I
said, "Uncle I'm sorry when I asked you a
couple of years ago about the internment

Uncle's barn, near Chipman, Alberta. [Sandra Semchuk]

and being a prisoner." He said, "It was a sad experience for me. I don't know why I went into the camp as a prisoner. I did nothing wrong."

And he didn't. He was the chairman of the church. He was on the school board. He did a lot of community work, and yet he was put in prison. When the war broke out my uncle had an Austro-Hungarian passport.

When the war people came to the farm, they accused him of being a foreigner. He was a suspect. He was of military age so they put him into prison. He went to Castle Mountain Internment Camp in Banff, around 1915 or 1916, as an enemy alien.

He was transferred by railcars to Jasper. Jasper National Park had been formed and there was no roadway there. So he was

shipped, along with many other prisoners, by boxcar to Jasper. He felt he was a slave labourer there in the internment camp in Jasper National Park. They worked there for quite a few months there and the payment there was very little. I remember him saying that he got fourteen dollars and some cents as payment, but he worked some more and he never got the last of the payment. He had a pocket watch and that pocket watch was taken away from him as well as some other personal belongings he lost at that time. I distinctly remember him telling me that this had happened. He did say something about a golf course that he worked on. Now, whether it's the one in Banff, golf course next to or across from the main hotel there, I'm not sure.

Well, it was a tragic loss because, as I said, my uncle was the eldest child at the time and the senior man on the farm. He would have been around twenty-six, twenty-eight years of age. He would have had two or three children of his own, and because they were small children, they didn't understand why he had gone away. My father was Uncle's youngest brother. My father was sort of the senior child of the place there. So he was already doing a lot of the yard work on the farm. He told me he enjoyed the responsibility because he was looked up to. So one brother would say, "Nick go help Uncle Mark get his house established." So my father would go there for months and months; work there; come back for springtime and help here at this place, at Uncle's.

When Uncle Harry started his home, my father said, well, "I went there." So to my father it was a great experience because he travelled from one place to another to a third. He looked at it quite positively from that perspective.

When my uncle was gone to the internment camps, my father stayed there to do the work, to help the family. Uncle's mother was living there too with Uncle's wife and the small children; they all lived together in the one house. My father always explained all of what he had to do in his own way: "Uncle would have done that," my father said "but I did it this way. Uncle would want to do it this way, I did it that way." And so, my father said in later years, "Uncle probably wasn't happy with what I did but I was the oldest and that was the way I knew how to do it and that's what I did." And in later years I remembering mentioning, talking to Uncle about what my father did. "Oh," he said, "he helped me out. He took care of everything here." Like, he was quite happy that his youngest brother was able to live in the house here, help him out in the yard while he was away.

In essence, he saved the farm. That's rather very startling because there was the family of eight children, the youngest was only, what, about three or four months old, when the grandfather died. Yet all the children survived here. Five of them married and got homesteads in the area. And the younger three also married. All the children eventually ended up in farming in the area.

They married young—one of them married at sixteen years of age. That was the way it was at the time. They were working children and they didn't go to school initially because there was no school here at that time. So my father didn't start school until he was eight years old.

My uncle was so distraught. He saw no reason for this. He was against what happened in Europe. The Austrians took the country (Ukraine) away—he did not support the Austrians. The Canadian government, with the War Measures Act, accused him of supporting the Austrians and that was the last thing he had in mind. A free Ukraine is what he was interested in and the land that he came for. He would have been fifteen or sixteen years of age when he left Austro-Hungarian Ukraine. He came here and he was accused of supporting the Austrian military when he was, in fact, dead against it. He just could not believe that he was an enemy alien seen to be supporting the German-Austro War.

It just didn't make sense and that's why he was so humiliated. And at the time you also have to remember that the Anglo-Saxon world frowned upon the Ukrainian people because they didn't know the English language. Their code of ethics, it was different. Ukrainian people stayed as a community together—they did not want to mix. They'd go to school and they didn't know a word of English when they started. The Anglo-Saxons were going to school and the teachers spoke with them easily and yet when the Ukrainians went to school—and there were a lot of them at that time—they didn't know the English language. It was very difficult for them to communicate in the schools. So, well, just to tell you an experience—my father went to Chipman School. Different teachers came there every year. Over a period of about eight years, his name was spelled eight different ways! He didn't know English initially so that when he pronounced his name, the Englishman wrote it, or I should say the Anglo-Saxon wrote it—some were English and some were Scots, some were different nationalities. What they heard, that's what they wrote.

The War Measures Act made a statement that anybody with a foreign passport, Austrian or a German passport, was a suspect immediately. It didn't matter what their contribution was or what their personal character was, whether they were an enemy or not. The fact that they had a passport that was not Canadian was considered "not supporting the allies." They were suspect. That's why my uncle went in as an internee, because he did not have a Canadian passport. Maybe the reason that happened was that when my grandfather died he hadn't yet registered his citizenship and the family didn't know about it. You had to wait five years to do so.

I didn't really think much about these problems growing up. In later years—after I finished school, after I finished university, and many years after—I started realizing how Ukrainians were regarded as a foreign

people in Canada. They were not recognized Canadian citizens in due form. At my job, and I thought my work was fully adequate, I wanted to get promotions. I got one promotion and a second promotion, and then my boss, up and told me, "Andy, if you want a promotion in the company, you have to change your name." That's when I started realizing, "What? Why do I have to change my name? I have done nothing wrong." It started to be really infuriating me at that point. And this is one of the things that led me to follow up on the Ukrainian internment because I had to change my name in order to get a special promotion, to be responsible for more people at work. That was humiliating to me at that time. When I reflected on how my father felt and how my uncle felt, I helped to form the Descendants of Ukrainian Canadian Internee Victims Association. One of our objectives was to get this story into the social studies curriculum in the schools and we have done that. We want recognition that this really happened during the First World War. The majority of people either are afraid to discuss this or they are reluctant to open this issue up. That's why we work quite diligently to get this story brought forward and to educate the public.

Yurko Forchuk

Interned at Jasper, Alberta
—As told by son Marshall Forchuk

You got to recall that I'm closer to seventy-eight than seventy-seven, so this began a long time ago. I was born in 1929. And when I first was old enough to know my father we were five children, five surviving children at the time. I knew that something was in his background because I was a nosy little bugger and I was always hanging around old people as they talked. I noticed that my dad was much more comfortable talking about experiences with some people than what he was with others. With some people he was extremely guarded and with others he was a totally different person. This is a poor part of the world at that time. This was during the Depression and so people did a lot of visiting. Under no circumstances was this a topic of discussion with just anybody. I knew that my dad was ashamed of something. I didn't know what. After some time, maybe in my tenth or eleventh year, I began asking my dad questions. There were people who talked as well and bit-by-bit, yes, I found out that Dad had been detained.

Being detained, being jailed is, can never be a happy experience, but being detained, losing everything you've got and not knowing why, except the fact that you know that you did not do anything wrong. My dad didn't do anything wrong. He lost his homestead; he lost everything that he had there. He was just taken and put to work in a

prison camp for twenty-five cents a day in the cold of a Jasper winter. It is cold in the Rockies. Even though he knew he had done nothing wrong, there was shame attached. How could he explain his five-year disappearance? It's a small community. It is a big country but it is a small community where they come from. Even now, almost ninety years later it still hurts me to talk about it.

Because it hurt my father so much—being accused and thought of like that. Like later: Was he a criminal? No, he wasn't a criminal. The public simply knew that a certain portion of our population was put, basically, behind barbed wire. It changed my dad a lot. It changed his politics, changed his outlook on life, but what it didn't do—and I can never understand this—it never made my father hate.

He never had hate. He had perplexion. Why, why, why? But he never hated the government and he never hated. There was a void in his life and it wasn't just the five years. It affected him all his life. It wasn't until he got to be a much older man and the public then sort of knew what had happened—accepted it as not a case of his having done something wrong, just a case of him being in the wrong place at the wrong time. That's why he got in trouble.

I know that there were many times when Dad would be asked to sit on the school board, be a trustee of this or that or the next thing, and he would almost always decline. It wasn't until the late thirties that he would agree to be part of anything, any type of establishment. I think that was because he was always afraid that if he sat on a school board, a co-op board, or whatever you have, that his past would be revealed and it might embarrass the institution that he was associated with.

It lasted. The jail term lasted a lot longer than five years. My dad escaped from the camp in 1917 and then hid out in the bush for the next two to two and a half years. He told me that he was sitting with a friend in a restaurant, near here, in Calgary, and because the Spanish flu was a big factor at the time, everybody was obligated to wear a mask over his face. Dad was conversing with a fellow detainee who hadn't escaped and had been released a lot earlier. They had just met on the streets of Calgary, went in to have a coffee, sat down and Dad pulled his mask down so that they could converse. A policeman walking by notices and logically—who are you going to pick up? Are you going to pick on the well-dressed businessman for removing his mask or are you going to pick on the most defenseless person going—whether they be Indian or Ukrainian or what have you? As long as they have two dollars. The fine [for not wearing a mask] was two dollars. So when the policeman chastised Dad and said, "I have to take you in to pay the fine for removing your mask," Dad said, "Well, you may as well know now, I'm also an escapee from a prison camp in Jasper." The policeman, of course, knew nothing about it, but Dad's friend then informed him. "No, George," he

said, "that was rescinded eighteen months ago." That was the first indication my dad had that he was no longer a wanted man.

Somebody has a reason for everything. I do the same thing that my dad always did. The Ukrainian word for why is "chuho." My dad used to say, "Chuho un a tasee a bella?" "Why did they do this?" And to this day I think, "Why did they do this?" Why do people do the cruel things? Why does government do the cruelties they do? Why, why, why?

My dad was somewhat smaller than I am. He was five foot ten, which was big in those days. He was a very stocky, healthy individual, and the other men used to kid him about being able to carry logs on his shoulder. He could pick up a log, fifteen or twenty feet long, put it on his should and virtually do a dog trot with it. He said, "This is the one thing they learnt me how to do in Jasper." He used to cut logs and carry logs. They had to make their own furnishings and build their own buildings. He was building bridges—the railroad was passing through, so trestles and bridges had to be built, which meant cutting timber—squaring timber, as we call it. The timber was round when you got it. You had to square it off. He also was involved—he used to later jocularly state—when people were impressed with particular government buildings—"Well, I contributed to building that." They worked very, very hard. He often mentioned that it was from dark to dark.

The winters there, as you know, Jasper is probably five, six, seven thousand feet above sea level. It would be extremely cold. My dad suffered in those days from what we called rheumata, rheumatism. It was a hard life. Dad came out of there, suffering from rheumatism. They would adapt as best as they could using what was available.

He escaped at night because they worked late at night. He just decided it was time to leave. The guards were armed and he ran away, as he often used to say, with "the bullets whistling through the trees over his head." He didn't know where he was escaping to. He certainly couldn't stay in the area. The Jasper area was very uncivilized at that time. So he spent time in the bush and later, at some stage, he had an alias—and worked in the coal mines around the Frank area, Lethbridge and Coleman.

Your question is, "What was his name?" What did he change his name to? Dad lost more than five years. He lost more than his homestead and the horses and the cattle that he had. He lost his identity. He had to become someone else because, even when he relocated later, in civilization he could not be the same person because he did not know who his enemies were. He had to be a frightened man. I don't know, to this day, I don't know for sure what Dad's original name was. I don't even know—and I suspect it isn't—if my name Forchuk is the name he came over with.

In my way and my belief, you can steal my wallet, steal my car, and I can get another. But when you steal my identity. When you steal my name, and I asked you before we began, "What is the worst thing the white

man ever did to the Indian when he came here?" When I say Indian, I am speaking of the people who were here before us. The worst thing they did was not taking their land because the Indians didn't "own" the land—he accepted the land for what it was. The worst thing we did as a "civilization," or lack of civilization, was to steal the Indian's identity. We tried to make him something else. We tried to make him white. We tried to make him be like us, and then to perpetuate this sheer stupidity we took their children and we put them into these schools with terrible teachers, into these terrible institutions, and we tried to make their children something else other than what they were. This is the greatest crime we have done to the Indians and it doesn't matter how many casinos we give them and it doesn't matter how many land claims we settle; we stole their identity and we knew that we were stealing their identity.

Nick Topolnyski, grandson of internee Yuri (George) Babjek.

[Sandra Semchuk]

Yuri Babjek and his brothers, John, Bill, and Theodore

Internment location unknown
—As told by grandson Nick Topolnyski

I have survived the war and spent almost three years in prison during the Second World War. Starting at seventeen years of age, the Romanians arrested me. Then I was held by Gestapo for ten months. I can empathize with the internees as a result. I have suffered detention, arrests, and abuses just like they did here. The thing is, they never expected it. They didn't do anything to anyone and they just fell victims of these horrible circumstances. That's what it is.

Four members of my family were interned during World War I in Canada: my grandfather on my mother's side and his three brothers. My grandfather was the oldest; his name was George (Yuri). I never

seen the passport but the pronunciation is "Babjek." George arranged for his next brother in age, John, to come to Canada. They were trying to avoid induction in the Austrian army. When they got together in Canada, they decided to bring their brother Bill. Bill was the family fighter. He was almost seven foot tall and a real scrapper. They brought him in and then they decided to bring the baby brother, Theodore. Just before the war started, they managed to get him into Canada.

I was four years old in 1929 when my father left for Canada. My father had been forcibly inducted in the Austrian army in 1916. He was a machine gunner, at the age of sixteen, shooting Italians on behalf Franz Joseph of Austro-Hungarian Empire. After having spent two years in that First World War, when Hitler began making his noises about another war, my father felt that he didn't want his family to live through the same difficulties again. He decided to go to Canada in 1929. He wanted to find a place for his wife, and myself, my brother, and two sisters here in Canada. Well, mother was supposed to sell the land at home in Bukovyna—house and everything but nobody's buying. Everybody was expecting the Soviets to march in anytime. And so she couldn't sell, and my father, he hit the Depression here in Canada and couldn't find a job. They couldn't sell out the way they planned to, so we got separated. He, in Canada. We, in Bukovyna. As a result, I grew up with my grandfather rather than my father.

The village was Kyseliv. Our house was a very modest three-room place. We were poor. My family could not afford to put me through high school in Romania so it was my absent father, who worked about only three months of the year in Canada, who still was able to send me some money to get me through three years of high school.

Well, grandfather had a beautiful home, larger home. And they had a boy that accidentally shot himself with a faulty Austrian army rifle. And his name was Nick. So they named me—when I was born—Nick. The grandmother insisted that I was to have his name. So I grew up with them. Practically every day I'd run over to Dido and Baba's place. Any time Baba needed something from the store, I would go for it. She liked my speed. I didn't walk. I ran all the time.

My mother would prepare dinner for him—her father—his three brothers, and their wives. They would come out of church on Sunday and come over to our house, [which] was next to the church in Kyseliv, and I would sit and have dinner with grandfather and his brothers. And they would talk about how good it is to eat that kind of food after what they had suffered in Canada in the internment camps. And they were saying that Canadians did not like them, our people, and that they went out of their way to maltreat them and insult them and so on.

Grandfather had gone to Canada to make some money. They were poor and there was a lot of work advertised. I think it was 1912. And so he decided to borrow money and come to Canada. Serfdom was abolished by

Maria Teresa way before the First World War—in 1845—right after the French Revolution. They had a little land of their own. There were four boys in their family and they felt that there wasn't enough land for more than one. So the oldest boy was the one to initiate something in the way of making money. So Dido, my grandfather, George, decided to go to Canada and try it.

When Dido arrived in Halifax he didn't have any money to continue travelling anywhere. So he was walking by a boat that was being loaded, men were carrying on their backs kegs of something—turned out to be bacon. Grandfather decided he could do that. Grandfather said one man was standing jotting down the number of kegs that were carried up the platform into the boat, so he made motions to this guy that he wanted to work. So the guy took his passport and wrote his name down and told him to go to work. So two days later, most of his skin on his back was gone, because he's carrying these kegs. You see, he was not dressed for that sort of work. But he worked. When they paid him finally, he thought he was the richest man in Canada. And he wrote to his brother and said, "Here is money for a one-way trip come join me. There is work here." And that was John. John joined his brother George in Halifax and then the two of them went into Ontario. They worked in lumber camps and then they proceeded to Northern Ontario. Of course, I was all ears when he was telling these stories. I was a nosy kid. I loved my grandfather. So when they got together, they decided to bring Bill right

away because they were only one year apart, you see. To avoid getting drafted in the military. And then of course, they decided baby Theodore had to come too. They sent him a ticket just before the war.

From listening, I understood that at that time—1912—before coming to Canada—Grandfather's family members were resigned to the fact that they were going to be forever poor if they didn't have some serious savings. There was no way you could do it at that time in Bukovyna. The country was overpopulated. There wasn't enough land really, too. Most of the better land was owned either by the church (the priest was the richest man in Kyseliv), or some foreign owners. Nobody had ever seen them. They lived in France or someplace, but they owned a lot of the best land. After being interned—later when my grandfather finally came back to Bukovyna with his brothers from Canada—they somehow managed to bring some money with them. He had sewn his dollars in his jacket and carried that so that they couldn't confiscate the money from him. So when he came back to Kyseliv, he was able to buy some of that land that was owned by these absentee owners. It was a beautiful land. And so did his brother. His brother Bill lived in the Okanagan Valley a few years apparently and he learned about horticulture. He loved orchards. And Bill, he planted a beautiful orchard on his land that he acquired in Kyseliv. They were good workers.

They said that Bill was very tall and they could count his ribs—he was so skinny.

They were afraid he'd fall apart! And one day after church, the men had a meal and a drink in our orchard by our house in Bukovyna. Their wives were sitting talking amongst themselves and doing the dishes. The men were reminiscing about their experience in Canada after eating the good food that Mother had provided for them. "How does this compare with what we got in Canada?" Dido asked. That was the reason they decided to return to Bukovyna. They would have stayed in Canada and sent for their wives here—see they were married at eighteen and grandfather had two children—but they were not treated well in the internment camps. They were not liked.

Grandfather worked all his life. He'd get up before the sun was up and he'll work until the sun was gone. He worked fourteen-hour days seven days a week. He was a very determined worker. And he saved some money from Canada despite the internment. It wasn't much but it enabled him to buy the land that made him into a kulak. When the Soviets marched into Kyseliv, my grandfather was one of the richer people in the place, and he was declared an enemy of the people. Everything was confiscated. He died at sixty-five, that young. They were so attached to their land that losing this land to—to go into the collective system—was their death. I was in Canada by then. I never was able to have any contact with them because of the Soviet isolation, the Cold War. We couldn't write a letter to the family. My brother was put away by the Soviets for twenty-five years in the Gulag. Our people were—because of their experience in the Western world—they were always suspects in the Soviet understanding of their control of the country.

Mikhail Danyluk

Interned at Castle Mountain, Alberta
—As told by granddaughter Florence McKie

This is the year 2006. I am sucking in the facts as I find them. Each time I do, when I breathe out, the story has changed. I have learned something. Tomorrow I will learn something new. It was my grandfather Mikhail Danyluk who was interned at Castle Mountain. There were a number of Danyluks in the book for Project Roll Call.[16] In fact there was another internee also called Mikhail. In my research, I was so excited because the archivists had said they'd found something. When the information came it wasn't Grandfather; it was a man half his age. Both were interned in 1915 at Castle Mountain in Alberta. It was something we didn't know in the family until the year the book *In the Shadow of the Rockies* was published.[17] I scurried to the bookstore to get it for my father because I always bought him the newest books about Ukraine or written by Ukrainians. I gave it to him before I had a chance to browse it.

On Christmas Day my father patted the sofa and said, "Come here, I'll show you something." He pointed to the list of internee names in the roll call at the back of *In the Shadow of the Rockies* and said, "There, there is your grandfather."[18] That was the first we heard of it as a family story.

I was stunned because we knew Banff. We lived in Calgary. It threw what was my sense of reality off. Hearing the story created a geographic shift in the understanding of my world. Once I did the research in the archives, I found out that they built the road to Lake Louise; they doubled the golf course at the Hot Springs Hotel; and they built the bridge over the Spray River.

Yeah, I saw the ghosts.

That was 1991, I think—the year the book *In the Shadow of the Rockies* was published. That was very moving. I have few stories to tell because my grandfather shared very little. My stories came from my father to us. I am the eldest in the family but he did share some with my younger brother as well. My grandfather must have been one of the oldest men there. He was fifty-six years old at the time he was interned. I never met him.

Grandfather was from what we call western Ukraine ruled by Austro-Hungary, close to Chernivtsi, in a village nearby. He helped build village houses. As the family grew, they built the next house. Dad had a natural instinct for carpentry as well. Grandfather built their house. Of course, in his earlier trips to Canada, the money Grandfather sent back from Canada allowed my grandmother to purchase less swampy land. She hired carpenters then. So that money from Canada was very, very significant. There were nine children, one of whom, ironically, was in the Austrian-Hungarian army, at the time.

Grandfather was, I think, unusual in that he was on his third trip to Canada. He had come previous years and then came in the spring of 1914. He was sending money home. He worked in the mines. He wasn't

farming. He was rounded up and imprisoned in 1915.

Grandmother miscarried—she was carrying their last child—shortly after Grandfather left for Canada this last time. So it was very, very difficult for the women, and that is a story that is hardly told at all.

Grandfather was released when the Castle Mountain camp closed in July of 1917. The internment camp was built on a swampland, and the officer in charge was appealing to Calgary and to Ottawa, saying, "We cannot possibly bring the people here. This is swampland." So they had to relocate the camp further down to what we know as the site. I'm sure you've come across the research: the men arrived on July 14, late at night, marched through to the camp, and the next morning they were given shovels to start digging the road to Lake Louise.

My father told me that his father told him about hearing shots in the night. Someone had tried to escape. They had no way of knowing whether he had been killed or whether he had actually made the escape work. They never saw the person again.

I think he was in the Crowsnest Mine. This is speculation—I have no way of knowing for sure, but his name is entered as arriving at Castle Mountain Internment Camp in 1915. The reason I believe he was is because I know Grandfather was re-hired at Crowsnest Mine when they were closing the camps. He was asked for by name. The employers came to the camps desperate for labour. In a way that—the desperation for labour—may have worked for my grandfather and other internees, who were released at that time, because they were either dismissed—they weren't given jobs... when the camps finally closed, or they were simply released. And again, where would they find the work? They would be on their own. We know that in the area there was that resentment of Eastern Europeans taking jobs from Canadians.

My grandfather was indigent for a long time as well as working in the mines. Even with employment in the mines, he didn't get back to the old country until 1922. It took him that long to save money to be able to make the return trip.

My father tells of working in the fields in Bukovyna, near their home with his brothers. They saw this very gaunt tramp coming across the field towards them. He collapsed in their arms. It was their father. They hadn't heard from him for years. They had no idea what had happened to him. They knew he had been interned. They knew that the internment camps were closed. They had no way of knowing where he was. Somehow he made his way across the Atlantic to Gdańsk. He walked from Gdańsk and hitchhiked with wagons or whatever to get south through Europe to get home.

I have been active with the Descendants of Ukrainian Canadian Internee Victims Association because this story has to be part of Canadian history and education. This story is a piece of history that connects with everything else. Without this story, history

is incomplete. This history has the potential to be very, very constructive in, certainly in the Ukrainian communities, but also in many ethnic communities. It is important for all Canadians to say, "We did wrong."

I think for the younger generation it's an important story in that it shows that we're not infallible—that being a human being is difficult. I don't want it to be said that we learn so we won't repeat the history because we'll never get that far. I think each generation faces a different kind of problems, yet ironically the same undercurrent of problems, of how to deal with many people with their differences and their needs. It is, I think, an excellent example of a decision-making process, that if properly dealt with in the school curriculum—probably in social studies is the most natural place—that gives examples for the youngsters to analyze, to see and to understand why the internment occurred. Not just that it occurred and that it was wrong, but that there is something to be understood about the process of making decisions.

Frederick, Hilda, and Fred Jr. Kohse

Interned at Nanaimo and Vernon,
British Columbia
—As told by son and brother Gerald Kohse

My mother was British and my father was Prussian. He was raised in East Prussia and there, the wealthy people, they owned the land. Those who didn't own the land were simply expendable, I suppose you would say. When he was a young kid, I think they had it pretty rough going. They had maybe a hectare of land or something like that, and that was not enough to raise a family. You see, they had a system there, where the people who owned the land would always leave it to the oldest son, and that would go down the generations. Eventually, the land would be in very, very small plots, which were not sustainable. My older brother Fred was a baby. My father had this business of boats in Victoria renting out boats and doing jobs with boats and all this sort of thing. When the war came along, everybody knew he was German. He soon found that there was a policeman posted outside his place, so nobody would come near him or his business. So my father says, "Well, the boat business is over and done with, so I'm going to go up to the head of Bute Inlet." It was isolated. He had been up there on hunting expeditions previously. He said, "We can go up there and stay for six months and the war will be over and that will be it." So they loaded a boat up with provisions and set sail. He went and asked the police, the chief

of police first, "Is it okay if I go up coast?" "Oh sure, no problem." Well, he got up as far as Union Bay I think it was and the police sent the only cruiser they had on the coast out to hunt for him. They spent several days looking around and finally found him. They arrested him, put him in jail in Union Bay, south of Courtenay. And then he was put in a holding camp was at the head of the Gorge.

My mother rowed a boat up the Gorge with the baby, Fred, to join my father. She chose to be imprisoned with him rather than be alone with the baby. So somehow they all got transferred to the Nanaimo jail. The Nanaimo jail had a big fenced-in compound around it—I've seen some pictures and those papers.

I can remember my father saying that where their cell was it was right next to the office so they could hear what went on in the office. One day the Swiss consul came in; he was looking after German affairs in Canada, and he inspected the camp. Then the Swiss consul came into the office and was talking to the commandant or whatever you call them, the head guy. He said, "You know you have treated me very royally here. You have wined me and dined me and everything but I have to send in a report and in my report I have to put in that you are keeping prisoners of war in a common jail and this is against the Hague Convention."

Just like that the prisoners were shipped up to Vernon. Yeah. The concentration camp was right in the heart of town of Vernon. The town has built up all around it, but

Certificate of release for Hilda Kohse and child, 1920. It says that she is a subject of Germany. Her husband, Frederick, was Prussian. She was British.

[LAC, Custodian of Enemy Property and internment operations records, 010775957]

when they were there it was just out in the open...Their place to stay was just a wooden floor with a tent pitched over it. Gradually boards were brought in and it became a shack. And the tent rotted, and ripped, and flew away—that sort of thing—as tents do.

They lived in these huts in the internment camp in Vernon that were side by side. People named Holdorf lived on one side and Rosentrader was the neighbour on the other side. Each of these hut people—they were all families—had a little plot of land where they could grow a garden. One of the things

that my dad mentioned was in that camp you could run across people from every walk of life. If you wanted to learn how to speak Russian, there was somebody that could teach you Russian. If you wanted to learn to speak Spanish, there was somebody that could do that. If you wanted to learn how to brew beer, there was a person who knew how to do that there. My mother said that one of their close friends and neighbours was a man that had been a professional baker and he taught her how to bake bread. And she learned how to skate.

There was another "person" who wasn't a prisoner—he was a raven. Well, apparently this raven got injured. I don't know if the wing was broken or what it was. They caught the darn thing and fed it. Somebody there who knew quite a lot about birds fixed it; plastered the wing together and splinted it and all that. Clipped the other wing so he couldn't fly away. So the raven became quite a centre of attention—I mean it was an item. And this internee also loosened up the tongue of the raven, so the raven could speak German.

One of the neighbours, Rosentrader, threw things at him. And the raven had ways of getting even [*laughs*]. Now this gets really involved and when you stop and think of it. It is very intriguing. My mother was saying—and she could use her voice to imitate these people—that, one morning, real early, just at the crack of dawn, she heard this voice outside, "Frau frau frau Rosentrader," and it continued on until

finally Rosentrader came out, threw something at him and he flew away [*laughs*]. How would you program a raven to do that? Rosentrader went out one day and transplanted onions, or something like that where you had to take little plants and put them in, nice straight, perfect line, everything just so. Just perfect. He gets all these things in, gets finished and goes in. After awhile, the raven comes along and pulls each one out just like that and lays it over on its side [*laughs*].

Then Rosentrader went around to the rest of the people in camp to sign a petition to get the raven put down. They told him, "If anything happens to that raven, you better watch yourself." Because the raven, well, he'd take the part of a TV character today, you see. Because remember in that camp they didn't get to read newspapers until the papers were at least a year old. I think everything that came in that they could read was carefully censored. If it was anything touchy in it, they didn't get it; like books and stuff like that, it had to be approved by the censors. So remember this is in a time when there is no radio, there is no TV, certainly no movies, and then your reading material is censored and of short supply. So a thing like that raven would be a source of entertainment.

If my mother wanted to mail a letter, she had to go to the office and present the letter for the guy to read it. In fact, my mom did write a letter and they threw it in the wastepaper basket and that was that.

One day, after the war ended, Mother was out with friends in the compound, in the Vernon camp. This lady on the other side of the fence was playing tennis. She tossed a ball over the fence to my mother and my mother picked it up and there was a note in it. Mother read it and scribbled something on the note and threw it back. And they developed a, you might say, a friendship, by tossing notes over the fence.

My mother wrote a letter to the minister of justice. The war had been over for more than a year and she noticed that they were building all kinds of new housing around the camp. It seemed like some of the guards and that the internees were going to be there forever. So she wrote a letter to the minister of justice wanting to know why they were still in jail when the soldiers had gone home—the war was over. It was 1920. She rolled the letter up and put it in the tennis ball and tossed it over the fence. Then she asked this lady if she would mail it for her. My mom said to her, "You can read it first. And then if you don't like it, don't mail it." I guess that lady on the outside did mail it because apparently when they were released the guy that did the office, snarled at her, "How did you get that letter out?"

I remember my mother saying that when they finally left the camp in 1920, they were loaded onto the back of either a truck or a horse and wagon with all their belongings and away they went, down to the train station. And the raven, the raven went flopping along with them. And when they got off, and got ready to get on the train, the raven turned around and went back to camp.

My brother Fred literally grew up in an internment camp. He was six when they left Vernon. They went back to Victoria after they were released from the camps. They had a float house when they had this boat business that had been looted and vandalized and whatnot in their absence, but they patched it up somehow or the other and got back into it.

Metro Olynyk

Interned at Lethbridge, Alberta
—As told by son Fred Olynyk

My father helped found a community. Well, from the beginning I believe that they called it the Six Mile community. Afterwards they gave it the name Mount Cartier community. It was located south of Revelstoke in BC. It was settled with Ukrainians mostly. Some were Polish but the biggest majority was Ukrainian. It was a nice community. The people got together.

My father was in an internment camp when I was born. I remember living with my grandfather, my mother's father's place. My older brother was a baby.

As kids we didn't know much about war or anything. We were living our life the same as others were living theirs, you see. It was later on in the years, when he came home, that my father would break out and tell us about some of the experiences he had during the war. It had become law that you had to register yourself and you had to. If you had a job, you had to notify them every month that you were still there and what you were doing. He had to report back that he was still around. That's how they kept track of you.

He was interned in Lethbridge. He spoke of how they were working for the farmers during the harvest time, how they stooked grain for the farmers to make a dollar. Whatever the farmers decided, they would pay their workers, that's what you got. There

was no difference between one farmer and another farmer. Do what the farmer said. It was a very small amount.

It was the end of the war when they let them go. But I remember him telling us that him and another fellow walked all the way from Lethbridge, and they went through the Kootenays because they mentioned that the best treatment that they ever received was through the Kootenays, going through Doukhobor country, up in through there. They never refused to give you a meal and that, so he says they were good people, he says, "A lot better than a lot of the people before we got to the Kootenays." I think three of them started out but one stopped along the way and worked in the coal mines and just the two kept coming back to Revelstoke. Whether his partner, after they got out of the Kootenays, stayed around there maybe or whether he came on, I'm not too sure. But my dad kept on coming until he got back to Revelstoke.

My father said at the time they were angry but then they realized that being angry didn't help you so you just took it as it came—as though it was what you were supposed to do because if you tried to skip out, they would find you anyhow.

Well, I guess, in a way you did learn that there were different types of people living in the country. Then, when the Second World War came, you saw the way they treated the Japanese. Then you knew that there is something wrong. The Japanese are people too. A lot of them were born here and they put

them into camps. So it makes you wonder sometimes. We like to think that this country is good, but sometimes it shows you that you are wrong. In Revelstoke, they had these Japanese camps, internment camps. Some of them moved around after, but a lot of them stayed in Revelstoke, found jobs and they worked, stayed there. A lot of us, we were friends with them. They were friends with us. Nobody ever talked about it—we just let it lie. Silence.

What you learn from your father being one of them interned in the First World War, you learn that the people that are interned are just as good people as you are.

Yeah, I remember that the people in that community would often tell you that Ukrainians were regarded as bohunks on jobs or any other place. If they did get a job, it'd be the job that other nationalities wouldn't want to take. You were a lower class than they were. When you look back at the thing, sometime you say, "Why do people treat people that way?" I think, I think that at times people think they are better than others. That's the treatment. I'm better so you're below me. My father taught us, "Don't worry about that. If you get a job do your job. The company then has to make a decision whether you are a good worker or not, and keep you on the job."

We were taught that we were no better than the next man. Equal. Anyone else has got as much right to live on this planet or this world as I have, regardless of what race or religion he is. We all lived through it. We lived through it because that's how we were taught to live, through times like that.

Like they say, you closed your eyes and said nothing. And abuse, you just let it ride. So they called me a bohunk, so I'm a bohunk as far as you're concerned. But as the years went by, we proved that we were just as good people as the others. You had to have patience. The anger would come out when there was nobody around you but not if you were with that bunch and you were being treated that way.

You had to grow up fast. And a lot of them say, "Well, you seem to be well educated." And when you tell them that you never finished grade seven because you had to do chores, they say, "Oh that's foolish, you should have kept going." Well, you couldn't. Twenty-five cents: if you had twenty-five cents in your pocket, you were a rich person in them days. That, if that was to happen today, there would be a lot of people that would never survive it—the way my age were surviving back then. It could happen.

The good thing was everyone felt he was important, right. You had a job to carry out, whether it was going bringing the cow over to him to be milked—one of us, the older one would always be the milker or something else on the farm. There was that type of stuff because your dad was always out trying to make a dollar someplace. You were important to help the family survive.

Maksym Boyko
*Interned at Petawawa, Ontario, and
Spirit Lake, Quebec
—As told by son Otto Boyko and daughter-
in-law Kathleen Boyko*

My dad was interned at Petawawa and at
Spirit Lake. His name was Maksym Boyko.
He was walking home from work in Ottawa
during the fall of 1914 when two police offi-
cers confronted him and arrested him. He
was forty-two at the time, unmarried and
a carpenter. He had come from what we
call Ukraine in 1911. He had done nothing
wrong. He wanted to be a Canadian.

When I was ten, eleven, and twelve, Dad
and I used to go fishing in the Saskatchewan
River, and of course when you're waiting for
a bite there's lots of things to talk about—

a lot of time to talk. We used to play cards
also, in the evenings.

Dad liked to talk about his military ser-
vice. We always thought that because it
had come up that he had been a prisoner of
war, that maybe he was picked up during
the fighting, during the First World War
and then sent to Canada as a prisoner and
then released in Canada. He was always
calm; he was never gruff or sorry. I don't
think he held any animosity toward any-
body for what happened to him. I never felt
that. Maybe he never showed it or wanted
to show it. He spoke of two cold winters cut-
ting trees. He spoke about his watch that
was taken away. Well, we never knew that
he was picked up and held here in Canada.

I remember one day my dad brought us
all into the house—it was just as the second
war was beginning. And he said, "Look it, if
you see somebody coming up to the house
that you don't know, or who is not one of
our neighbours and he is approaching the
house, we want you to come quick and tell
us that somebody who we don't know is
coming to the house." Then, I could never
understand why he would say that. It didn't
make sense. Now, I feel that it's probably
because he was afraid that maybe they were
coming to get him again.

The only way we learned about the actual
location of his internment came in the early
'50s from my kid brother. While my older
brother and I joined the army when the
Korean War was on, he was sent for training
to Camp Petawawa. And my mother says,

"Oh that's where your dad was, was held in internment camp there." From Petawawa my father was transferred to Spirit Lake.

It's quite comical in a way because like I say, my brother, before he went to Korea, he was telling me how he had to get up at two and three in the morning and stoke those cold fires in Petawawa because the wind was blowing into these tar paper shacks [*laughs*]. We didn't know at the time that our dad probably had something to do with building these things [*laughs*]. And here is his son complaining about it. I find that really comical.

He was arrested sometime, well, shortly after the war broke out. We don't know the exact date. Possibly September, October. So that would have been the fall probably of 1914 and the winter of 1915. So we felt that possibly, if he talked about two cold winters, the winters aren't really that cold in Petawawa. He probably spent the early part of a winter there. The internment camp opened at Spirit Lake in 1915. I believe it was in January, I'm not particularly sure, but he was probably sent there and spent that portion of the winter there and then also the winter of 1916 in Spirit Lake.

This wooden hook—it is a hook that my dad used to hook mitts for us kids. My sister, who is older than me, asked me where the hook was and I said that I had it. She said, "Well do you know it's the hook that your dad used in the internment camps?" Apparently, he hooked mitts and boot inserts for the prisoners there. He was up

in Spirit Lake and it was very cold and they didn't have the proper clothing. So they made do with what they had and what they could fashion out of what was available for them. I didn't know about the hook until my sister told me about it. I didn't know the significance of it. But it goes back into the history of the internment camps in Spirit Lake and his internment there. It's one of the very few things we still have from him [*crying*]. Some of the things that he cherished, that he told me about a pocket watch that he had, which was seized from him when he was arrested and it was never returned [*chimes ringing*]. He prized this watch and I know that it meant a great deal to him because he always mentioned it. When he came over to this country, he brought a satchel with clothing and this watch. We know that he had forty or fifty dollars on him when he came and that's it. Oh, and his leather coat. Yeah. It was very thick, heavy leather. I still have it downstairs. And when he was released from internment, he left with only his clothes. The things that were seized from him before were never returned to him.

Well, we were so young when our fathers were around. And you don't get a chance to talk or discuss the things that he has done. I knew a lot of the stories, at the age of ten or eleven, but you don't really have any in-depth questions to ask, "Well, where did you get this watch and why, why did you do this? Why did you do that? How long were you interned?" We never asked those

questions. That is one of the things that really hurts.

When he was finally released in 1916, one of the conditions was that he was not allowed to take out Canadian citizenship until ten years after his release from internment. That very day ten years later, when we checked on his naturalization certificate, is the day that he was issued his naturalization certificate as a Canadian. A lot of them left the country, but my dad stayed here and persevered—just like Anne Sadelain's dad, Vasyl Doskoch, stayed and persevered. They built a nice home for themselves. They were nice families. If those people who made negative comments about Ukrainians during World War I came back to see the contribution that the internees and the descendants of the internees made to this country, they would probably have another change of view. I think in our family, the last time I counted, we had something like three hundred years of married life between all my brothers and sisters. My oldest brother was an architect. The next brother had a construction company. My oldest sister had an antique store and then she got to be an auctioneer, believe it or not [laughs]. I served twenty-two years in the military. Twenty-one years with the RCMP. My youngest brother has a degree in electrical engineering. There's a lot of good that came out of, my dad staying in Canada, instead of going back.

I have tried to do my part. The Ukrainian Cultural Heritage Village, east of Edmonton, never really had a monument for the internee people there, so I wrote a letter to the minister and said it would be a good idea because of the thousands of visitors that are there. I found, when I was doing my research, that when I asked a lot of young people of Ukrainian descent to tell me about the internment only one out of ten knew what happened during the First World War. So I know that there's probably fifty or sixty thousand visitors come to the Ukrainian village each summer. It was great place to erect a plaque and a monument showing what really happened. It has to be told…and that is what my wife, Kathleen, said: "Hey this is the history of Canada."

William Sharun

*Interned at Fernie and Morrissey, British
Columbia*
—As told by son Lawrence Sharun

Dad came from the part of Poland that was
part of the Austro-Hungarian Empire prior
to the war. Yeah, he came there in 1913, just
before the war. So he worked for a while in
the mines at Coal Creek. Oh, many of them
were forced to leave. At that time Italy was
on our side of the war; they were allies in
the war, so they formed the home guard and
it was all the Italian guys in Fernie that put
all these other Ukrainians and Poles and all
these guys in the internment camp.

Poland—a part of it—they belonged to
the other part of the world—the Austro-
Hungarian Empire—so they were basically
the enemy, whether they liked to be the
enemy or not. Dad knew when he left
Poland that there was probably going to be
a war in the future, or in the near future,
you see, but he didn't know how that would
work out actually. He used to work in a post
office in Poland, you see.

The postmaster said, "You better get out
of here." "Right," he said, "If you're smart
you'll go." And he went. He didn't even tell
his parents or nothing, just took off and
went. He just came here and that was it. He
had saved money up, and he came, and that
was all there was to it. So he came to Canada.
They were looking for new immigrants at
the time and miners and everything, so that
was how come he got here. I'd say he was

about eighteen. When he arrived in Fernie,
he didn't have any money so he slept in
the bush for one month until he got paid.
Yeah, he was pretty tough actually. I've got
his naturalization papers and stuff. Look:
1896, that's when he was born, 1896. Right.
Poland. Right. Koniuszkow Brody. That's the
second part.

When I was about ten Dad took me to
where the camp at Morrissey was. After
the skating rink that was where he was
interned. We still had the '28 Chev and there
was still a few buildings sitting around
there. They are in the process of tearing
them all down actually. I remember there
are two old hotels there and a person bought
them was tearing them down. He would
be selling all the lumber off them build-
ings to different people in Fernie, because
they were either building houses or making
improvements to their homes.

Dad was more interested in the build-
ings, that's all. Internment was put out of
his mind completely, see. He never talked
about it much, but he said they did the work
on the road on the main street during the
internment. Internment, yeah, that was a
city project, see. That's what they used to do
all the time.

The old skating rink. That's where they
put all the prisoners in there. There was no
toilets in there or nothing. I guess they had
running water because they had to make
ice there, so they must have had running
water but there was nothing else there. That
is where they kept them, down there. You

figure, you had that many people in that skating rink. There was nothing there. So all living conditions were very poor actually. I think they were given a blanket and that was it. See, at that time they would be marched up to Victoria Avenue, which is 2nd Avenue in Fernie now, that is the main street, and they were just putting new cement on the road. The street was just getting fixed up, you see. So that was their job: level it, haul rock, and fix it, and get ready for the cement as they were pouring cement. In them days, they just had wheel barrels; that's how they moved the materials. It was a big project, actually, from the Central Hotel right down to where the old Fernie High School is now; it's all condominiums in there now. All that was, that was all cemented, you see.

I don't know how long he was interned for but it was quite a while, and in the end, you see, they let them all go because I guess somebody finally came to their senses, because there was a lot of manpower being wasted actually, you know. The prisoners, plus people had to feed them, plus the guards that had to look after them—all that is wasted money actually.

So when they released him, they give them some kind of a card. They had to report once a week, you see, to the police. And so my dad, he threw that thing away—so he told us—and he went and got a job coal mining in Corbin. Up there they had a big mine—they call it Big Shoal—the whole mountain is just about all coal so it wasn't underground mining. That was the first strip mine basically in western Canada. In them days, they didn't haul it by truck because they had all these tracks back and forth. And they used to drill what they call cayoot holes, so far in the mountain. They'd dig them out like this, six by four feet, dig all the coal out, and they'd load that up with dynamite, and then they'd blow it. The shovels were loaded in these carts. That was run by, I think, Spokane International, out of Spokane, see. In them days, when they worked in Corbin they used to get paid in American gold pieces. That's how you got paid. He stayed right to the end of the war.

Dad said his family in Poland, they were all killed during the First World War. Yeah, outside of the sister, they were all killed. She was the only one who survived but she never came. Yeah. There were a lot of people wiped out in that First World War too. Just like in the second. Same thing. Like my dad said, where they lived, well, war goes back and forth there all the time.

He continued to live in Fernie. He liked working in the mine, so he says. And then after that he just figured it was about the best place to live from everywhere, because he used to, he worked in Lethbridge, he worked in Nobleford, and Foremost and all them places. He says he worked in the mines; the climate is always the same temperature. You know, it's never too hot or too cold. It's always the same. Oh yeah, after, as soon as they got out, they went back into mining and everything carried on. They just

crawled in a hole and were sort of ashamed of the fact that they were interned. They didn't bother to make any waves or nothing. Just carried on that way. The hole at home, see. Yeah, you just come home and you just were out of circulation. You just didn't bother mixing with too much, see.

Their kids were sort of forced to mix, actually. Because you go to school and you have to do it. That's all. What are you going to do? You're sent to school and that's where you'd be. So you'd participate with them—do class work, you know.

They did the same thing to the Japanese. In the second war they did it to the Germans again. A lot of German people were interned in the Second World War, too. See—my sister-in-law's father, he was interned in Creston. He was interned in the Second World War. They moved everybody from the Vancouver area in the Second World War, all the Japanese; well, I guess they were scared that the Japanese down there were going to attack us or some bloody thing. The Japanese actually developed the farming industry here in Lethbridge to a big extent. The potato growers and corn growers and stuff, they were all good at what they did.

Harry Levitsky

Interned at Cave and Basin, Banff, Alberta
—As told by step-granddaughter
Donna Korchinski

Total anger. I feel, what an injustice that our people, our Ukrainian people, were not free to speak about this horrible thing that's happened to them.

I found out about it by accident, I think, because I was the president of the Ukrainian Professional Business Federation, a national federation. And I started learning about this and I thought, "What? What? You mean they did this?"

I didn't even realize that a relative of mine was involved here, interned. I was telling my parents about it and my dad says, "Yeah, your dido was there." And I said, "What?"

I remember my brother Richard said that when he was around ten years old he asked Dido, "What did you do during the war?" And Dido said, "Oh, I was an engineer in the mountains," and that's where it ended.

I was outraged. Then I started. I'm a voracious researcher. So I went to the library, to the Glenbow Foundation in Calgary. I was going through every document I could find and thought, "Where is it? Where is this name? Where is he?" By then my grandfather was dead so I couldn't go interview him. I'm a journalist and I want to know everything. All of a sudden I realized it was my own family who was there. This was surreal. Surreal would be the only word—the fact that I did not know about it. Then the

outrage. Why wouldn't he talk about it? Of course he's not going to talk about it, because he was ashamed. Or he wanted to put it out of his life and go on as though it didn't happen...no matter what, no matter what, the injustice, inequity of this whole thing was wrong. No matter what.

After the war was over my father told me, "Dido just didn't talk about it," but later Dido said, "You know, I was supposed to get paid." It was, I can't remember twenty-five or fifty cents a day. It was something. He said, "I never did receive that money." And so he asked my dad to write a letter to the government. So my dad wrote a letter to the Canadian government at the time and received no reply; no money; nothing was ever received; nothing. It was as though it didn't exist. So I guess, and then I learned later, as a reporter, out of sight out of mind— didn't happen. The same thing with respond- ing to my father—if you don't answer, then these people will go away. You have to realize Ukrainian people were not as aggressive. They would not have persisted as people do today. They would have not written a second letter and a third, "Well, I haven't heard from you." And call long distance, you know, dial the old phone. They would not have done that. They would have not called upon the government to make good on this or to say, "Hey, look what you did." You don't really realize what influence the British might have had on that silence. So there are all kinds of undercurrents that go back and forth.

Ukrainian Canadians are a dignified people. And they don't want to ruffle feath- ers; they don't want to rock the boat. Call it what you like. They don't want to offend the government. They have a great deal of reverence for government and respect. Now, is the opposite true? I don't think so. I think basically in Canada there is underly- ing current of racism. "What do those crazy Ukrainians want? All they do is eat pero- gies and dance in those costumes—that's all they're good for." They don't understand the soul of Ukrainians. We, like many other eth- nic groups, have come to this country, have built this country, have worked, and are still continuing to work to make it a better place for everybody, are still not appreciated at the same level that maybe a white, Anglo-Saxon Protestant is. I feel that. So how do we get past that?

Well, we believe hugely in education. We make sure that our children get really good education. When they get that edu- cation they can be leaders, and we've seen that across the country—we're beginning to see it. But we're still on the fringes and until we are the central part, the heart of the country, of the government, of the rul- ing class, we are not going to see a genuine apology. One that really means I'm sorry. One that really means from the heart, not just the words, "I'm sorry that your govern- ment did this to you and your people." And I think that's an underlying thing that we have to do. We have to prove ourselves con- stantly in this world that we're just the same

as everybody else—that you don't have to be racist towards us. We don't have horns growing out of our heads. We're just ordinary folks. I want to see a full public apology in Parliament, but I don't want it to be a phony one—just words to make the prime minister look better or make the government look better, make others think more highly of them and get votes, or whatever. I want a genuine heartfelt "I'm sorry." I want them to see that. I actually don't want an apology until they can do it that way.

The whole story of the internment needs to be put into our schools. The whole story—it needs to be part of the curriculum, in the textbooks. The people to do it are we, as descendants, that's our job. It needs to be done and there is money now (with the Endowment Fund) to do some of it. It needs to be part of the curriculum in the schools. It needs to be a course in university. It needs to be part of understanding ethnicity. Wherever we get an opportunity, we need to speak about it. I think education is the only key. Education.

In some ways, it was a healing experience for me to go right to Castle Mountain Internment Camp. When we go to any of these sites where our kin were interned, we use the healing power of mother earth. We connect with her and she helps us to forgive in our hearts. We can't expect other people to help us get rid of our pain. We have to get rid of it ourselves. It's like saying, oh, you go to a doctor and you say to her, "Please fix me." Well, you know what? You've got

to fix yourself. In the Ukrainian community we have to fix ourselves. We can build on the positive. And if we build on the positive, then the outside community can build on our foundation because we're creating a foundation.

I sit down with Japanese Canadians and talk with them about their story. I've heard wrenching stories from Vietnamese. It would make you cry. They escaped—one of my husband's friends escaped out of Vietnam. His family all got shot. He hid under a wagon and he could see the blood of his family was flowing down through the boards of that wagon. He got freed. We're not the only ones who suffered. We need to realize that and we need to come together. That is what makes us more of a solid Canada. We can't just dwell on that. We have to say, "Okay, what's good about this? What's good about this country? What's good about the relationships we have with all ethnic groups and within our own community?" I think we need to go to another level of education.

I don't think we'll ever understand what our forefathers went through by coming to this country from a repressive regime under Austria-Hungarian rule—from having to be torn away from the families to come to a better country. But then they come here and they get this. The pain must have been unbearable. We're not the only ones. I mean 'twas ever thus. Look at how many other groups, ethnic groups, and you could keep on mentioning them on and on: the Chinese

people, the Japanese, and nowadays the people from the Middle East, the people still from the former Soviet Union. From Serbia. All over. First Nations in Canada. We were not unique is what I'm saying. Maybe that kind of inner strength has to come through and that's what makes a Canadian. That's what makes us, because we've got land aplenty. Here we are. We've come from repressive countries. We came here for a reason: for a better life. Our ancestors came for a reason: they wanted a better life for themselves but not just for themselves; for the children; for their grandchildren, great-grandchildren, great-great grandchildren, and down the line. But ours was not unique and so I don't think we have to say, "Well, look, poor us." I don't think we need to dwell on that.

We will teach all Canadian children about this, but we will no longer be thought of as victims. When you are a victim that energy stays with you and everybody treats you as victim. Well, quit it. We have to quit being victims. We have to start taking charge, empower ourselves. We have to be in charge. We will deal with it. We cannot be victims anymore.

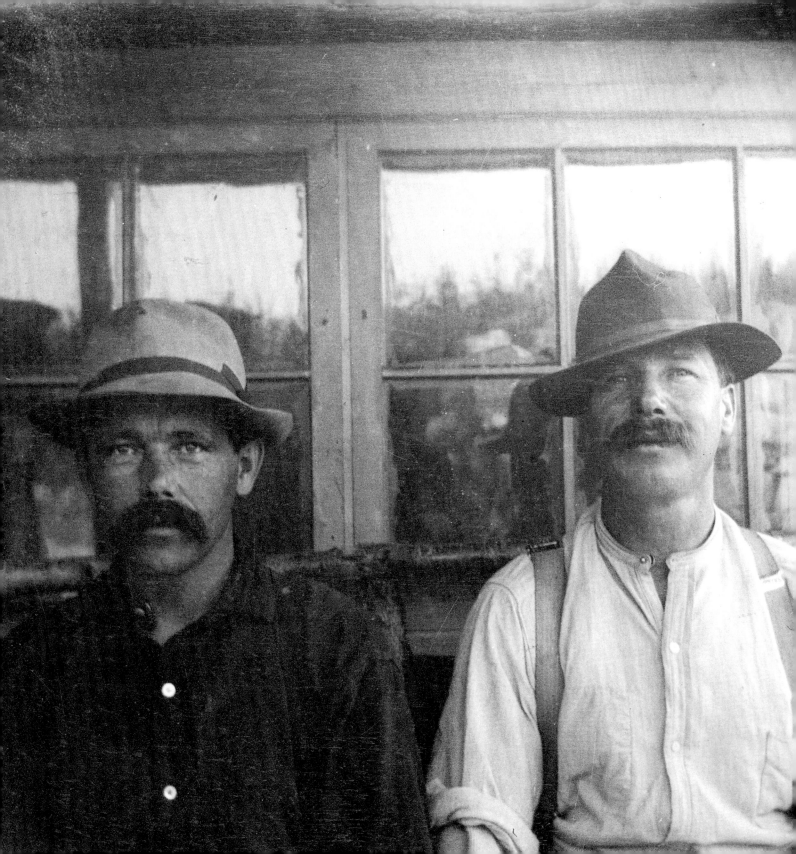

4 Spirit Lake Photographs

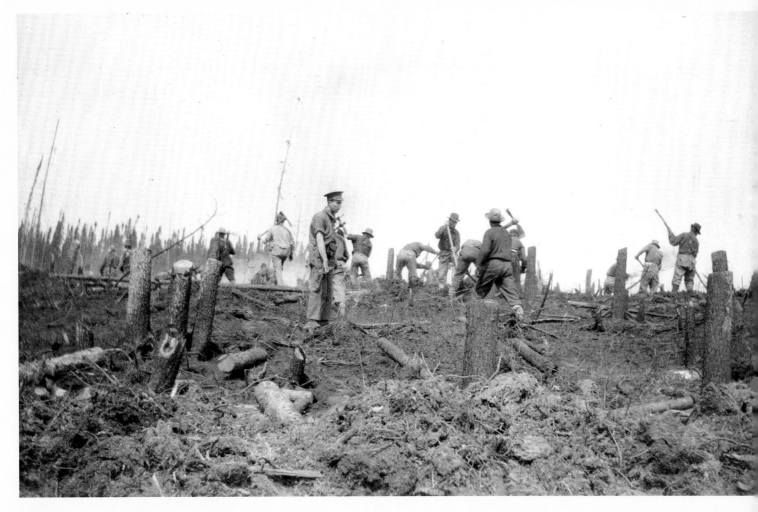

< Portrait of two internees.

[LAC PA-170451]

^ Internees clearing wood under
supervision of guard.

[LAC PA-170424]

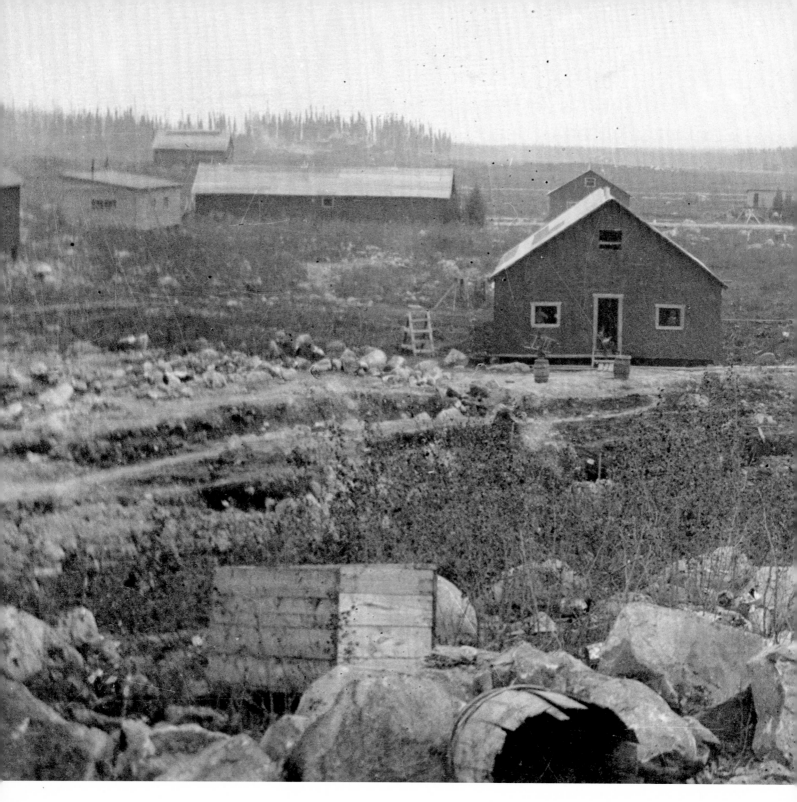

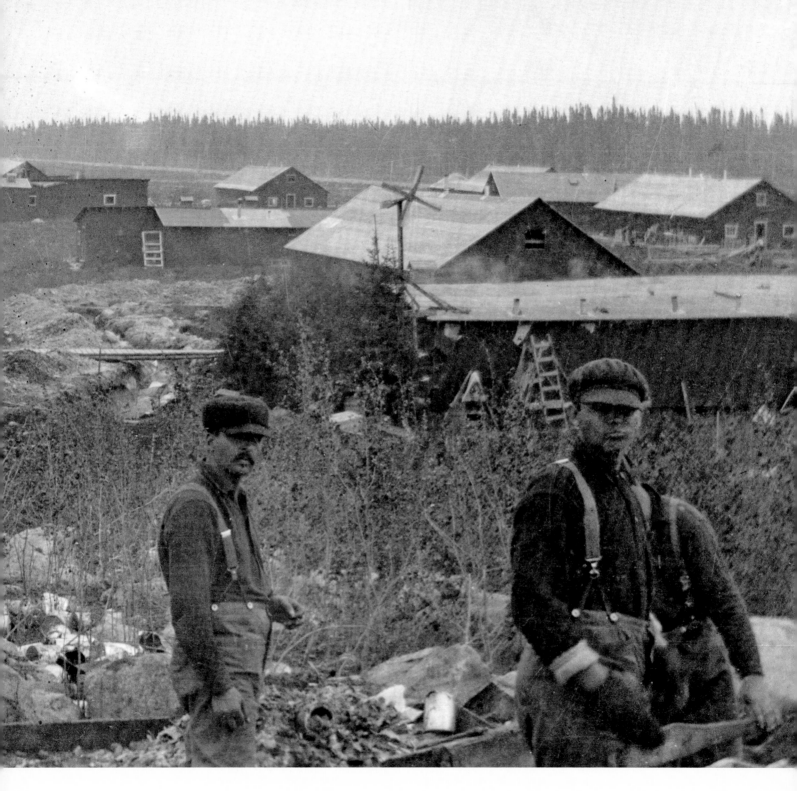

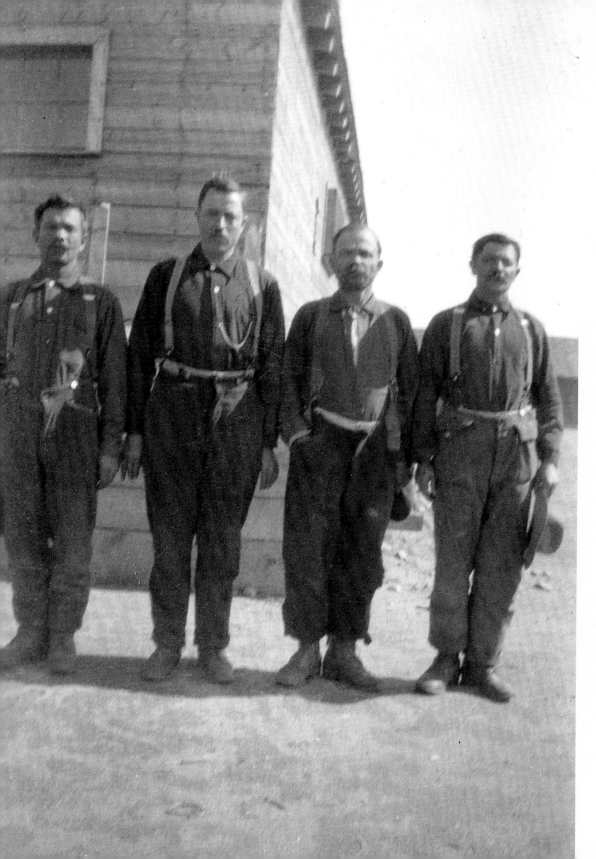

< Pages 158–59

Internees and barracks.

[LAC PA-170435]

Recaptured escapees.

[LAC PA-170493]

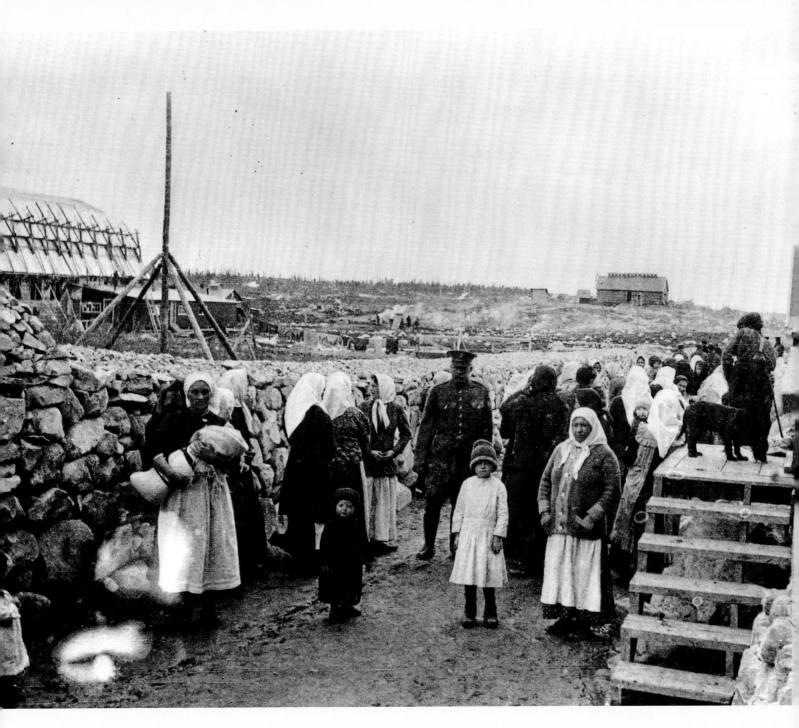

Women and children under guard.

[from Yurij Luhovy's documentary *Freedom Had a Price*]

< Garden in internment camp.

[LAC PA-170531, credit: R. Palmer]

^ Forest pathway, possibly
for water.

[LAC PA-170528, credit: R. Palmer]

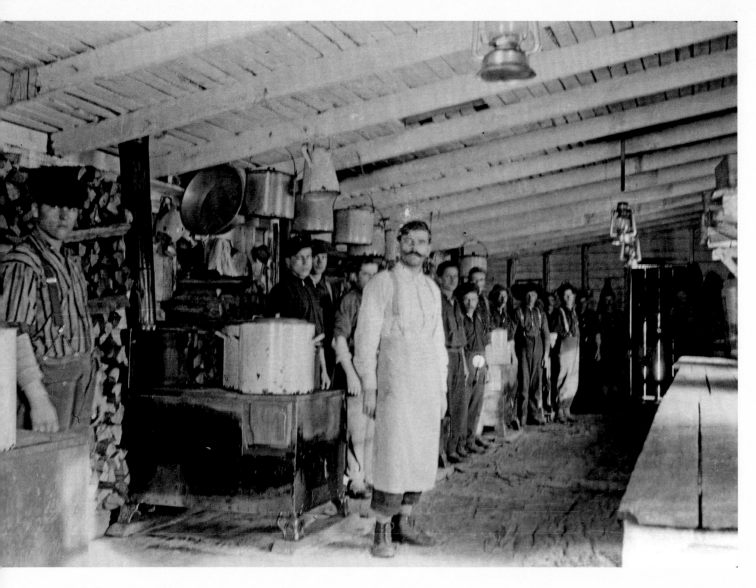

^ Cook stove, eating tables,

and internees. [LAC PA-170649]

> Dining barrack with clothes

drying. [LAC PA-170558]

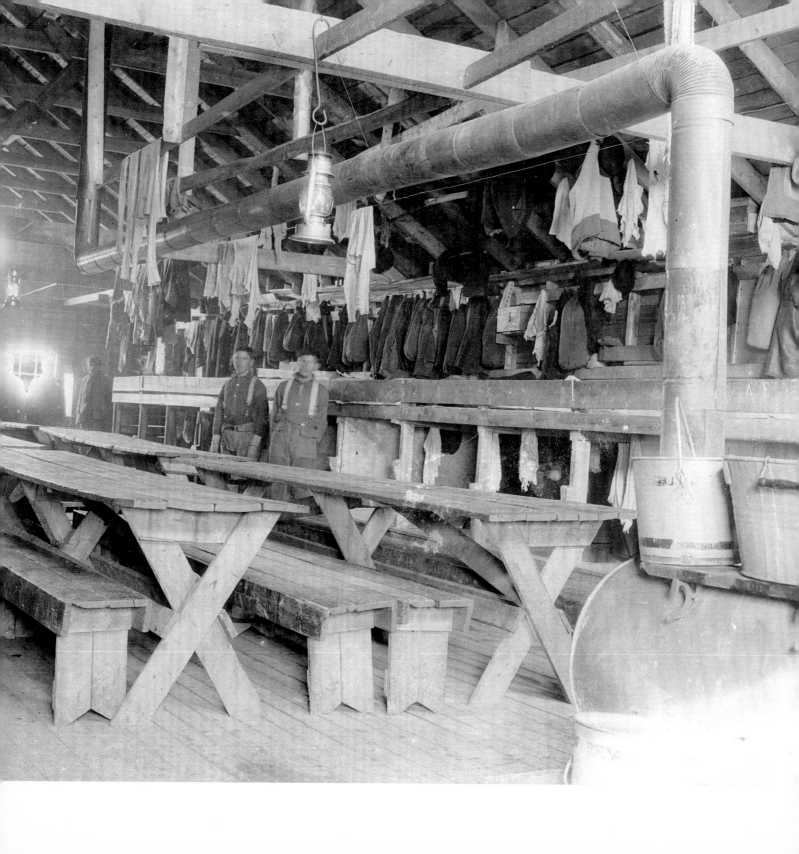

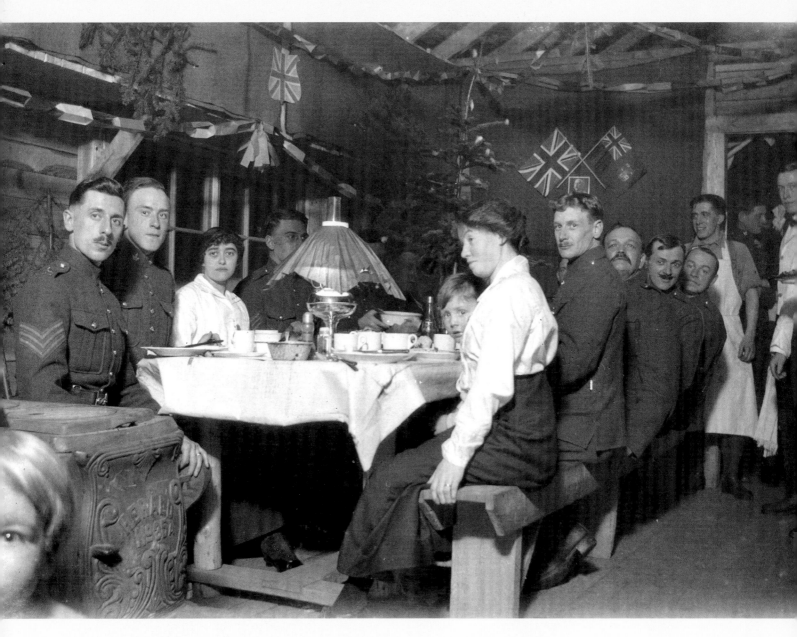

Officers and family gathering at
the table. [LAC PA-170638]

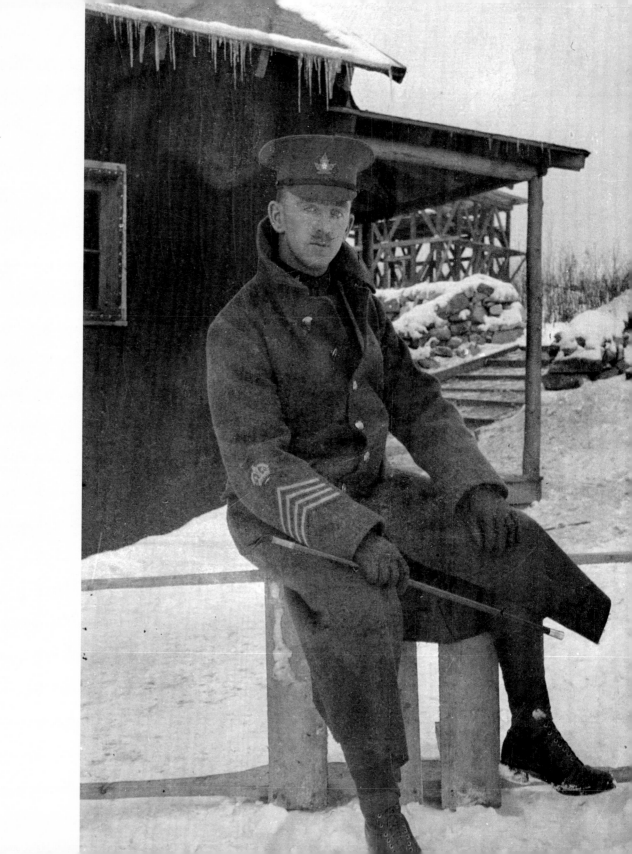

Guard with swagger stick.

[LAC PA-170629]

Internee or guard.

[LAC PA-170601]

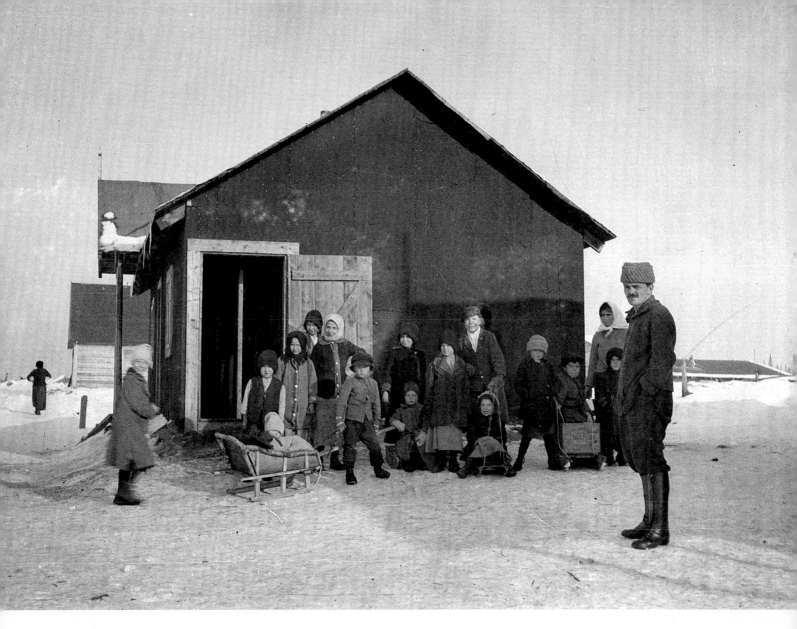

Internee families.

[LAC PA-170623]

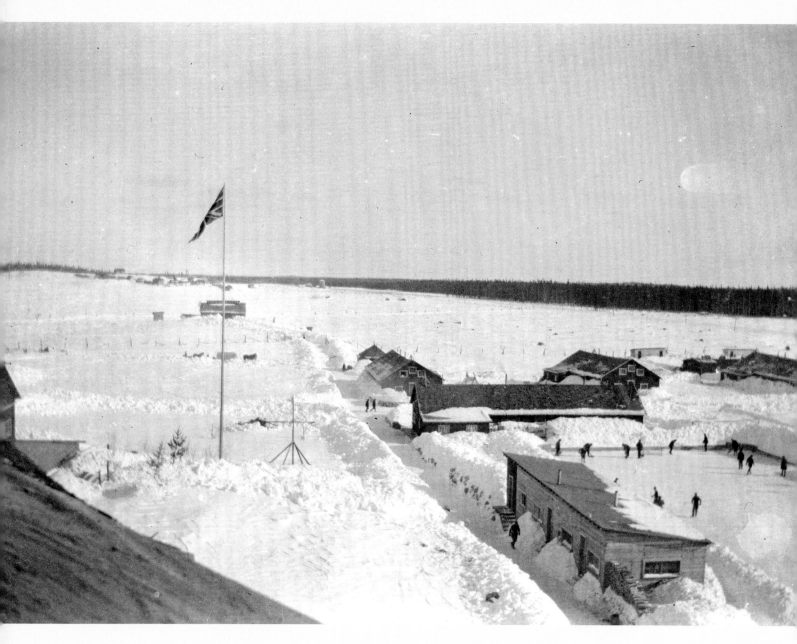

Skating rink and British flag.

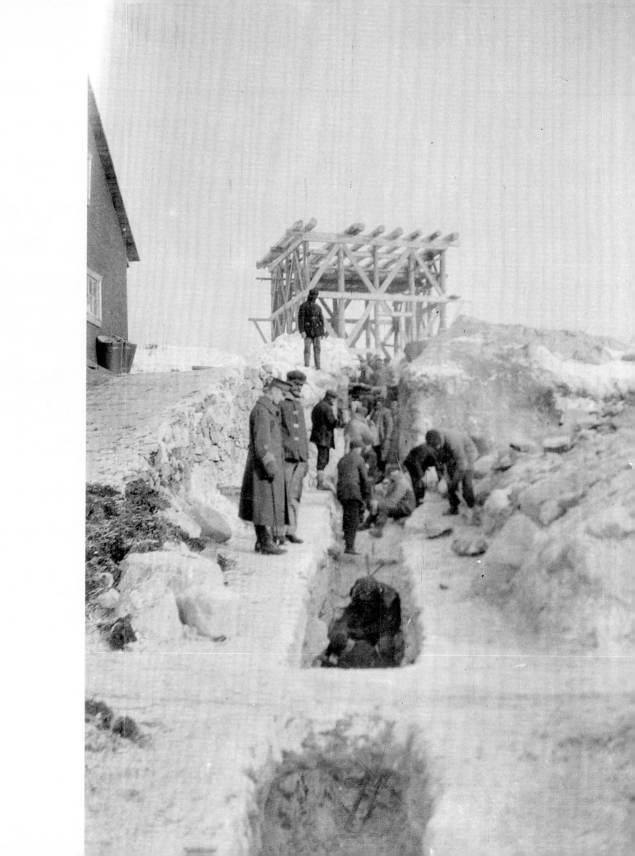

Winter excavation.

[LAC PA-170615]

^ Ivan Hryhoryschuk, shot dead
attempting to escape.

> Funeral procession.

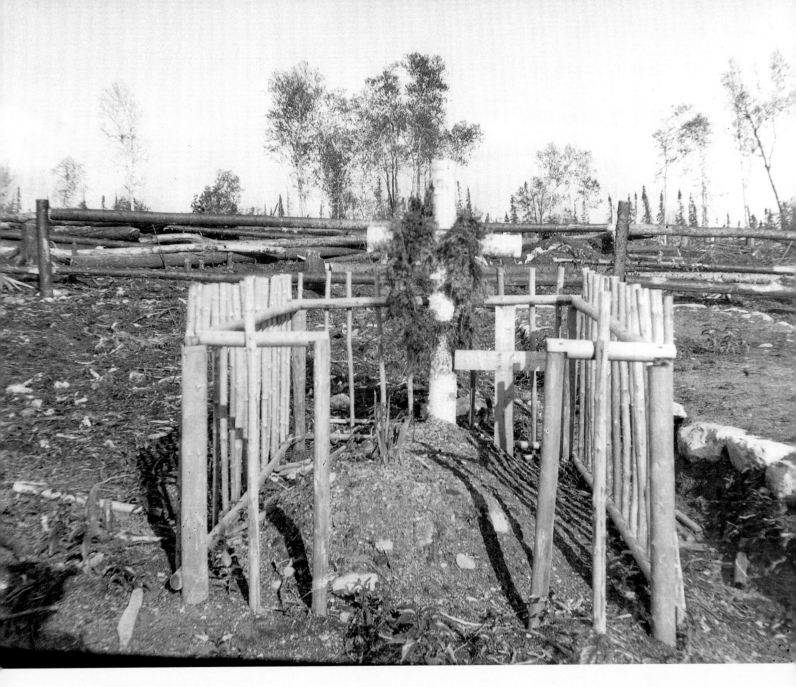

Burial site with shadow of
photographer.

[LAC PA-170561, credit: R. Palmer]

Internee in the infirmary.

> Pages 176–77

Visit from a foreign consulate.

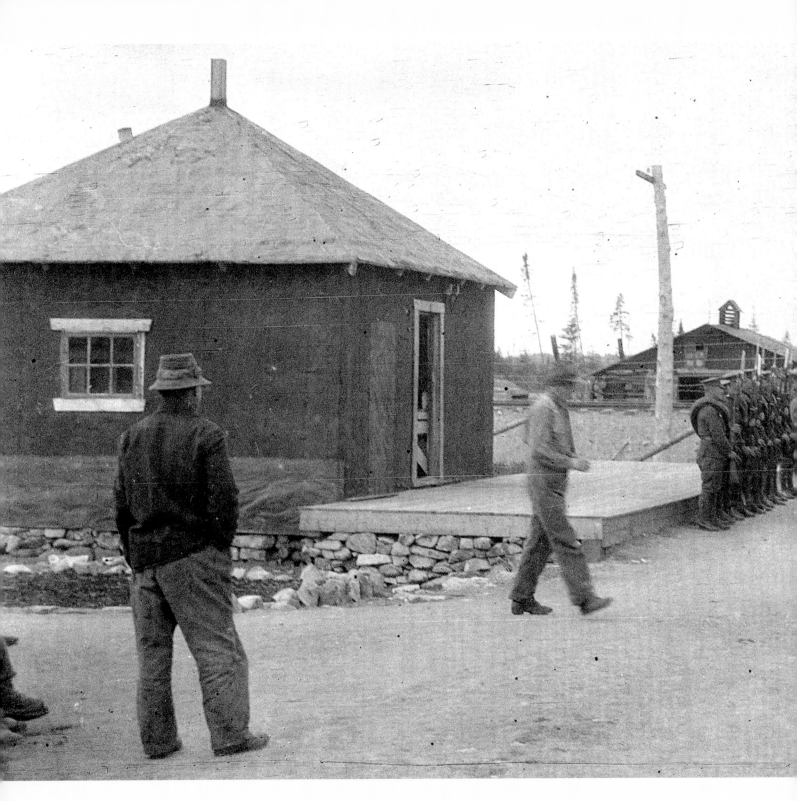

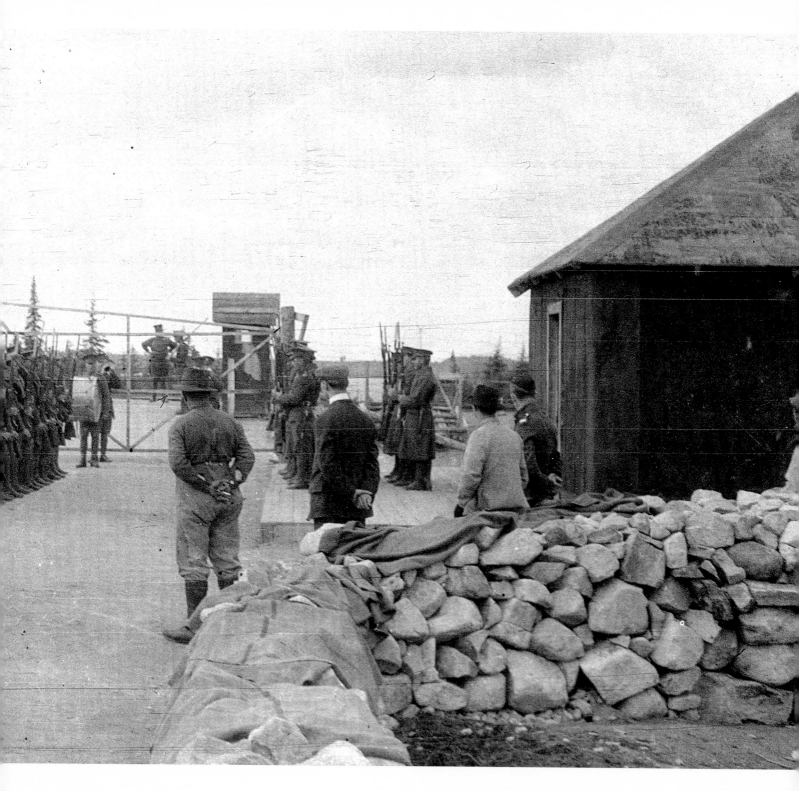

177

5 Engaging Memory Work

Memory, as opposed to history, rings true for us now as an unauthorized version of events, something an elder told us, a seed turned over and over with our tongues until it sprouted in our own words.

—Martha Langford, *Scissors, Paper, Stone: Expressions of Memory in Contemporary Photographic Art*

Memory work has a great deal in common with forms of inquiry which—like detective work and archaeology, say—involve working backwards—searching for clues, deciphering signs and traces, making deductions, patching together reconstructions out of fragments of evidence.

—Annette Kuhn, *Family Secrets: Acts of Memory and Imagination*

Friends playing at Spirit Lake Internment Camp, Quebec.
[LAC PA-170434]

HISTORIAN FRANCES SWYRIPA argues that "the event leaving the deepest scars on the Ukrainian Canadian psyche was their treatment as enemy aliens during World War I."[1] These scars are largely hidden. For those whose communities have been marginalized by violence and non-recognition, careful and empathetic critical thinking may help to deal with the past.

"What children learn subjectively about the past is utterly different from the historical knowledge that experts impart," writes social psychologist Harald Welzer.[2] Does the belief that we have historical knowledge free us from dealing with the past? I hope not. There is individual responsibility in the development of collective awareness of the past—of what it means to be a good woman or man in the present—that begins when we are children. Historians, archivists, teachers, parents, grandparents, and friends provide guidance, but they do not do the work for us. My father's history and activism taught me that an assertion of human

rights can penetrate personal muteness in the collective remembrance of what has been suppressed. When Dad talked about social change and justice he said, "It takes education, education, education." He wasn't referring only to institutional education; he was referring to lifelong learning—the questions being asked, the clues found, the insights discovered, and the actions that followed. Reclaiming or reforming identity and agency is a form of memory work. "As with photographs, so with other memory prompts," Annette Kuhn writes, "the democratic quality of memory work makes it a powerful practical instrument of 'conscientization,' the awakening of critical consciousness, through their own activities of reflection and learning, amongst those who lack power: and the development of a critical and questioning attitude towards their own lives and the lives of those around them."[3] This was true of the internees and the descendants who have told their stories and shared their memory work in this book. It is with great respect for their sense of responsibility, curiosity, and criticality about the internment of their loved ones that I continue with my own memory work and engagement with their stories.

A Loss of Identity

Ukrainians have been oral storytellers for centuries. Minstrels, called *kobzars*, often blind, would wander from village to village singing epic tales and playing instruments.

These songs were often directed against oppressive native and foreign rulers. Marshall Forchuk asked me to meet him at Tim Hortons in Brantford, Ontario. Marshall chose that place because he felt at home there. He was a tall, well-built man with a leather cowboy hat. Impressive, yet unassuming, I thought—a direct man. I liked him immediately. We shook hands—you know the handshake, strong, a full hand—ordered coffee, and sat down. He pulled out a map from his case, spread it out on the table and pointed. He wasn't wasting time. He wanted to locate me, tell me the story *in situ*, to put my feet on the ground his father had walked on. He wanted me to know how serious this incident was. His father, Yurko Forchuk, had lost his homestead, his land, and his animals. He was picked up in town and taken away immediately by the Royal North West Mounted Police, then interned in Jasper as an enemy alien. He never found out what happened to his animals. Marshall was clearly focused. He had reflected on his father's story and its effects on his own life. It had to be told. He explained,

This is in the area of Willingdon, the Vegreville (Alberta) area. It is extremely good agricultural land. This is where my dad originally homesteaded. When he was picked up and interned and eventually worked his way back to civilization, all the good land was taken up by the returning vets and so on. So he

then homesteaded in the Myrnam area. You see Myrnam and you see St. Paul and the North Saskatchewan River runs between them. So he farmed between Myrnam and St. Paul...Terrible, terrible country from a farming point of view.[4]

Marshall said that his father escaped with bullets whistling over his head.

Yurko Forchuk couldn't go back to the Willington area. He was afraid he was a wanted man. He hid out, changed his identity. In time, he found land—albeit much poorer land—far enough away from Willingdon not to be known and began again.

But something crucial had changed. Something much more than a farm had been stolen. Marshall Forchuk describes his father's invisible loss by speaking about the horrors of containment and control of First Nations children in residential schools. He said, "We tried to make their children something else other than what they were."

I asked Marshall if that happened to his father.

He replied, "Yes."

They Were Kids

James and I were walking along the ocean dykes on western edge of Canada when we were spontaneously invited to a family feast and gathering on Tsawwassen First Nation territory. We sat on a long green couch, eating salmon and watching a five-year-old boy speaking on a family video of another more formal feast. While small children watched with us, the boy in the video said, "I know who I am," then told us his great-grandfather's, grandfather's, and grandmother's names, and his father's and mother's names. He was so proud to know who he was.

Primary relations—our relations to place and to loved ones, to the outer and inner landscapes of our childhood—provide as with our foundational stories, the stories that teach and inform us about who we are, for good and for bad. That landscape shapes us. Neal McLeod, in his book *Cree Narrative Memory: From Treaties to Contemporary Times*, writes about how we become storytellers, recalling stories that make our kin the people they are and reveal how we "thread" experiences together.[5] Internees and descendants have modelled for us the shaping of experience by telling their stories. Until recently, the curriculum of Canadian histories in schools excluded the stories of the internment camps during the First World War. This denial became a part of our inner landscapes in Canada. It included indifference that affects cultures, families, and individuals, silently over generations. I am grateful that it is changing.

It was internee Mary Manko Haskett's insights as an adult about her childhood experiences in the northern landscape of the Spirit Lake camp that directed the Ukrainian Canadian Civil Liberties Association in their campaign to get government funds to educate the public about this story. Mary reflected,

Kids at Spirit Lake Internment Camp, Quebec. [LAC PA-170470]

Perhaps Canadian historians don't think that what happened to me and the others mattered. But it did. We were born here. We were Canadians. We had done nothing wrong. And those who, like my parents, had come from Ukrainian homelands to Canada came seeking freedom. They were invited. They worked hard. They contributed to this country with their blood, sweat, and tears. A lot of the later. What was done to us was wrong. And because no one bothered to remember or learn about the wrong that was done to us, it was done to others again, and yet again. Maybe there's an even greater wrong in that.[6]

Mary Manko Haskett was six years old when she was interned with her parents, her brother, and her two sisters. The barracks that internees were forced to build quickly to house themselves and the separate villages for their families in Quebec

were drafty and cold during the long dark winter nights. The two-year-old baby, Nellie, died from an infection in her lungs. "They put two pennies on her eyes, and made a cross," said Fran Haskett, Mary's daughter.[7] Mary remembered hearing her mother crying and crying. It was only when she was an adult that she was finally able to tell her story of her family's forced confinement to her own children. Her children did not believe her at first because the story was not in the history books and Spirit Lake could not be found on the map.[8] There was a generation gap. Her daughter, Fran, told *Globe and Mail* reporter Elizabeth Church, "She would say things like, 'When I was in a prison camp and there were guards all around us.'...How could we make sense of that? She was born in Canada."[9]

Christine Witiuk was ninety-eight years old when we met. From her story, family members learned specifics of homesteading from a child's point of view. The near starvation that her family and others endured was a part of the larger context for new homesteaders or the unemployed who were interned. Christine's memories opened my eyes to the living conditions in the Manitoba bush and slough lands that her family survived during the First World War. If they had wheat, it was just a little bit, not enough to make flour. They had no dishes, nothing. Her parents carved out a place in that bush and broke what land they could with few tools.

All of us listening to Christine tell the story—her son and daughter, her niece,

myself—heard how vulnerable the family was at this time. When Christine stopped to recall the story of the event that could have destroyed her family, she became very still. She was very small, she said. It was night and dark on their homestead when the hammering knock came on the door made of logs. Everyone was crying.

This child, the immediate relative of a possible internee, alive a century after the event of the internment camps, is an Elder now. Positive exchanges, including of difficult stories, between Elders and younger people are crucial to an empathetic imagining of the past or memory work. This family was isolated on their homestead, with no roads in or out. The wife was often alone with the children. The family didn't know much English and had little access to the news. Christine's father did go out to work on the railway, returning by foot every couple of weeks or so to the homestead. We were told that he was not able to report to the officials as required because of the distances involved and the stresses of trying to survive. Was he afraid of becoming visible to the authorities?

Christine's confusion and fear are emotional memory. And then there is the absolute mundane and child-like memory of her sister's bath. Those memories contain the essence of the story. How much of this telling was her story? How much was what her mother had told her? What were the facts? "There would be a lot of confusion," author and historian Peter Melnycky told me. "One minute they were made to report,

then they are told that as enemy aliens they cannot serve in the Canadian army and are interned if they try to do so, and then later they are conscripted!" he said.[10] Some were deported. It is what we experience and what we remember, or are taught to remember, that shapes our lives. How we individually and collectively interpret events throughout our changing lives gives direction to the future, shapes identity, empowers or disempowers peoples and nations as well as individuals. Those experiences are passed forward silently in the body as inner landscapes and orally to future generations as a peoples' history.

Christine's Uncle Emile—nicknamed Milko—disappeared, never to be seen by the family again. Was he interned? We can't be sure. Bill Waiser spoke to me about the importance of the oral, how the essence of what has been experienced is passed from generation to generation, even while the historical details are being lost.[11] When I visited David Lowenthal, and told him I was working on this book, he said, "Fact is filtered by time, by memory and by attempts to make sense of it. It becomes a narrative. Bits and pieces are brought together to make it real, not necessarily true. The further back it is, the more it becomes the way it has always been. Two people—for example— see and remember things differently."[12] We filter experience through what we know and value, through what we are trying learn about in our own lives. We tell stories from memories that shift entrance points as our learning through and within them changes our inner landscape.

As a seven-year-old child, Valdine Ciwko, internee Petro Witrowicz's granddaughter, asked to hear the story behind a ship built in a mickey bottle that was in her baba's china cabinet. The boat in a bottle, with its sea blue colour, drew her in. Valdine said, "the detail on the ship made it look so real." Objects from the past often point to stories that have to be recovered along with possible collective identities. They give us an entrance to the story by locating us tangibly in the physical everyday life of individuals in the past.[13] In time Valdine was able to sort the few details that her family told her, interpret misunderstandings and new information to puzzle together a story that had meaning for her and that was more historically accurate. The intergenerational shift her research created from shame to pride was familial and historical: she recognized that her grandfather was unjustly imprisoned by chance and circumstance.

Harry Williams was from a British family living in Fernie, British Columbia, during World War I. He was ninety-six years old when he told me that he had a boat in a bottle as well. It was made by one of the internees imprisoned at Morrissey, and given to him when he was six. He spoke of how he had kept the bottle safe all these years, how it was one of his most valued possessions. When I asked him why he was given this gift, he responded,

Well, me and my sister, we used to walk around there and take cookies and cakes things for the prisoners. We used to walk around the track, it was about eight miles. Me and my sister, Ida. Yeah, she used to make cakes and cookies and take them down to them. That's why I got a boat in a bottle. It's a ketchup bottle. You wondered how they stood everything up in the bottle and he said he made it so when he pulled one string it stood everything up. The boat is standing up and everything. Yeah, we had a good turnout for the cookies... They were all good people...They didn't put them in there because they were bad. They put them in there because they were Germans or Ukrainians. And they had to take them out—all the miners went overseas—and the mine, they had to take the prisoners out of there and put them to work.[14]

It is possible to grow and learn from difficult experiences such as internment. I wonder about Harry Williams's parents. Were they aware that their children were taking cookies to their former neighbours? Perhaps. Would such acts of kindness by these thoughtful children remind both internees and guards who they were? That boat in the bottle was one of Williams's most important possessions.

Authorities Can't Control Memory

When I listened to descendants, I remembered intimate family history—the way that Baba and I shared stories, the way she looked, her gestures, the inflections, and the peppering of Ukrainian within her English. No authority or official history can take away, constrain, or erase those memories. They can change, dissolve, and mix with other memories, become fragile, but no one can dispossess another of their memories and how they shape lives individually and collectively.[15] The landscapes of our memories shape us.

There is a different kind of authority functioning in the stories of the past that we are compelled to dig deeply for if we hold the tentative threads and fragments close and give meaning to them over time. There is a sense of what it means to be a good person in those stories that we pass from generation to generation. There is, in each of us, a possibility of an evolving comprehension of what power is, and of what gives us the confidence to thrive, the will to live, to support one another, to heal our wounds, and to imagine peaceful futures collectively. It was difficult to listen or read these stories but also empowering at the same time. The stories we tell ourselves and pass on are reactions to circumstances and events. They are keys to learning. It is not about resolution or conclusion, but it is about the ongoing unfolding of the story, of which James spoke, of becoming human.

I remember the day I met Albert Bobyk. It was mid-morning. I stood at the door of a small bungalow in Brandon, Manitoba, knocking. Albert opened the door. His eyes had determination in them as he stepped aside to welcome me. I had phoned ahead, and he was waiting, ready. He immediately began telling the story of his father, Wasyl Bobyk, who was interned in Brandon. The date on his signed release paper reads 11/4/16.[16] "Wait, wait, I have to get my camera ready," I say. I pull my video camera out, but I have already missed what he is saying. There is urgency is his voice. He has waited a long time to tell these stories. I am shocked by the stories he tells of how the guards treated the internees. Albert engages his father's experiences by telling me the stories in a strong and steady way.

We learn from Albert Bobyk that some of the internees in Brandon were told not to tell the story and yet his father told it to his son. We do not know if this warning was given at other camps. Yet there is a tone to what he is saying that I recognize in Philip Yasnowskyj's written story, "Internment." Prisoners were afraid that what little food they were getting would be cut off. Rationing food was a way of controlling the internees, as Yasnowskyj recalls:

> I do not remember whether we were served breakfast and supper, but I do remember that all we got for lunch was two slices of bread, a piece of meat, a leaf of raw cabbage, and tea with sugar.

Before lunch was over an officer would appear in the doorway and holler, "Any complaints?"

Everybody answered, "No."

I did, too, but actually I felt there were a lot of things to complain about. "Wait," I said to myself, "We shall find out what kind of justice they practice here."

A few days later, after lunch, instead of shouting back the usual answer, "No," I hollered, "Yes."

The fellows sitting beside me whispered in dismay, "Shut up."

The officer looked around. Everyone was seated; I was the only one who stood up. He stalked up to me and demanded to know why I was complaining.

I spoke out. "I want more food."

The officer muttered to himself and walked out.

The German inmates immediately got after me to keep quiet and not make any demands for fear that even the little that we were getting would be cut off and we would end up fasting. It so happened that protest was ignored, and I dared not complain again.[17]

There would come a day when the story could be told and the complaints heard.

Vasyl Doskoch (left) and friends,
likely Morrissey Internment Camp,
British Columbia.

[LAC, William Doskoch Fonds, e010775969,
MG 30D 394, vol. 1, file 9]

Telling the Story as Resistance

The young man with the mustache and coveralls to the left in this photograph of four young men is Vasyl Doskoch—Bill, to his friends. He is twenty years old. Behind him is another young man wearing a black hat and suspenders. He too is staring directly into the lens of the camera. I am interpreting from the visual cues in the photograph that the hands rest with affection—a brotherhood, perhaps. Vasyl came from a family of boys and a large extended family. His daughter, Anne Sadelain, said that he was close to his brothers. Vasyl was waiting to hear about a job in a mine near Brittania in British Columbia where his brother John was working when he was picked up on the streets of Vancouver and interned. He never saw his brother again. John died of the Spanish flu before Vasyl was released.

In the front of Vasyl in the photograph, another young man sits cross-legged on the floor. His chin is up; the look on his face is direct and proud. I am imagining this ritual that they are enacting, posing together before a camera, naming themselves as friends, not as enemy aliens. I believe the photograph was made in Morrissey, in the old vacant hotel that had been converted quickly into an internment camp. It was a damp and ill-heated facility when chill and wet weather came to the mountains—an improvement from the Fernie skating arena that enemy aliens, like these four, were initially held in. That building had no heat, no toilets. Before them is a mess of shavings, possibly from someone doing carvings. Could the photographer be another internee or a sympathetic guard?

This photograph was found amongst the letters and images of Vasyl Doskoch's personal archive at Library and Archives Canada. We know from his children, Anne and Walter, that some of the friendships he formed in the camps endured. After days of forced labour clearing bush and building roads, Vasyl and his friends in the camp wrote letters to the consulates of Switzerland and the United States, both neutral nations, requesting help. For his efforts, Vasyl was put in the black hole, given diminished rations, ignored, and then, when taken out, forced to work even when he was seriously ill. He was moved four times: from Morrissey to Mara Lake, then to Vernon, and then to Kapuskasing.

In Vernon, there were well-educated Germans, prisoners of war, who shared their knowledge with Vasyl Doskoch. There is another document in Library and Archives Canada in Vasyl's own handwriting where he has copied out international law as would apply to the internees. One of his first actions when moved to the Vernon camp was to write again to the consulates in support of his fellow prisoners who were still interned under bad conditions back at the Morrissey camp. Finally, he ended up in the toughest camp of all, Kapuskasing, in the northern bush landscape of Ontario, where he remained until two years after the war. He was twenty-six years old by then;

he'd spent more than a quarter of his life behind barbed wire.

In 1920, Kapuskasing still held its prisoners. That year he earned the trust and friendship of an elderly guard, "allowing Vasyl's committee to get letters to the outside, explaining the plight of the civilian POW's in camp."[18] This is the story as told by his son Walter Doskoch,

> One of their jobs was cutting brush. To get to the work site, the prisoners had to cross the little creek. The water was flowing quite swiftly at this time because of spring run-off. The prisoners had to use a little bridge made of planks, and in the early spring morning, the bridge would be slippery with frost. Bill noticed that the old guard carrying the rifle, which was always aimed at Bill's back, was very nervous when it came to crossing the creek.
>
> A few days later, with lots of frost on the bridge, Bill jumped and came down hard on the planks. The old man lost his balance and fell into the water. Bill quickly grabbed the rifle and pulled the old man out of the water. When they got to shore the old man said over and over again, "Bill, you are a great man, you saved my life." This time going back to the camp, the guard was in front and Bill was behind, carrying the rifle. All the way back to the camp, the guard was in front and Bill was behind carrying the rifle. All the way back to the camp, the old man heaped praises on Bill. Bill did not say a word, just smiled, and kept smiling, all the way back to camp.[19]

When we tell stories, how we tell them depends very much on whom we are telling them to. In Walter Doskoch's version, his father's stories of resistance and freedom fighting appear heroic. The context is war. The father is strategically aware of the complexity of the situation, and he is ready to act when an opportunity arises.

Vasyl Doskoch married after he was released. His wife, Maria, had emigrated after the war from Lazy, the birthplace of both of them. She experienced the First World War in Austria and through listening to her husband's stories of the war in Canada. Anne Sadelaine heard the story from her mother, Maria. Maria may have softened the story for her daughter, respecting her husband's heroism but editing out the possibility that her husband may have been strategically opportunistic in his resistance. Or Anne Sadelain herself, as listener and now storyteller, may have shifted the emphasis because of not only how she learned the story but also at what point she enters the story. For me, strategy, trust, and humorous cunning are recognized in the first story. And kindness on the part of both Vasyl Doskoch and the elderly guard are recognized in the second version.

No two people see or feel the same event the same way. When I, as listener

or reader, participate in bringing the stories together, I am left with a larger sense of possibilities—a more complicated, even conflictual, open, and incomplete reality. Also in Walter's biography of his father, Walter explains, "One of the main reasons Bill did what he did was to earn the trust of the guard...trust is priceless. You cannot buy it, you have to earn it."[20] This statement helps me to understand that conscience and the ethics of trust can be active under dire circumstances and within strategic actions. Alan Clements sums up Myanmar leader of the National League for Democracy Aung San Suu Kyi's observations about collective change: "For those in the democracy struggle, it's the courage to feel self-esteem, self-worth and dignity—the courage for action. And for the authorities it's the courage to feel shame and remorse; the courage to love and the courage to humble themselves to people."[21] Both Vasyl and the guard had the courage to act to change the situation.

The years that he spent in the camps aged Vasyl. In Kapuskasing, he went on a hunger strike for better conditions in the camp. He got pneumonia. His heart was physically never the same after. When released, he became a union leader with the Canadian Brotherhood of Railway Employees to help improve working conditions. He was blackballed for his union organizing and socialist beliefs during the 1930s and was unable to get work for many years. Shortly after he finally got work in 1941 in the mines once

more, Vasyl Doskoch died of a heart attack. He was forty-seven years old.

Anne Sadelain offered me the hospitality of her home. She fed me. "*Yeaste*," my baba used to say, "*Shidaite, yeaste.*" Eat, sit down, eat. I am fed by our conversations and borscht. Anne learned a fierce desire for equality and justice from an older version of that young man in the photograph. I understand those values from my father.

She spoke to me of her father's bitterness. Sometimes I hear it, the bitterness, in her voice—she lost her father so young. She suspects that the physical and mental strain on her father's health in the camps hastened his early death. In the 1980s, Anne and her brother, Walter, began the work to have the story of the internment told in the schools. She was one of the founders of the Descendants of Ukrainian Canadian Internee Victims Association, which has been successful in getting the story of internment told in Alberta schools.

Humiliation

I met Andy Antoniuk at his uncle's old farm not far from Edmonton. The canola seed crop was just coming into bloom. Andy reached out his hand to touch the barn built by Antoniuk's family and neighbours before the First World War. He stood there telling the story as the sun was going down. Nikolai, Andy's father, took on the responsibility of the farm when he was a teenager, helping the family when his older

brother was interned. Nikolai helped his grandmother, his brother's wife, and all the children from two families. As Andy stared at the field of canola, he remembered what his uncle said about Andy's father: "Oh, your dad helped me out. He took care of everything here."[22] Andy reflected on the importance of what his father did: "In essence, my father saved the farm."[23]

We don't know the circumstances of the uncle's arrest. Bohdan Kordan, in *No Free Man*, writes that the Order in Council that created internment "collapsed two categories of individuals: those who potentially harboured ill will and hostile intent but also those who could no longer fend for themselves. By treating both identically—either category could be interned as prisoners of war—the government gave credence to the idea that the jobless enemy alien was, in fact, a security threat."[24] While most of the men were interned in urban centres because they did not have a means to survive, there were homesteaders who had to work outside the farm to support the farm and their families. I also recorded instances of farmers being picked up and interned when they went to town for supplies.

I am listening to Andy Antoniuk. A sense of responsibility, co-operation, and, most importantly, love of family defines what it is to be a good man for my own and extended Ukrainian family. I tell him that. "My uncle was that kind of man," Andy responds, "a good man."[25] His uncle's identity as the senior man depended on his being there to support the extended family after a tragic accident killed his own father. "My uncle," Andy says, was a respected, "active member in the community one day and a criminal the next."

The uncle hid the story well. Andy didn't even know the story until 1940 when his dad, Nikolai, got his very first car and the family went to Jasper to investigate. Nikolai was forty years old at the time of that trip, an age when he felt a pressure to know the truth of where and what had happened to his brother during the war. Nikolai told the story where his brother had been interned, close to the river, in Jasper National Park. He said this was where his brother was forced to work clearing the forest. Along with witnessing his father's strong feelings, standing in the place where his uncle had been interned shook the teenager. He realized that his uncle was forced to labour. It takes a curious mind, time, and a kind of personal punctuality or experiential readiness for younger people to become aware of wrong doings that have happened to their Elders, to begin understand why family members behave the way they do.

After this trip to Jasper, Andy tried to get his uncle to talk about the internment, but his uncle, who was usually a friendly down-to-earth man, became angry. "His personality just changed. I was shocked as he said in a harsh voice, '*Nichoho ne kazhy!*' Don't say a thing. And abruptly turned and walked away. He would not talk about his experiences. That was where everything

turned bad for him."[26] Andy later apologized to his uncle.

Andy's uncle was a homesteader and a father. The authorities saw him as an enemy alien and a labourer. His status as senior man responsible for the farm and family was irrelevant to them. He had been broken off from his own life, however stressful it was as a homesteader, and forced to accept a life that was not of his own making. Andy said that his uncle was humiliated because he was seen and treated as if he was an ally to the Austrian-Hungarian Empire who ruled his people. Andy said, "He just could not believe that he was a prisoner of war supporting the German-Austro, the war."[27]

One of the symptoms of traumatic memory is the inability to speak of the event. Psychologist Judith Herman has worked with many people whose traumas have caused them to "suffer damage to the basic structures of self."[28] She writes, "Their self-esteem is assaulted by experiences of humiliation, guilt and helplessness." Identity is profoundly affected.[29] It is unlikely that internees would want to continue to be identified as "foreigners" or enemy aliens after they were released. It was too painful. After a century of near silence, we don't know if there were opportunities for internees to grieve the losses of self and connections with others or to express their anger without further humiliation. Herman tells us traumatic losses of the internal structures of belonging disrupt "the ordinary sequence of generations

and defy the ordinary social conventions of bereavement."[30] There is little evidence that internees' losses as a result of the internment camps were acknowledged. Even today, family members of internees' find it hard to believe or deny that it happened. Many were told nothing. These losses were psychological and invisible. Herman explains, "The telling of the trauma story thus inevitably plunges the survivor into profound grief."[31] Suppressed grief, once released, bit by bit, provides relief. But it takes time. Caring listeners help.

Like so many Ukrainians who settled in Canada, Andy Antoniuk's uncle felt that it was important for Ukrainian Canadian children to become educated. After the internment camps of the First World War, ongoing prejudice effected the Ukrainian youth. "Why," Andy asks, "were students in the school system abused for so long because they were of Ukrainian origin?"[32] My father told me a story about the first snow of the season when he was in grade one. He was so excited he ran to the window in wonder saying, "*Snih, snih.*" Snow, snow. The teacher took a sharp ruler and whacked him, telling him never to speak that language in school again. When Andy was in grade one he was told to leave the classroom because he used a Ukrainian word to describe a picture of a pig on the wall—"*svynia.*" Not so long ago, Andy told his granddaughter about the internment camps. His granddaughter listened closely. She asked her history teacher when they

were going to learn about the internment of Ukrainians. The teacher replied that he did not know that story.[33] Antoniuk helped to make the Descendants of Ukrainian Canadian Internee Victims Association a registered society dedicated to this education. Teachers now have access to this story.[34]

These Are the Last Flowers
I Will See in My Life

I am driving towards Toronto on Highway 401. The speed of the traffic is shocking. I am really tired. I think I will bypass Peterborough and go to Toronto. When the exit to turn Peterborough comes, I change my mind and turn into the city's centre. I had been in a lively email conversation for several months with a woman who mistakenly thought that she was a relative of internee Dmetro (Michael) Bahri. In her research she found details of his internment and hanging, and passed them on to me. He had been interned at the Spirit Lake Internment Camp in northern Quebec where both Mary Manko Haskett and Mary Bayrak had been held prisoners. Michael Bahri was hanged to his death along with Tom Konek (Korncheck) in 1920 at Peterborough Jail for the alleged murder of Philip Yanoff. A robbery had gone very wrong when the shotgun went off by accident. I drive to the Peterborough Library, where I am shown microfiche documentation in the newspapers about the alleged

murder, the trial, and the executioner, John Ellis. I found a poem by a Rev. G.E. Ross, who spent time with the young Bahri while he was in jail. Here is an excerpt of his poem "Michael Bahri."

> There on the hill, while the
> morning glow
> Of the sunbeams kiss the virgin snow,
> Silently, sadly, cold and slow
> Youth and Bahri moves to die,
>
> There on the hill, while the coming day
> Glides over the snow, like a child at play,
> Looms the scaffold, cold and gray
> Where Bahri pays the toll,
>
> There on the hill in the iron hold
> Of the law, relentless cruel and told,
> Youth, and name, and life are sold
> To a custom born in hell.
>
> Gentle bury the stranger dead,
> He's paid for the blood another shed,
> But I must write on the slab at
> their head.
> "Please do not blame the Flag."[35]

Bahri was fifteen years old when he was picked up on the streets of Montreal.[36] A teenager. He was held at Immigration Hall in Montreal, then shipped to the Valcartier Internment Camp where he became POW #73. He was transferred to Spirit Lake and released from there on June 13, 1916. From Spirit Lake Internment Camp he was

Michael Bahri before his death
by hanging, Peterborough Jail,
Peterborough, Ontario.
[Photograph from the Roy Studio, Peterborough
Museum & Archives]

Certificate of release for Michael Bahri.

[LAC, Custodian of Enemy Property and internment operations records, e010775941]

sent with 225 other POWs to work on the Welland Canal.[37] Michael Bahri's father, Nickolas, had been interned at Petawawa and Kapuskasing. In a letter dated April 22, 1920, the father wrote to the Internment Operations Office in Ottawa:

To my great sorrow I have to report that my son Mike Bahri who was executed at Peterborough Ontario, on the 14th day of January, 1920, was interned for about 16 months when he was taken from Montreal during the month of April 1915, the first place he was taken I do not know, but I am certain that he was released from Spirit Lake. Now being the only heir left, I would ask you confidentially as to how much is coming to my late son, and whether a strong affidavit with good securities and all legal precautions taken, would satisfy you. Again I have to repeat is, if the amount is very little as in more cases, then it would not pay even the small expenses, namely:

Copy of sentence, Death certificate, Furnish Bond of Indemnity, etc.

Hoping you will help a down heart breaking father, who has lost a son not quite twenty-one (21) years.

Hoping that you will direct me, what step, I may take as to get the funds belonging to my late son, and oblige

I remain

Yours truly X

Sgd. (Mark) Nickolas Bahri

P.S. I personally first was interned at Petawawa under No. 555 and thence I went to Kapuskasing from where I was released, and I received $32.18.[38]

I was happy to read a letter from the Internment Operations office that said $45.01 was approved by the deputy minister of justice to secure the funds for the late Dmetro Bahri.[39]

Many internees were released from the camps with nothing into a society that was hostile towards them. We don't know what happened between 1916 when Michael Bahri was released to the supervision of

the Welland Canal authorities and 1920. In 1920, Bahri was arrested with four other men: Sam Zaluski, Philip Rotensky, Aleander Martynich, and Tom Konek. The newspapers of the day called them the Russian Gang of Five. As the newspaper tells the story, the plan was to rob workmen living in a bunkhouse at the Canadian Rock Company near Havelock. When the fivesome arrived at the bunkhouse, Mr. Konek was leading (up the stairs) and Mr. Bahri was holding up the rear. Mr. Konek's gun went off, apparently accidentally. Mr. Konek maintained until the day he was hanged that he didn't purposely fire the weapon at anybody. Philip Yanoff, a Bulgarian labourer, was dead. It was reported that the money was stolen from under the dying man's head and that when Yanoff asked for water he was ignored. The Peterborough jury gave three of the men life sentences in the Kingston Penitentiary. Bahri and Konek were sentenced to be hanged.[40] On December 8, 1919, the Ministerial Association of the City of Peterborough unanimously voted to appeal to the minister of justice on behalf of the condemned men. They had each spent time with Bahri and Konek, saw how contrite they were, how they spoke of it being an accident. The ministers, all from different faiths, addressed the political climate of the day: "While we would not for a moment lose sight of the fact that great care is being taken by the Government in dealing with the restlessness of the country, and its cause, nor would we, in any way minimize the danger and menace of the foreigner, yet we plead for the life of five young men, who feel their position keenly, are mild, obedient, and simply ignorant of all that goes to make up true citizenship."[41]

A telegram to the minister of justice in Ottawa from P.T. Ahern, Esq., Counsel for Korncheck, dated January 13, 1920, states,

KORNCHECK CONFIRMS CONFESSION MADE TO FATHER SECHINSKY RELIEVING BAHRI FROM RESPONSIBILITY OF ORGANIZING AND DIRECTING ROBBERY STATES ZELUSKI WAS THE REAL ORIGINATOR. IN VIEW OF THIS STATEMENT OBTAIN ANY DELAY POSSIBLE THAT FACTS MAY BE PROPERLY PRESENTED BEFORE THE MINISTER. KORNCHECK PERSISTS FIRING OF SHOT ACCIDENTAL. DUE ENTIRELY TO NERVOUSNESS, FRIGHT AND HAIR TRIGGER. PLEASE ADVISE ME AT PETERBORO AT ONCE OF ACTION TAKEN IF ANY.[42]

The pleas of the nine signatories, in addition to the request from ministers, were denied, as was Thomas Korncheck's defence of Mike Bahri. Canon J.C. Davidson assured the public that there was "nothing really criminal in the nature of Bahri...A short time before his execution he held a bouquet of flowers sent to him by the Ladies Guild of St. John's Church, and remarked, 'These are the last flowers I will ever see in my life.'"[43]

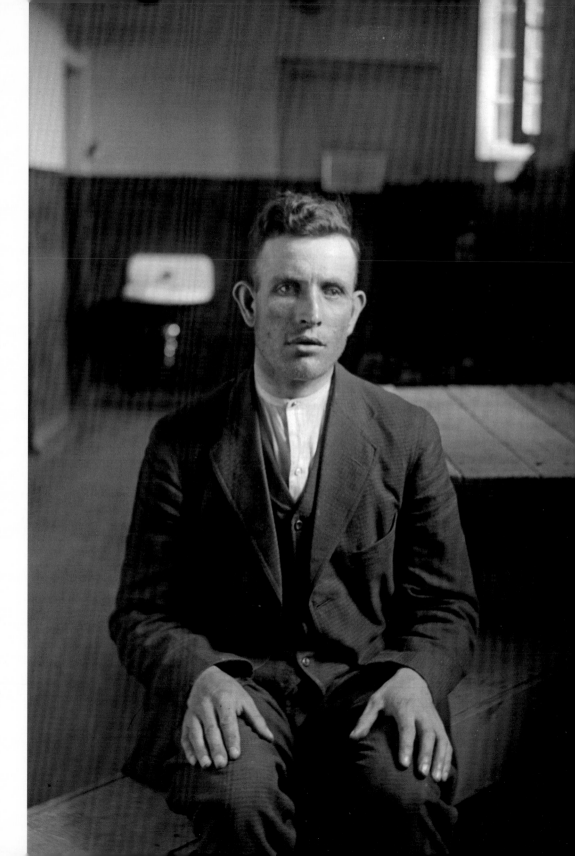

Thomas Konek, before his death
by hanging, Peterborough Jail,
Peterborough, Ontario.

[Photograph from the Roy Studio, Peterborough
Museum & Archives]

Michael Bahri and Thomas Konek (Korncheck) were hanged on January 14, 1920.

"Oh—you must go to the Black Horse Pub on George Street, go!" the librarian said to me. The owner of the pub sent me down to the basement washrooms where I found photographic portraits of the "Russian Gang of Five" made during the murder trial. The photographs were taken by the Roy Studio of Peterborough. On the "Gents" door there was a portrait of Michael Bahri shortly before he was hanged. He is sitting on a wooden bench outside the prison cells. His tweed hat is at a slight angle. This young man has style. He is handsome. His gaze is direct, into the lens of the camera. I imagine it is a look addressed to a loved one—to let his mother, father, brother, sister know that he is alive at this moment, present. There is a dignity and a vulnerability in the portrait. Only in the tension in his arms, in the claw-like gestures of his hands, do I see the trapped animal.

No one I met in Peterborough knew that Michael Bahri had been interned and then put on parole and forced to labour on the Welland Canal for a fraction of the going rate. No one I met knew that this story of a robbery and death is a part of another larger story of the internment and what happened after when the internees were released. The three other men who had been charged were spared the gallows. At the Peterborough Archives I am shown the archeologist's report on the excavation of the graves outside the Peterborough Jail.

When the archeologist and I have time to talk it is at the University of Western Ontario in London, Ontario. The bones of Bahri and Konek are there. I have found their remains. They have been using both Michael's skeleton and that of Konek to learn about the hanging technology particular to John Ellis—the drop, a method created to cause as little discomfort as possible to the hanged person. They knew of no family members who would be interested in the remains.

I told the scientists about Michael Bahri. I told them I knew little of Konek except that I had found a portrait from Spirit Lake Camp that looked like him. The hairline was identical. They listen intently and then were silent. Obviously disturbed. They agreed that the remains of both men should be identified and laid to rest. The Ukrainian Canadian Civil Liberties Association made arrangements for their bones to be buried respectfully in a ceremony in Ottawa. Reverend Petro Galadza of Ottawa presided over the ceremony to inter the bones of Michael Bahri and Tom Konek at the Beechwood Cemetery in Ottawa in October 2012.

Healing

They were in control. *It* was never named. It eats you away.

This morning I got up before the sunrise and waited quietly. I watched the intricate shifts of light slowly build over the land and the sky until a line of light stretched

horizontally across the dark contours of the top of a massive cloud, and the sun rose. It takes time to feel the past in the present. The pieces of the puzzle are found in unexpected ways, echoes continue and clues emerge. The story is not over. David Lowenthal sent me an essay in which he writes about changing the "mindsets" of superiority or inferiority through honest dialogue. He writes that the wrong done can become a part of the core identity of either the person harmed or the transgressor. The mindset of being a victim is understood to be a moral highroad while the transgressor also sees her or himself as morally superior.[44]

I remember being in the sweat lodge with my husband, James, one summer in the early 1990s. I would rather be a victim than a victimizer, I thought. I could call myself a good person. I was on what the Cree call the "red road," the road of life, not the "black road," the road of death, I thought. *"Pimatisiwin"* — the Cree word for life — "is the most precious thing," James would say. I realized that the role of the victim can create a narrative loop without the agency needed to change the story. How deadly, I thought, then I laughed: the black road! The trickster, Wesakechak, James said, was turning things upside down. I understood too well what Lowenthal means when he suggests that both mindsets feel that they have the high ground:

Such identities harden into "moral fortress[es]." Dialogue degenerates into fruitless recrimination, "escalating... accusation and counter-accusation, exaggeration and denial," as Eva Hoffman says of Polish–Jewish relations. She thinks historical honesty the only cure. Just as "the majority culture...[must] admit its history of dominance or injustice," so the minority must relinquish "powerlessness as proof of moral superiority," and cease "to hold the majority moral hostage in perpetuity."[45]

The desire not to be seen as victims or to pass trauma forward informed my grandparents' silence about their past in the homelands. They really did want to start again fresh. Donna Korchinski, a journalist whose step-grandfather was interned, was adamant that we not make the story of the internment into another victim story. She insisted, "We will teach our children. We will teach all Canadian children about this but we will no longer be thought of as victims."

When I asked my father if Ukrainians in Eastern Europe victimized others, he hesitated, then said, "Maybe there was tit for tat." It takes time to acknowledge the degradations along with the suffering within our own peoples, the sense of entitlement over and brutalities towards other peoples and our own.

Immigrants to Canada have benefitted from the dislocation of First Nations. The cycle of being ruled over by foreigners in the

Austro-Hungarian Empire, which included control over the land, denial of identity, and cultural suppression, was well under way in Canada when Ukrainians were invited to the country. In the late 1800s and early 1900s, Ukrainian immigrants were used by the Canadian government to claim and cultivate the land. This strategy was a part of colonizing First Nations territories and assuring the land was not grabbed by the United States. To have the historical honesty that Lowenthal suggests, there is a need for dialogue across generations and cultures.

Lateral violence is finally being recognized as a collective as well as a personal responsibility. On Wednesday June 11, 2008, Prime Minister Stephen Harper, on behalf of the Government of Canada, apologized to First Nations not only for residential schools but also for damage to subsequent generations. "The burden of this experience has been on your shoulders for far too long," he noted.

> We now recognize that in separating children from their families, we undermined the ability of many to adequately parent their own children and sowed the seeds for generations to follow, and we apologize for having done this. We now recognize that, far too often, these institutions gave rise to abuse or neglect and were inadequately controlled, and we apologize for failing to protect you. Not only did you suffer these abuses as children, but also as you became parents, you were powerless to protect your own children from suffering the same experience, and for this we are sorry.[46]

Such statements by heads of nations are significant; they reveal the government's responsibility to acknowledge state-sanctioned violence, including culpability for the lateral violence that occurs after that violence. There is a duty for society to see how we participate in the creation of systemic inequalities and racism, to act to lessen the burden on those victimized, and to recognize that entitlement is a root problem.

Major-General Otter recognized that the internment camps in Canada during the First World War, to borrow a phrase from Harper's apology, "gave rise to abuse or neglect and were inadequately controlled" as well. The legacy of pain caused by the internment, intergenerational trauma, has not been discussed. Kathleen Boyko, wife of descendant Otto Boyko, explained, "I don't think the suffering is ever over. I think it's passed down by the very fact that children grow up with their parents and if their parents are hurting, or have been mistreated in some way, that it shows through to the children. I think just children pick this up. I don't think what happens ever disappears, not in the first generation because it's firsthand experience of what they grew up with."[47] Historical honesty and the suppression of the story of internment are national issues and demand societal problem

solving. "We can't expect other people to help us get rid of pain," Korchinski said. "We have to get rid of it ourselves." She continued, "If you build on the negative, it just rots you away...If we build on the positive, then the outside community can build on our foundation because we're creating a foundation."[48] This is what many of the interned communities did in Canada: they built on the positive.

The deep education of understanding is slow, a telling of story to ourselves and those around us. We each find those insights when we are ready. Telling our own stories and being heard as a part of education supports the reclamation of identity across generations.

Descendant Jean Gural better understood her father, Nikolai Tkachuk's, paranoia once she better understood what was lost when he was interned. With the War Measures Act he was assumed to be guilty with no recourse to justice. He had escaped the camp in terror. That understanding is a part of the foundation of historical honesty that Lowenthal and Korchinski say needs to be built. It is important to recognize the truth of why your father, your mother, or your grandfather may have behaved the way they behaved. Jean spoke to me in her home in Toronto, pointing to a photograph made at Castle Mountain Internment Camp of a defiant man standing behind barbed wire with his hands on his hips. "That could be my father," she said, "that is how he looked." In the morning, she spoke with compassion to her deceased father through the lens of my video camera. Jean struggled to use Ukrainian and English to address her father: "*Ia ne znala iak to bulo tiazhko, duzhe tiazhko.* I did not know how very difficult it was, how you were in these camps, and *Vy boialysia* means you were frightened, *pro zhyttia*, for your life. I will never forget it. That is my address to my father."[49]

Resilience

Individuals and groups act in ways that profoundly hurt others all over the world without any awareness of having done anything wrong. At times, the sense of entitlement appears ironclad. The victim is often perceived as the problem.

In 2004, I walked into a restaurant in Hamilton, New South Wales, Australia, and soon joined a long-bearded gentleman in conversation. I learned that he was one of the soldiers who, upon returning from the Vietnam War, was spat on when their plane landed on the tarmac. Returning soldiers, he said, experienced a lack of understanding at home. There often was an inability to empathize with them, even by loved ones. Without time and space being made for their stories to be told, it was difficult for soldiers to articulate their trauma and suffering. The veteran told me that the denial was yet another hurt. Many family members denied what they had been through. There was little or no help for dealing with post-traumatic stress.

In Canada, after the First World War, soldiers came back to a jubilant public, appreciative of their efforts. The suffering they experienced, the physical and mental disabilities created by what they had seen and done, was beyond imagination. Many returned soldiers kept their stories quiet. Silent and silenced. There are those who, with courage, spoke out. They have left us wiser, helped strip us of the romance of war.[50]

The Australian war veteran told me of how he went into the bush to reconnect with the land and the more-than-human world. He went to save himself from his wartime experiences and the lack of recognition at home of what had transpired. I know soldiers in Canada and the United States who have done the same when they have returned home shattered. As I went through the photographs on the internment camps in Library and Archives Canada, I found a number of images of internees with animals and birds. I found images of prolific vegetable and flower gardens from the Vernon camp—evidence of the earth's ability to nurture, which the internees knew well. These were some of the opportunities that the internees had to bring the outer landscape and the inner landscapes together.

I have been imaginatively holding the internees and their families in my heart for months, still listening to their words. It is similar to how I continue to "listen" to my baba after her death; her stories and theirs within me continue to inform me. "It is astonishing that shards of these stories of the camps remain," cultural theorist Joan Borsa told me, "and there is nothing that can destroy the memory or the impact of these stories. Lives continue to be affected by them. In so many ways, the stories have a generative power and will live on."[51] There are descendants who tell us that their fathers did not hate. Otto Boyko's father, Maksym, was one of those fathers who did not hold animosity towards those who imprisoned him. While I was speaking with Otto, I turned my head briefly to look at Anne Sadelain, who was bringing tea. When I turn back to Otto, I see he is crying. He is a big man—a former RCMP officer—a man who loved his father. He is holding a handmade wooden crochet hook. It is a small, narrow round of wood maybe seven inches long with a single hook on one end. He is holding it with care. I ask why the hook affects him so much. He responds, "It's one of the very few things we still have from him. The hook was one of the things that he cherished, that he told me about."[52] I wonder who taught him to hook mitts. Was it his mother or another internee who passed on that skill? At the Spirit Lake camp, he could hook mitts for the cold hands and feet of the men who worked cutting logs, or the women who struggled to feed their families with food rations and the small children who suffered forty below temperatures. He could do something. Yes, I thought, the hook is precious to his children; it caught and

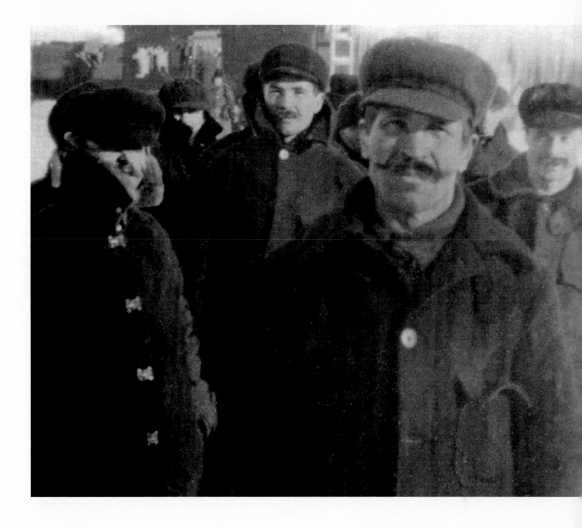

Internees at Kapuskasing
Internment Camp, Ontario.

[Ron Morel Memorial Museum]

knitted their father's humanity. Otto's father also cherished "a pocket watch that he had that was seized from him when he was arrested. It was never returned. He prized this watch."[53] The watch was brought from the homeland. Time, I think, that is what was taken from the internees and never returned.

When I sat down with him in Tim Hortons in Brantford, Ontario, I did not know why Marshall Forchuk was hurting so much. He told me that it was because his father hurt so much. That hurt must have been transferred to the family. His father had committed no crime to be incarcerated. He had been made guilty without a reason. Marshall remarked, "It changed my dad a lot. It changed his politics, changed his outlook on life but what it didn't do, and I can never understand this—it never made my father hate. He never had hate. He had perplexion. Why, why, why?"[54]

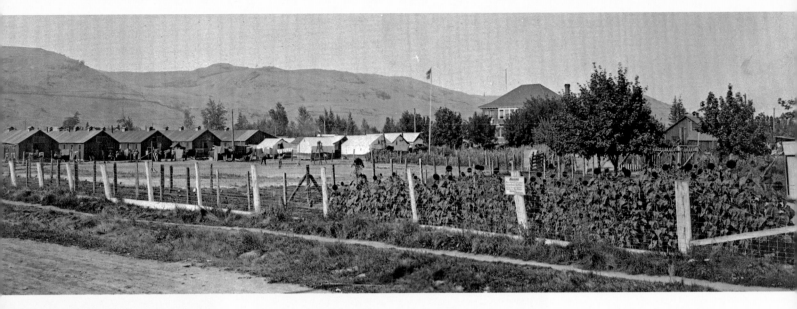

I am still—sitting in my kayak, staring at the bush in front of me. I am taking the war veteran's advice—being still. The sun has risen; the light reflected from the water is playing on the birch tree. I am thinking about the internees' stories as the descendants told them, about their lack of hate. What was frozen into individuals of the next generation? A flash of orange appears. An oriole lands on a nearby branch and pecks at the white berries of the dogwood. I am delighted. Orioles are elusive here. Another oriole comes and they chase each other around the tree, stop and nibble at this and that, then are joined by young thrashers. One thrasher flies down to the ground, two white berries stuffed in its mouth. A catbird comes and meows, then one golden finch and another. A mouse scrambles over the rocks by the water. My mouth opens in awe. There is a reciprocity in nature, a continuous to and fro. The orioles leave and one comes back, this time to the branch closest to me. She looks hard at me; then, as if she has startled herself, leaves quickly. I thought about the internees, the escapees, and those released. Did the time they spent in the bush after their escape or in their new lives return them to self-reliance and dignity? What observations did they make about survival in the wild? Did small animals and birds, the harsh quick deaths, endless births, and the silence of sunrises on water help them accept what happened in the camps, and remind them of who they were?

The Doors Open

Almost one hundred years after the first internment camp opened, on September 13, 2013, Jason Kenney, then federal minister of employment and social development and

< Gardens at Vernon Internment
Camp, British Columbia.
[LAC C-017583]

< Young bears playing, Spirit Lake
Internment Camp, Quebec.
[LAC PA-170645]

Internee and owl, Spirit Lake
Internment Camp, Quebec.
[LAC PA-170542]

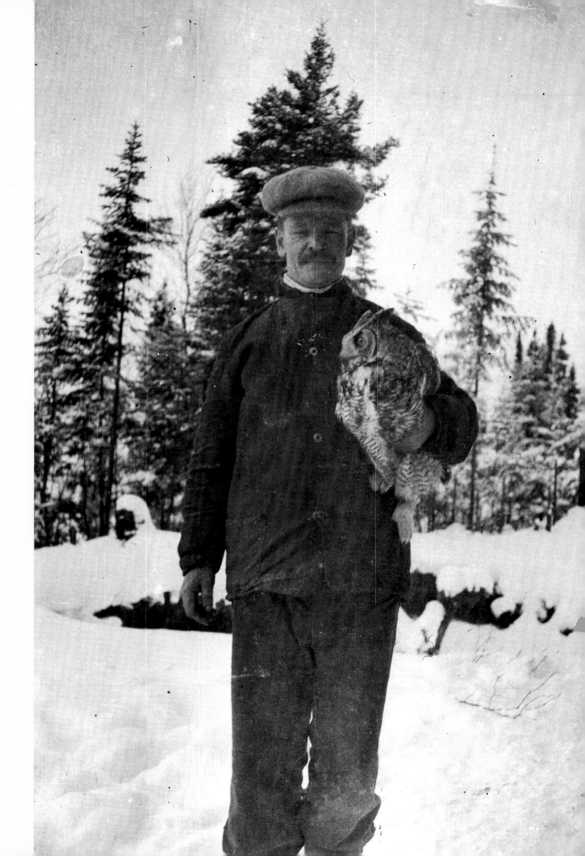

Enemy Aliens exhibit, Cave and Basin National Historic Site, Banff, Alberta, 2013.

[Sandra Semchuk]

minister for multiculturalism, stood before a thousand-square-foot contemporary bunkhouse at the Cave and Basin National Historical Site in Banff, Alberta, to open Parks Canada's exhibit *Enemy Aliens, Prisoners of War: Canada's First World War Internment Operations, 1914–1920.*[55]

Before he asked for the door to be opened, the Honourable Minister Kenney acknowledged the mountains and the wilderness that surrounded us. He reflected on Holocaust survivor Elie Wiesel's words about a moral society committed to memory[56] "to remember the good of which we have been blessed and the evil that we suffered."[57]

In front of the minister were witnesses: descendants of internees; Elders and young

people from communities affected; spiritual leaders who would do the blessings; a senator, politicians, and advocates for justice. On behalf of Canada, Kenney recalled what the internees had endured. The memory was "almost willfully forgotten," he said, thanking the members of the affected communities for having revived the memory of the internment. He spoke eloquently about how we protect the dignity of all persons by creating a site of "permanent memory to transmit to future generations the collective memory of what happened in these places," and to learn so that "future generations will not be tempted by xenophobia—by prejudice—into treating fellow Canadians as enemy aliens." He acknowledged the forced labour, the lack of contact with families, and the censoring of internees trying to communicate with their families.[58]

Kenney continued, "Many of these places kept internees until 18 months following the armistice of November of 1918. If there was any evidence of bad faith and injustice, in this policy of internment, that is it. Then, when they returned home, they simply wanted to put it behind them. And I know amongst many of you, there were parents and grandparents, who were interned in these places, but who did not want to tell the stories. And so it was lost in history." Recognizing the shame that silenced internees and their families, he said, "there was no reason for them to be ashamed."[59] I appreciated the minister's comments and the humility with which he spoke. The responsibility for the near loss of the story does not lie solely in the hands of those interned or the government. It was more than shame that kept them from speaking—there was ongoing racial prejudice after the war was over.

He continued, "The historical record is clear that the Imperial Government in London specifically told the Canadian authorities during the First World War that there was no reason to treat the so-called, 'subjects of Austro-Hungary,' as enemy aliens, that they did not pose a security risk. And so this was a policy designed, conceived and executed—I believe the historical records show—in bad faith. But today we seek symbolically to correct that bad faith through an act of faith, through an act of collective memory." This was a poignant moment in the history of Canada. Kenney added, "We look back with deep regret on a policy that never should have been implemented."[60] An apology had not been requested by the affected communities.[61] Recognition came first.

As the minister spoke, an elderly woman dressed in blue sitting in the front row leaned forward attentively. I observed Lubomyr Luciuk of the Ukrainian Canadian Civil Liberties Association, and Andrew Hladyshevsky, president of the Ukrainian Canadian Foundation of Taras Shevchenko. When the Ukrainian Men's Chorus[62] sang "Vichnaya Pamyat"—eternal memory—they stood together. I thought of people such as Inky Mark, former member of Parliament

for Dauphin–Swan River–Marquette, Manitoba,[63] internees Mary Manko Haskett and Mary Bayrak, and all the descendants who struggled for recognition—to have their stories told and to protect human rights. Kenney's speech was an ethical acknowledgement of the violence, both inner and outer, that the nation had done to innocent men, women, and children in the name of security. Such national self-reflexivity is both humbling and maturing.

The doors opened. Croatian Canadians who had placed a wreath to honour their internees at the door, stood for a photograph, and then went in together. A slight woman bent down to read a text. After twenty minutes or so, Borys Sydoruk and I turned to look at each other.[64] Sydoruk had fought to have this story recognized.[65] "Where are the internees' stories?" he asked. "There is too much here of the jailor's stories."[66] A man nearby paused with his hand curled to his throat staring at a photograph of women and children interned at Spirit Lake.

Jerry Bayrak, a Ukrainian Canadian whose mother, Mary, was born in the Spirit Lake camp, was in conversation with Walter Gerdts, a descendant of a German POW. They had just met. "There was a bounty on Germans. My father had been turned in," Gerdts said. "My father was interned in 1916 and sent to the Banff prisoner camp. He lost everything, the homestead, the horses, a bull, a good plough and three years of his life." His father had refused to break rocks at the Cave and Basin camp. "He said

it was a waste of humanity." Gerdts continued, "So they sent him to Kapuskasing. He was so hungry there that he used to steal potatoes from the pigs. He was released on September 3, 1919 — ten months after the armistice."[67] Bayrak told Gerdts about the tuberculosis his grandmother developed in the camp, how it plagued three generations of women in his family. Stories were exchanged across affected cultures.

Another interpretive centre opened at the site of Spirit Lake Internment Camp, near Amos, Quebec, on November 24, 2011.[68] These centres are a small part of the recognition needed to slowly transform the social and political effects on immigrant communities that experienced internment. I think of the Japanese Canadian story. Filmmaker and friend Linda Ohama goes to see the family home and where her grandfather's boat-making business was in Steveston, British Columbia, as a visitor to a museum.[69] She is a visitor to her family home. It is tragic. The intergenerational implications of the second time that the War Measures Act was used, to intern Japanese Canadians, have not been recognized collectively in Canada. For democracy and the protection of human rights to have meaning across cultures in Canada, it is important that these stories register, be accepted, and become a part of comprehending the roles that race and immigration have played in the building of the nation.

A small note was posted on a bulletin board for comments: "The stories are being

told." "I wept," descendant Marsha Forchuk Skrypuch said when she realized that the stories were going to be told in these centres. "It makes me cry. It is so important to have the recognition and the memory, but it also really hurts."[70]

I turned to leave the Interpretative Centre at Cave and Basin where Parks Canada has told the stories. Outside the open back door, just a few feet away, was a young tree, backlit, its leaves caught with horizontal strands of spider webs, shivering in the sun. I smiled remembering Forchuk Skrypuch's story, *Silver Threads*, where Ivan and Anna offer food to the spider for good luck before fleeing the homeland to Canada to avoid conscription into the foreign government's army.[71] When Dad got older he used to gently pick spiders up and carry them out of the house to be free. James did too. I thought of Gerdts and Bayrak telling stories across cultures that were interned, and about the bits of dialogue I overheard. As in my experience of the mushrooms at Castle Mountain, the presence of the internees appeared and disappeared, remaining liminal, their past in the present.

Notes

Foreword

1. Italo Calvino, *Six Memos for the Next Millennium*, trans. Patrick Creigh (Cambridge, MA: Harvard University Press, 1998), 16.
2. Calvino, *Six Memos*, 20.
3. James Gilligan, *Violence: Reflections on a National Epidemic* (New York: Vintage, 1997).
4. Lubomyr Y. Luciuk, with the assistance of Natalka Yurieva and Roman Zakaluzny, *Roll Call: Lest We Forget* (Kingston, ON: Kashtan Press for the Ukrainian Canadian Civil Liberties Association and the Ukrainian Canadian Congress, 1999).
5. Christine died in 2017 at the age of 104.
6. Dorothy E. Smith, "Telling the Truth after Postmodernism," in *Writing the Social: Critique, Theory, and Investigations* (Toronto: University of Toronto Press, 1999), 109.
7. Thank you to Natalia Khanenko-Friesen for watching the video recording of the interview with me and translating this phrase from Ukrainian.

Preface

1. It has been largely through the foresight, persistence, and determination of the Ukrainian Canadian Civil Liberties Association (UCCLA) that the story of Canada's first internment operations has been recovered and brought into collective memory. This is the text from the plaque put up by UCCLA in 1995 at the site of Castle Mountain Internment Camp. Similar plaques have been placed with ceremony and acknowledgement of the internees at each of the sites of the camps with money raised by the UCCLA and the Descendants of Ukrainian Canadian Internee Victims Association, and with funds from the Ukrainian Canadian Foundation of Taras Shevchenko.
2. Orest Subtelny, *Ukrainians in North America: An Illustrated History* (Toronto: University of Toronto Press, 1991), 37, 38.
3. Subtelny, *Ukrainians in North America*, 37. British Canadians, English, Scots, Irish, and Americans comprised the majority of immigrants to Canada soon after 1870. Subtelny writes that Germans, Jews, Icelanders, Mennonites, and Ukrainians came more than a decade later.
4. Subtelny, *Ukrainians in North America*, 35.
5. *Bohunk* was derivative from *Bohemians* and *hunkie* from *Hungarians*. Both terms were used pejoratively to name Slavs and Eastern Europeans.
6. Medicare was spearheaded by Tommy Douglas. In 1962, in the province of Saskatchewan, the Co-operative Commonwealth Federation government of Woodrow Lloyd successfully piloted Medicare into implementation. Medicare was a provincial health-care system that provided equal access to medical services without cost. There were conflicts and strikes. My father's life, as a member of the Legislative Assembly at that time, was threatened. Canada's universal health-care system emerged out of this initiative.

7. Bernice King, "Speech at the Walk for Reconciliation," Vancouver, September 27, 2013, video, Reconciliation Canada, http://reconciliationcanada.ca/bernice-kings-speech-at-the-walk-for-reconciliation/.

8. Wikipedia, s.v. "Ukrainian Canadian Internment," last modified February 4, 2018, 1:06, http://en.wikipedia.org/wiki/Ukrainian_Canadian_internment.

9. Ali Kazimi, *Undesirables: White Canada and the Komagata Maru: An Illustrated History* (Vancouver: Douglas & McIntyre, 2012), xvii.

Introduction

1. There were two classes of prisoners: prisoners of war and enemy aliens. Prisoners of war could not be forced to labour, according to the Hague Convention. Enemy aliens were seen to be outside of that law and were forced to labour.

2. Orest Subtelny, *Ukraine: A History*, 3rd ed. (Toronto: University of Toronto Press, 2000), 307.

3. The term *conciliation* is used by author, artist, and teacher David Garneau to signal that there is no "re." David Garneau, "Imaginary Spaces of Conciliation and Reconciliation," *West Coast Line* 46, no. 2 (Summer 2012): 35, www.belkin.ubc.ca/file_download/34/Pages+from+West+Coast+Line+74.pdf.

4. Trinh T. Minh-ha, *Woman, Native, Other: Writing Postcoloniality and Feminism* (Bloomington: Indiana University Press, 1989), 1.

5. Walter Benjamin, "The Storyteller: Reflections on the Work of Nikolai Leskov," in *The Novel: An Anthology of Criticism and Theory 1900–2000*, ed. Dorothy J. Hale (Malden, MA: Blackwell Publishing, 2006), 362.

6. Charles Taylor quoted in Pierre Dessureault, *Sandra Semchuk: How Far Back Is Home* (Ottawa: Canadian Museum of Contemporary Photography, 1995), 23, exhibition catalogue.

7. *The Medicine Project*, a collaborative work by Sandra Semchuk and James Nicholas, can be accessed at www.themedicineproject.com.

8. Barry Lopez, "Story at Anaktuvuk Pass: At the Junction of Landscape and Narrative," *Harper's Magazine*, December 1984, 2, https://harpers.org/archive/1984/12/story-at-anaktuvuk-pass/.

9. UCCLA placed a plaque in Nanaimo marking the internment offsite, close to a walking path and the water.

10. Annette Kuhn, *Family Secrets: Acts of Memory and Imagination* (London: Verso, 1995), 5.

11. Kuhn, *Family Secrets*, 9.

12. Kuhn, *Family Secrets*, 2–6.

13. *Jajo's Secret*, dir. James Motluck (Toronto: Guerrilla Films, 2009), DVD.

14. Benjamin "The Storyteller," 364.

15. Manuel Piña, in discussion with the author, Vancouver, June 2011.

16. Piña, discussion.

17. Anastasia Malowski, in discussion with the author, Prince Albert, SK, 1979.

18. Edmund Carpenter, "Art and the Declassification and Reclassification of Knowledge," *The Structurist* 10 (1971): 18.

19. Blair Stonechild and Bill Waiser, *Loyal till Death: Indians and the North-West Rebellion*, new ed. (Markham, ON: Fifth House, 2010), 220.

20. Diane Tootoosis, in discussion with the author, Poundmaker Cree Nation, SK, May 2013.

21. Bill Waiser, *Park Prisoners: The Untold Story of Western Canada's National Parks, 1915–1946* (Saskatoon, SK: Fifth House, 1999), 3.

22. Stonechild and Waiser, *Loyal till Death*, 126, 127.

23. Waiser, *Park Prisoners*, 10.

24. Lubomyr Luciuk, *In Fear of the Barbed Wire Fence: Canada's First National Internment Operations and the Ukrainian Canadians, 1914–1920* (Kingston, ON: Kashtan Press, 2001), 6.

25. "Keeping Tab on the Aliens," *Brandon Sun*, August 12, 1915, as cited in Luciuk, *In Fear of the Barbed Wire Fence*, 7.

26. Joy Kogawa, *Obasan* (New York: Knopf Doubleday, 1993), epigraph.

27. Roy Miki, *Redress: Inside the Japanese Canadian Call for Justice* (Vancouver: Raincoast Books, 2004).

28. Miki, *Redress*, 255.

29. Kogawa, *Obasan*, 69.

30. Fred Olynyk, in discussion with the author, Kamloops, BC, July 2008.

31. Olynyk, discussion.

32. Jean Gural, in discussion with the author, Toronto, October 2006.

33. Avishai Margalit, *The Ethics of Memory* (Cambridge, MA: Harvard University Press, 2004), 4.

34. Bill Waiser, in discussion with the author, Saskatoon, SK, June 2007.

35. Bert Hellinger, *Love's Hidden Symmetry: What Makes Love Work in Relationships* (Phoenix, AZ: Zeig, Tucker & Co., 1998), 10.

36. "Nearly 400 Interns at Fernie," *District Ledger* (Lethbridge, AB), June 19, 1915.

37. "Nearly 400 Interns at Fernie," *District Ledger* (Lethbridge, AB), June 19, 1915.

38. Hellinger, *Love's Hidden Symmetry*, 10.

39. Anne Sadelain, in discussion with the author, Edmonton, AB, November 2010.

40. Hellinger, *Love's Hidden Symmetry*, 10.

41. Jay Frankel, "Psychological Enslavement Understood through Ferenczi's Concept of Identification with the Aggressor, with a Focus on the Clinical Situation," presentation given at the Western Branch Canadian Psychoanalytic Society conference, Vancouver, October 2011, 1.

42. Frankel, "Psychological Enslavement," in answer to a question by the author.

43. Frankel, "Psychological Enslavement," 2.

44. Letter from Sir Hugh Macdonald to the Honourable A. Meighen, July 3, 1919, reprinted in *A Delicate and Difficult Question: Documents in the History of Ukrainians in Canada, 1899–1962*, introduction and annotations by Bohdan Kordan and Lubomyr Y. Luciuk (Kingston, ON: Limestone Press, 1986), 43–45.

45. Marsha Forchuk Skrypuch and Michael Martchenko (illus.), *Silver Threads* (Markham, ON: Fitzhenry & Whiteside, 2004), 3.

46. Skrypuch and Martchenko, *Silver Threads*.

47. Subtelny, *Ukraine*, 309.

48. Subtelny, *Ukraine*, 310.

49. Nick Topolnyski, in discussion with the author, Calgary, AB, September 2008.

50. Gerald Kohse, in discussion with the author, Nanaimo, BC, July 2006.

51. Anna Reid, *Borderland: A Journey through the History of Ukraine* (Boulder, CO: Westview Press, 2000), 73.

52. Subtelny, *Ukraine*, 310.

53. Subtelny, *Ukraine*, 310.

54. Taras Shevchenko, "To the Living, the Dead and the Not Yet Born," as quoted on the jacket of Lubomyr Melnyk, *To the Living, the Dead and the Not Yet Born*, Studio 306, 1984, LP album.

55. Aung San Suu Kyi, *The Voice of Hope: Conversations with Alan Clements* (New York: Seven Stories Press, 1997), 61.

56. John Gregorovich, in discussion with the author, Canmore, AB, September 2008.

57. Mary Manko Haskett, afterword to *Righting an Injustice: The Debate over Redress for Canada's First National Internment Operations*, ed. Lubomyr Luciuk (Justinian Press, 1994), accessed May 29, 2018, http://www.infoukes.com/history/internment/booklet02/doc-105.html.

58. David Lowenthal, "On Arraigning Ancestors: A Critique of Historical Contrition," *North Carolina Law Review* 87, no. 3 (2009): 901–66, http://scholarship.law.unc.edu/cgi/viewcontent.cgi?article=4367&context=nclr.

59. Lowenthal, "On Arraigning Ancestors," 956.

60. Lowenthal, "On Arraigning Ancestors," 957.

61. Excerpt of minutes of meeting of the Treasury Board, Ottawa, March 5, 1954, as reproduced in Lubomyr Luciuk, *Without Just Cause: Canada's First National Internment Operations and the Ukrainian Canadians, 1914–1920* (Kingston, ON: Kashtan Press, 2006), 48.

62. Ukrainian Canadian Civil Liberties Association, "Internment Operations Museum to Open in Banff National Park," media release, February 14, 2013, http://ukrainianvancouver.com/internment-operations-museum-to-open-in-banff-national-park/. Donations for this important work came in from all over the country as well as from grants from the Ukrainian Canadian Foundation of Taras Shevchenko.

63. Bohdan S. Kordan and Craig Mahovsky, *A Bare and Impolitic Right: Internment and Ukrainian-Canadian Redress* (Montreal and Kingston: McGill-Queen's University Press, 2004), 67.

64. Kordan and Mahovsky, *A Bare and Impolitic Right*, 58.

65. Andrew Hladyshevsky, president of the Ukrainian Canadian Foundation of Taras Shevchenko, transcribed from video, Ryan Boyko, *The Camps* webseries, season 2, episode 15, accessed July 1, 2017, https://www.internmentcanada.ca/.

66. Bill c-331, Internment of Persons of Ukrainian Origin Recognition Act, 1st sess., 37th Parliament, sc, 2001, http://www.parl.ca/DocumentViewer/en/37-1/bill/C-331/first-reading/page-16.

67. Member of Parliament Inky Mark, in discussion with the author, Dauphin, MB, November 2006.

68. Lubomyr Luciuk, Editor's introduction to *Righting an Injustice: The Debate over Redress for Canada's First National Internment Operations*, ed. Lubomyr Luciuk (Justinian Press, 1994), accessed July 9, 2017, https://infoukes.com/history/internment/booklet02/index.html.

69. Lubomyr Luciuk, "No Request for Apology, re: 'Cult of Apologies Raises Issues,' June 4," letter to the editor, *Kingston Whig-Standard*, June 7, 2016, www.thewhig.com/2016/06/07/letters-to-the-editor-june-8.

70. As explained in the "About CFWWIRF" section of their website, the fund "is designated for the support of projects

to commemorate and recognize the experiences of ethno-cultural communities affected by the First World War Internment. Only the interest earned on the $10 million is used to fulfill the objective of the Fund" (accessed June 14, 2018, https://www.internmentcanada.ca/about-the-fund.cfm).

71. Luciuk, "No Request for Apology." The fund also supported Ryan Boyko's *The Camps* webseries (Armistice Films); Boyko also worked with descendants and camp sites. For a list of other projects, go to https://www.internmentcanada.ca.

1 Learning From the Past

1. Sandra Semchuk and James Nicholas, *Enemy Aliens: Castle Mountain Internment Camp*, 2006, photographic installation.

2. Waiser, *Park Prisoners*, 5.

3. Waiser, *Park Prisoners*, 5, 6.

4. Desmond Morton, transcribed from *Freedom Had a Price*, directed by Yurij Luhovy (Montreal: M M L Inc. and N F B, 1994), D V D.

5. Tim Cook, *At the Sharp End*, vol. 1, *Canadians Fighting the Great War, 1914–1916* (Toronto: Viking, 2007), 22.

6. Cook, *At the Sharp End*, 23.

7. Donald Sutherland in his reply to the Governor General's Speech from the Throne on August 19, 1914, *Official Report of the Debates of the House of Commons of the Dominion of Canada*, vol. 118, 4, http://oxfordcounty.ca/portals/15/documents/timeline/categories/wwi/Military%20Action/sutherland%27s%20speech%20-%201914.pdf.

8. Sutherland, quoting Prof. F.V. Riethdorf of Woodstock College, in his reply to the Governor General's Speech from the Throne on August 19, 1914, *Debates of the House of Commons*, vol. 118, 4.

9. Sutherland, in his reply to the Governor General's Speech from the Throne on August 19, 1914, *Debates of the House of Commons*, vol. 118, 4.

10. Prime Minister Robert Borden, House of Commons, August 19, 1914, *Official Report of the Debates of the House of Commons of the Dominion of Canada*, vol. 118, 15.

11. Minister of Justice, the Honourable C.J. Doherty, House of Commons, August 19, 1914, *Official Report of the Debates of the House of Commons of the Dominion of Canada*, vol. 118, 20.

12. Doherty, *Debates of the House of Commons*, vol. 118, 20.

13. The Honourable William Pugsley, House of Commons, August 19, 1914, *Official Report of the Debates of the House of Commons of the Dominion of Canada*, vol. 118, 22.

14. Doherty, *Debates of the House of Commons*, vol. 118, 22.

15. Peter Melnycky, "Internment of Ukrainians in Canada," in *Loyalties in Conflict: Ukrainians in Canada during the Great War*, ed. Frances Swyripa and John Herd Thompson (Edmonton, AB: Canadian Institute of Ukrainian Studies Press, 1983), 2.

16. Bohdan S. Kordan, *No Free Man: Canada, the Great War, and the Enemy Alien Experience* (Montreal and Kingston: McGill-Queen's University Press, 2016), 41.

17. Melnycky, "Internment of Ukrainians," 3.

18. Luciuk, *Without Just Cause*, 2.

19. Roger Daniels, presentation at the Kingston Symposium, Canadian First World War Internment Recognition Fund event, Kingston, ON, June 17–20, 2010.

20. Gregorovich, discussion.

21. Kordan, *No Free Man*, 38.

22. William Otter, *Report on Internment Operations: Canada Internment Operations, 1914–1920* (Ottawa: Printer to the King's Most Excellent Majesty, 1921), 6; Desmond Morton, *The Canadian General Sir William Otter* (Toronto: Hakker, 1974), 338.

23. Melnycky, "Internment of Ukrainians," 3.

24. Hilda and Frederick Kohse's stories, as told by Gerald and Pamela Kohse, in discussion with the author, Nanaimo, BC, July 2006.

25. *Free Dictionary*, s.v. "habeas corpus," accessed July 7, 2017, http://legal-dictionary. thefreedictionary.com/Habeas+corpus.

26. The Hague Convention, Hague Convention IV, Convention Respecting the Laws and Customs of War, October 18, 1907, accessed June 21, 2016, http://net.lib.byu.edu/-rdh7/ wwi/hague/hague5.html.

27. Waiser, *Park Prisoners*, 10.

28. Luciuk, *Without Just Cause*, 50.

29. Waiser, *Park Prisoners*, 10.

30. Luciuk, *In Fear of the Barbed Wire Fence*, 5.

31. Waiser, *Park Prisoners*, 4.

32. Waiser, *Park Prisoners*, 12.

33. Waiser, *Park Prisoners*, 17.

34. Waiser, *Park Prisoners*, 14, 15.

35. Luciuk, *Without Just Cause*, 3.

36. Albert Bobyk, in discussion with the author, Brandon, MB, November 2006.

37. Gwen Cash, *I Like British Columbia* (Toronto: Macmillan, 1938), 13.

38. Cash, *I Like British Columbia*, 13, 14.

39. Peter Melnycky, "Internment of Ukrainians," 9.

40. Transcribed from videotaped conversation with author's father, Martin Semchuk, Murray Lake, SK, August 1984.

41. Internee Nicholas Lypka, transcribed from Yurij Luhovy's documentary *Freedom Had a Price*.

42. Charles Taylor, *Multiculturalism and the Politics of Recognition* (Princeton, NJ: Princeton University Press, 1992), 32.

43. Philip Yasnowskyj, "Internment," in *Land of Pain, Land of Promise: First Person Accounts by Ukrainian Pioneers 1891–1914*, trans. and ed. Harry Piniuta (Saskatoon, SK: Western Producer Prairie Books, 1978, 1981), 189.

44. Cash, *I Like British Columbia*, 8–12.

45. Cash, *I Like British Columbia*, 12.

46. Melnycky, "Internment of Ukrainians in Canada," 1–24.

47. Sir Wilfrid Laurier, House of Commons, *Hansard*, September 10, 1917, 5889.

48. Melnycky, "Internment of Ukrainians," 9.

49. Andrew Hladyshevsky, QC, has given permission to publish this letter from the Dr. Myroslav Hladyshevsky Archives, Calgary, AB.

50. District Officer Commanding, Military District No. 13 (signature unreadable) to Major J.S. Stewart, O.C. 25th Battery, C.F.A., May 8, 1917, Internment Camp, Lethbridge, RG24 4694, 448.14.20, vol. 2, Library and Archives Canada.

51. Peter Melnycky, "Badly Treated in Every Way: The Internment of Ukrainians in Quebec during the First World War," 1993, accessed June 1, 2018, http://www. infoukes.com/history/internment/ badly_treated_in_every_way/.

52. General Secretary E.A. McKillop, quoted in Bohdan S. Kordan and Peter Melnycky, eds., *In the Shadow of the Rockies: Diary of the Castle Mountain Internment Camp, 1915–1917*

(Edmonton, AB: Canadian Institute of
Ukrainian Studies Press, 1991), 76.

53. Otter, *Report on Internment Operations*, 7.

54. Gerald and Pamela Kohse, discussion.

55. Otter, *Report on Internment Operations*.

56. Otter, *Report on Internment Operations*, 6.

57. Otter, *Report on Internment Operations*.

58. Morton, *Sir William Otter*, 67.

59. Morton, *Sir William Otter*, 69.

60. Morton, *Sir William Otter*, 71.

61. Sandra Semchuk and James Nicholas, *Enemy Aliens: Castle Mountain Internment Camp*, 2006, photographic installation.

62. From a collaborative photographic installation with my father, Martin Semchuk, titled *In Death's Embrace*, Katmai, AK, and Vancouver, BC, 1994.

3 Stories from Internees and Descendants

1. Mary Bayrak, in discussion with the author, December 2007.

2. Excerpt of "Internment," by Philip Yasnowskyj (originally in Ukrainian), trans. and ed. Harry Piniuta, in *Land of Pain, Land of Promise: First Person Accounts by Ukrainian Pioneers 1891–1914* (Saskatoon, SK: Western Producer Prairie Books, 1978, 1981), 189–95. In his translation of Yasnowskyj's book *Pid ridnym i pid chuzhym nebom* (Under native and alien skies), Piniuta explains, "Philip Yasnowskyj describes his experiences in an internment camp or aliens during World War I. The author was working in a mine in Schumacher, Ontario, when the war broke out, and though an Austrian only by citizenship and not by nationality, he and thousands of others like him were defined as enemy aliens by the Canadian government and, as such, were rounded up and confined in forced-labour camps" (179).

3. Bohdan Khmelnytsky was Hetman, or leader, of Ukraine from 1648 to 1657. He led a successful uprising against Polish rule that resulted in a great national movement and the establishment of the Ukrainian Hetman State. The statue in Kiev was carved by Mikhailo Mykeshyn.

4. The People's Daily.

5. "Christ is Risen," a stirring, traditional Ukrainian Easter hymn.

6. Ukrainians of the Greek Catholic and Greek Orthodox faith observe Easter Monday and Easter Tuesday as holy days.

7. The feast is celebrated on the fortieth day after Easter.

8. *Svoboda*, the oldest Ukrainan daily in North America, was founded in Jersey City, New Jersey, in 1893.

9. Transcript of interview with Nikola Sakaliuk, by Lubomyr Y. Luciuk, "WWI Internment Account of a Ukrainian at Fort Henry," in Royal Military College of Canada, "Internal Security and an Ethnic Minority: The Ukrainians and Internment Operations in Canada, 1914–1920," SIGNUM 4, no. 2 (1978): 55–58. In the SIGNUM publication, this transcribed interview is titled Appendix 1, "An Internee Remembers"; the publication is held at Special Collections, Massey Library, Royal Military College of Canada, Kingston, Ontario. The original videotaped interview is stored at the Multicultural History Society of Ontario in Toronto.

10. In her article "Pioneer Bishop, Pioneer Times: Nykyta Budka in Canada," Stella Hryniuk gives this bit of important historical context: "On 27 July 1914—

at a time when war on the European continent seemed imminent but when no country was at war and very few Canadians thought that the British Empire would be involved—Budka issued a Pastoral Letter in which he urged Ukrainians who still had military reservist obligations in Austria to return home: 'Perhaps we will have to defend Galicia from seizure by Russia with its appetite for Ruthenians....'...By 4 August Britain was at war and Russia was on the same side" (34). Budka wrote a letter on August 6 asking that his July 27 letter be disregarded because of the changed situation and that everyone do their duty to Canada. Despite the new letter, and with no substantiation, Budka was accused of disloyalty in the *Manitoba Free Press*. The damage had been done. See Stella Hryniuk, "Pioneer Bishop, Pioneer Times: Nykyta Budka in Canada," *Historical Studies* 55 (1988): 21–41, http://www.cchahistory.ca/journal/CCHA1988/Hyrniuk.pdf.

11. Kim Pawliw, "Tribute to My Grandmother," in *Kobzar's Children: A Century of Untold Ukrainian Stories*, ed. Marsha Forchuk Skrypuch (Markham, ON: Fitzhenry & Whiteside, 2006), 28.

12. *The Barbed Wire Solution: Ukrainians and Canada's First Internment Operations, 1914–1920*, curated by Svitliana Medwidsky, 1995.

13. During the Depression of the 1930s, boys wheeled steel hoops obtained from scrap piles for a fun challenge, much as boys push and ride skateboards today.

14. The conversation was in Ukrainian. The author's version of it in English here is from memory. Consequently, this is not necessarily a precise word-for-word translation of their conversation. However, the meaning of their conversation and its ambience is conveyed here in a very reliable way.

15. Racist hatred permeated society at this time. Young people expressed such hatred freely through pejorative name-calling. The boys would not have been charged or reprimanded for an expression of racial hatred at that time as they might today.

16. Initiated in 1999, Project Roll Call is the work of Lubomyr Luciuk, Natalka Yurieva, and Roman Zakaluzny, who reviewed and compiled the available records of the Office of Internment Operations in an effort to provide specific information about the Ukrainians and other Eastern Europeans who were imprisoned as "enemy aliens" during Canada's first national internment. The resulting publication lists nearly 5,200 internees' names. See Lubomyr Y. Luciuk, with the assistance of Natalka Yurieva and Roman Zakaluzny, *Roll Call: Lest We Forget* (Kingston, ON: Kashtan Press for the Ukrainian Canadian Civil Liberties Association and the Ukrainian Canadian Congress, 1999). A link to this document can be found at https://www.uccla.ca/ukrainian-canadian-internment.

17. Bohdan S. Kordan and Peter Melnycky, eds., *In the Shadow of the Rockies: Diary of the Castle Mountain Internment Camp, 1915–1917* (Edmonton, AB: Canadian Institute of Ukrainian Studies Press, 1991).

18. Kordan and Melnycky, *In the Shadow of the Rockies*, 139.

5 Engaging Memory Work

1. Frances Swyripa, "Ukrainians," in *Encyclopedia of Canada's Peoples*, ed. Paul Robert Magocsi (Toronto: University of Toronto Press, 1999), 1309.

2. Harald Welzer, "The Collateral Damage of Enlightenment: How Grandchildren Understand the History of National Socialist Crimes and Their Grandfathers' Past," in *Victims and Perpetrators: 1933–1945: (Re)Presenting the Past in Post-Unification Culture*, ed. Laurel Cohen-Pfister and Dagmar Wienroeder-Skinner (Berlin: De Gruyter, 2006), 285.

3. Kuhn, *Family Secrets*, 8.

4. Marshall Forchuk, discussion with author, Brantford, ON, November 2006.

5. Neal McLeod, *Cree Narrative Memory: From Treaties to Contemporary Times* (Saskatoon, SK: Purich Publishing, 2007), 93–94.

6. Mary Manko Haskett, as quoted by Lubomyr Luciuk, brochure for the Kingston Symposium, a Canadian First World War Internment Recognition Fund event, June 17–20, 2010.

7. Fran Haskett, transcribed from "Flowers for Nellie," *The Current*, CBC Radio, 2008.

8. Mary Manko Haskett, transcribed from "Flowers for Nellie."

9. Elizabeth Church, "Internees' Stories Can Finally Be Told," *Globe and Mail*, September 12, 2009, https://www.theglobeandmail.com/news/national/internees-stories-can-finally-be-told/article1203946/.

10. Peter Melnycky, in discussion with the author, Edmonton, AB, November 2010.

11. Bill Waiser, in discussion with the author, Saskatoon, SK, August 2010.

12. David Lowenthal, in discussion with the author, December 2010.

13. David Lowenthal, *The Past Is a Foreign Country – Revisited* (New York: Cambridge University Press, 2015), 395.

14. Harry Williams, in discussion with the author, Fernie, BC, June 2006.

15. Nancy Huston, *Losing North: Essays on Cultural Exile* (Toronto: McArthur & Company, 2002), 79.

16. Wasyl Bobyk certificate of release, Brandon, MB, April 1916, e010775944, Library and Archives Canada.

17. Yasnowskyj, "Internment," 185.

18. Sadelain, discussion.

19. Walter H. Doskoch, *Straight from the Heart: Biography of W. (Bill) Doskoch 1893–1941* (Edmonton, AB: self-pub., 1985–1993), 3. Permission to publish from the Estate of Walter Doskoch.

20. Doskoch, *Straight from the Heart*, 3.

21. Aung San Suu Kyi, *The Voice of Hope*, 209.

22. There was a request that the uncle remain anonymous.

23. Andrew Antoniuk, discussion with the author, near Chipman, AB, August 2007.

24. Bohdan S. Kordan, *No Free Man: Canada, the Great War, and the Enemy Alien Experience* (Montreal and Kingston: McGill-Queen's University Press, 2016), 79.

25. Antoniuk, discussion, 2007.

26. Andrew Antoniuk, in discussion with the author (phone), October 2011.

27. Antoniuk, discussion, 2007.

28. Judith Herman, *Trauma and Recovery: The Aftermath of Violence—From Domestic Abuse to Political Terror* (New York: Basic Books, 1997), 56.

29. Herman, *Trauma and Recovery*, 56.

30. Herman, *Trauma and Recovery*, 188.

31. Herman, *Trauma and Recovery*, 188.

32. Antoniuk, discussion, 2007.

33. Antoniuk, discussion, 2007.

34. Funding from the Canadian First World War Recognition Fund has made it possible for the Descendants of Ukrainian Canadian Internee Victims Association to encourage the public education system to develop curricula based on the internment camps. Information is available at https://www.internmentcanada.ca.

35. Rev. G.E. Ross, "Michael Bahri," *Peterborough This Week*, September 17, 1920. Ross was pastor of the Mark Street Methodist Church.

36. Bahry [Bahriy], Dmetro–Subject of Austria, Certificate of release from internment camp at Spirit Lake, Quebec, 1916, RG6-H-1, vol. 772, file Ba-Bl, e01077594, Library and Archives Canada.

37. Custodian of Enemy Property and Internment Operations, 1916, RG6-H-1, vol. 756, file 3360, Pt. I, Welland Canal, POW Labour, Library and Archives Canada.

38. Internment-Disposition of balance of working pay at credit of Dymetro Bahry, executed at Peterborough, RG13, Ministry of Justice, series A-2, vol. 249, file 1920-1136, Library and Archives Canada.

39. RG13, Ministry of Justice, series A-2, vol. 249, file 1920-1136, Library and Archives Canada.

40. *Peterborough This Week*, September 17, 1920.

41. Members of the Ministerial Association (Malott, Srobb, Davidson, Ross, Chapman, White, Poque, Thomas, MacKenzie) to the Minister of Justice pleading for the lives of the young men, December 8, 1919, Peterborough, ON, RG13, vol. 1503, file 638A/CC127, Library and Archives Canada.

42. P.T. Ahern, Esq., Counsel for Korncheck, Telegram to the Minister of Justice, Ottawa, January 13, 1920, Peterborough Museum and Archives, Peterborough, ON.

43. "Thomas Kornek and Michael Bahri Hanged This Morning," *Peterborough Daily Review*, January 14, 1920.

44. David Lowenthal, "On Arraigning Ancestors: A Critique of Historical Contrition," *North Carolina Law Review* 87, no. 3 (2009): 901–66, http://scholarship.law.unc.edu/cgi/viewcontent.cgi?article=4367&context=nclr.

45. Lowenthal, "On Arraigning Ancestors," 946.

46. Prime Minister Stephen Harper, "Statement of Apology to Former Students of Indian Residential Schools," Speech in House of Commons, June 11, 2008, https://www.aadnc-aandc.gc.ca/eng/1100100015644/1100100015649.

47. Otto and Kathleen Boyko, in discussion with the author, Edmonton, AB, September 2006.

48. Donna Korchinski, in discussion with the author, Calgary, AB, September 2008.

49. Jean Gural, transcribed from *Security: The Internment of Nikolai Tkachuk*, videographer Sandra Semchuk (2007).

50. Wade Davis, *Into the Silence: The Great War, Mallory, and the Conquest of Everest* (New York: Knopf, 2011), 33.

51. Joan Borsa, in discussion with the author, Saskatoon, SK, August 2014.

52. Otto Boyko, in discussion with the author, Edmonton, AB, September 2006.

53. Otto and Kathleen Boyko, discussion.

54. Forchuk, discussion.

55. Colette Derworiz, "Exhibit into First World War Internment Camps in Banff Officially Opens," *Calgary Herald*, September 14, 2013,

http://www.calgaryherald.com/news/ alberta/Exhibit+into+First+World+ internment+camps+Banff+officially+ opens/8910908/story.html.

56. Elie Wiesel, "Hope, Despair and Memory," Nobel Lecture, December 11, 1986, accessed May 7, 2018, http://www.nobelprize.org/ nobel_prizes/peace/laureates/1986/ wiesel-lecture.html.

57. Address Delivered by the Honourable Jason Kenney, Minister of Employment and Social Development and Minister for Multiculturalism, at the Opening Ceremony of the National Internment Exhibit at Cave and Basin National Historic Site, Banff, AB, September 13, 2013, https://www.internmentcanada.ca/PDF/ Address%20delivered%20by%20the%20 Minister%20Kenney.pdf.

58. Kenney, Address.

59. Kenney, Address.

60. Kenney, Address.

61. Lubomyr Luciuk, "No Request for Apology, re: 'Cult of Apologies Raises Issues,'" letter to the editor, June 4, *Kingston Whig-Standard*, June 7, 2016.

62. The Ukrainian Male Chorus of Edmonton and the Axios Men's Ensemble.

63. On November 25, 2005, Inky Mark, then member of Parliament for Dauphin–Swan River–Marquette, Manitoba, had his private member's Bill C-331, Internment of Persons of Ukrainian Origin Recognition Act, receive royal assent.

64. Inky Mark met Borys Sydoruk from the Ukrainian Canadian Civil Liberties Association, at the unveiling of a plaque to commemorate the internment camp in 1994 in Brandon, Manitoba. The dialogue, friendship, and cross-cultural learning that followed in their exchange about the Chinese Head Tax and the internment of Ukrainians in Canada set the stage to the development of Mark's private member's Bill C-331.

65. Borys Sydoruk was on the executive for the Ukrainian Canadian Civil Liberties Association for two decades.

66. Borys Sydoruk, in discussion with the author, Banff, AB, September 2013.

67. Walter Gerdts, in discussion with the author, Banff, AB, September 2013.

68. James Slobodian worked to develop the Spirit Lake Camp Interpretive Centre; for a video of the opening of the centre, see https://www.youtube.com/ watch?v=Ybk8kSmLuDY&feature=player_ embedded, accessed October 24, 2013.

69. See Linda Ohama's documentary film *Obachan's Garden* (Montreal: National Film Board, 2001).

70. Marsha Forchuk Skrypuch, as quoted in Bill Graveland, "First Word War Internment Camps a 'Difficult Scar' for Canadian Ukrainians," *StarPhoenix* (Saskatoon, SK), September 9, 2012.

71. Skrypuch and Martchenko, *Silver Threads*.

Bibliography

Conversations with the Author

Andrew Antoniuk, near Chipman, AB, August 2007

Andrew Antoniuk, phone, October 2011

Albert Bobyk, Brandon, MB, November 2006

Joan Borsa, Saskatoon, SK, August 2014

Otto Boyko, Edmonton, AB, September 2006

Otto and Kathleen Boyko, Edmonton, AB, September 2006

Marshall Forchuk, Brantford, ON, November 2006

Walter Gerdts, Banff, AB, September 2013

John Gregorovich, Canmore, AB, September 2008

Jean Gural, Toronto, ON, October 2006

Gerald Kohse, Nanaimo, BC, July 2006

Gerald and Pamela Kohse, Nanaimo, BC, July 2006

Donna Korchinski, Calgary, AB, September 2008

David Lowenthal, London, UK, December 2010

Anastasia Malowski, Prince Albert, SK, August 1979

Inky Mark, Dauphin, MB, November 2006

Peter Melnycky, Edmonton, AB, November 2010

Fred Olynyk, Kamloops, BC, July 2008

Manuel Piña, Vancouver, BC, June 2011

Anne Sadelain, Edmonton, AB, November 2010

Borys Sydoruk, Banff, AB, September 2013

Diane Tootoosis, Poundmaker Cree Nation, SK, May 2013

Nick Topolnyski, Calgary, AB, September 2008

Bill Waiser, Saskatoon, SK, June 2007

Harry Williams, Fernie, BC, June 2006

Secondary Sources

Aung San Suu Kyi. *The Voice of Hope: Conversations with Alan Clements.* New York: Seven Stories Press, 1997.

Benjamin, Walter. "The Storyteller: Reflections on the Work of Nikolai Leskov (1936)." Translated by Harry Zohn. In *The Novel: An Anthology of Criticism and Theory 1900–2000,* edited by Dorothy J. Hale, 361–78. Malden, MA: Blackwell Publishing, 2006.

Cash, Gwen. *I Like British Columbia.* Toronto: Macmillan, 1938.

Cook, Tim. *At the Sharp End.* Vol. 1, *Canadians Fighting the Great War, 1914–1916.* Toronto: Viking, 2007.

Cyrulnik, Boris. *Resilience: How Your Inner Strength Can Set You Free from the Past.* Translated by David Macey. London: Penguin, 2009.

Davis, Wade. *Into the Silence: The Great War, Mallory and the Conquest of Everest.* New York: Knopf, 2011.

Dessureault, Pierre. *Sandra Semchuk: How Far Back Is Home.* Ottawa: Canadian Museum of Contemporary Photography, 1995. Exhibition Catalogue.

Fooks, Georgia Green. *Prairie Prisoners: POWs in Lethbridge during Two World Conflicts.* Lethbridge, AB: Lethbridge Historical Society, 2005.

Hellinger, Bert. *Love's Hidden Symmetry: What Makes Love Work in Relationships.* Phoenix, AZ: Zeig, Tucker & Co., 1998.

Herman, Judith. *Trauma and Recovery: The Aftermath of Violence—From Domestic Abuse to Political Terror.* New York: Basic Books, 1997.

Huston, Nancy. *Losing North: Essays on Cultural Exile.* Toronto: McArthur & Company, 2002.

Kazimi, Ali. *Undesirables: White Canada and the Komagata Maru: An Illustrated History.* Vancouver: Douglas & McIntyre, 2012.

Kogawa, Joy. *Obasan.* New York: Knopf Doubleday, 1993.

Kordan, Bohdan S. *Enemy Aliens, Prisoners of War: Internment in Canada during the Great War.* Montreal and Kingston: McGill-Queen's University Press, 2002.

——. *No Free Man: Canada, the Great War, and the Enemy Alien Experience.* Montreal and Kingston: McGill-Queen's University Press, 2016.

Kordan, Bohdan, S., and Lubomyr Y. Luciuk, eds. *A Delicate and Difficult Question: Documents in the History of Ukrainians in Canada, 1899–1962.* Kingston, ON: Limestone Press, 1986.

Kordan, Bohdan, S., and Craig Mahovsky. *A Bare and Impolitic Right: Internment and Ukrainian-Canadian Redress.* Montreal and Kingston: McGill-Queen's University Press, 2004.

Kordan, Bohdan, S., and Peter Melnycky, eds. *In the Shadow of the Rockies: Diary of the Castle Mountain Internment Camp, 1915–1917.* Edmonton, AB: Canadian Institute of Ukrainian Studies Press, 1991.

Kuhn, Annette. *Family Secrets: Acts of Memory and Imagination.* London: Verso, 1995.

Kuhn, Annette, and Kirsten Emiko McAllister, eds. *Locating Memory: Photographic Acts.* New York: Berghahn Books, 2006.

Langford, Martha. *Scissors, Paper, Stone: Expressions of Memory in Contemporary Photographic Art.* Montreal and Kingston: McGill-Queen's University Press, 2007.

Lowenthal, David. *The Past Is a Foreign Country – Revisited.* New York: Cambridge University Press, 2015.

Luciuk, Lubomyr. *In Fear of the Barbed Wire Fence: Canada's First National Internment Operations and the Ukrainian Canadians, 1914–1920.* Kingston, ON: Kashtan Press, 2001.

——. *Roll Call: Lest We Forget.* With the assistance of Natalka Yurieva and Roman Zakaluzny. Kingston, ON: Kashtan Press for the Ukrainian Canadian Civil Liberties Association and the Ukrainian Canadian Congress, 1999.

——. *A Time for Atonement: Canada's First National Internment Operations and the Ukrainian Canadians 1914–1920.* Kingston, ON: Limestone Press, 1998.

——. *Without Just Cause: Canada's First National Internment Operations and the Ukrainian Canadians, 1914–1920.* Kingston, ON: Kashtan Press, 2006.

Luhovy, Yurij, dir. *Freedom Had a Price.* Montreal: MML Inc. and NFB, 1994. DVD.

Margalit, Avishai. *The Ethics of Memory.* Cambridge, MA: Harvard University Press, 2004.

McLeod, Neal. *Cree Narrative Memory: From Treaties to Contemporary Times.* Saskatoon, SK: Purich Publishing, 2007.

Melnycky, Peter. "Internment of Ukrainians in Canada." In *Loyalties in Conflict: Ukrainians in Canada during the Great War,* edited by Frances Swyripa and John Herd Thompson, 1–24. Edmonton, AB: Canadian Institute of Ukrainian Studies Press, 1983.

Miki, Roy. *Redress: Inside the Japanese Canadian Call for Justice*. Vancouver: Raincoast Books, 2004.

Morton, Desmond. *The Canadian General Sir William Otter*. Toronto: Hakkert, 1974.

Motluk, James, dir. *Jajo's Secret*. Winnipeg: Canadian First World War Internment Recognition Fund, 2009. DVD.

Piniuta, Harry, trans. and ed. *Land of Pain, Land of Promise: First Person Accounts by Ukrainian Pioneers 1891–1914*. Saskatoon, SK: Western Producer Prairie Books, 1978, 1981.

Reid, Anna. *Borderland: A Journey through the History of Ukraine*. Boulder, CO: Westview Press, 2000.

Skrypuch, Marsha Forchuk. *Prisoners in the Promised Land: The Ukrainian Canadian Internment Diary of Anya Soloniuk, Spirit Lake, Quebec, 1914*. Toronto: Scholastic Canada, 2007.

Skrypuch, Marsha Forchuk, ed. *Kobzar's Children: A Century of Untold Ukrainian Stories*. Markham, ON: Fitzhenry & Whiteside, 2006.

Skrypuch, Marsha Forchuk, and Michael Martchenko (illus.). *Silver Threads*. Markham, ON: Fitzhenry & Whiteside, 2004. First published 1996 by Penguin Canada.

Stonechild, Blair, and Bill Waiser. *Loyal till Death: Indians and the North-West Rebellion*. New ed. Markham, ON: Fifth House, 2010.

Subtelny, Orest. *Ukraine: A History*. 3rd ed. Toronto: University of Toronto Press, 2000.

———. *Ukrainians in North America: An Illustrated History*. Toronto: University of Toronto Press, 1991.

Taylor, Charles. *Multiculturalism and the Politics of Recognition*. Princeton, NJ: Princeton University Press, 1992.

Trinh T. Minh-ha. *Woman, Native, Other: Writing Postcoloniality and Feminism*. Bloomington: Indiana University Press, 1989.

Waiser, Bill. *Park Prisoners: The Untold Story of Western Canada's National Parks, 1915–1946*. Saskatoon, SK: Fifth House, 1999.

Welzer, Harald. "The Collateral Damage of Enlightenment: How Grandchildren Understand the History of National Socialist Crimes and Their Grandfathers' Past." In *Victims and Perpetrators: 1933–1945: (Re)Presenting the Past in Post-Unification Culture*, edited by Laurel Cohen-Pfister and Dagmar Wienroeder-Skinner, 285–95. Berlin: De Gruyter, 2006.

Index

Page numbers in *italics* refer to photographs.

Other Titles from University of Alberta Press

Baba's Kitchen Medicines
Folk Remedies of Ukrainian Settlers
in Western Canada
MICHAEL MUCZ
An incomparable compendium of tinctures, poultices, salves, plasters, and tonics will fascinate and often mortify.

Folk Furniture of Canada's Doukhobors, Hutterites, Mennonites and Ukrainians
JOHN A. FLEMING & MICHAEL J. ROWAN
An impressive visual record and commentary on the culture and values of four ethno-cultural groups as reflected in their items of furniture.

The Little Third Reich on Lake Superior
A History of Canadian Internment Camp R
ERNEST ROBERT ZIMMERMANN
MICHEL S. BEAULIEU & DAVID K. RATZ, *Editors*
Accessible history of the controversial POW camp run during World War II in northern Ontario.

More information at uap.ualberta.ca